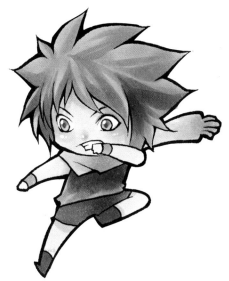

Shojo Wonder Manga Art School

Create Your Own Cool Characters and Costumes with Markers

Supittha "Annie" Bunyapen

IMPACT
CINCINNATI, OHIO
impact-books.com

Contents

What You Need for This Book

PAPER
Cardstock paper, at least 110-lb. (200gsm) thickness

PENCILS
Blue pencil (such as Prismacolor Col-Erase)

Mechanical pencils with harder leads (H, HB and 2B) in 0.3mm, 0.5mm, 0.7mm and 0.9mm sizes

PENS
005 (0.2mm) waterproof, fine-point technical pens in brown, sepia, gray and blue (such as Pigma Micron or Copic Multiliner)

White gel pen

Gold marker pen (Sakura Pen-touch Gold 0.7mm suggested)

Brush pens (such as Pentel Color Brush)

MARKERS
Copic brand in assorted colors, including 0-Colorless Blender

Other suggested brands: Neopiko by Deleter and Prismacolor

White marker

ACRYLICS AND ACRYLIC MEDIUMS
Heavy body acrylics (assorted colors, including white)

Fluid acrylics (assorted colors)

Crackle paste, opaque and semiopaque (such as Kroma Crackle Medium)

Glazing medium

Acrylic gel medium

Acrylic clear gesso base

WATERCOLORS
Assorted transparent colors (professional-quality tubes)

Opaque watercolor (such as Dr. Ph. Martin's Bleed Proof White)

BRUSHES
Nos. 2 and 4 round

1-inch (25mm) flat

Worn or inexpensive no. 2 round

Optional: Mop, script, various sized flats

MISCELLANEOUS
Masking fluid (also called liquid frisket)

Rubbing alcohol

White vinyl eraser (such as Mono Tombow or Pentel Hi-Polymer)

Eraser sticks

Rubber cement eraser

Plastic painting knives

Magazines or photos for reference and inspiration

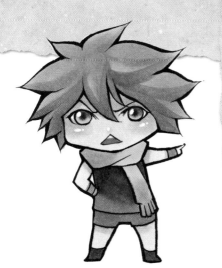

Introduction

There are countless ways to draw manga characters. From simple and cute to striking and realistic, how you choose to draw your figures is all up to you as the artist. There are two main goals of this book. The first is to learn to draw your own cool manga characters in colorful marker. We'll start off with the basics—how to choose the right art tools and how to use them. Then we'll move into the basics of drawing heads, faces, bodies, clothes and costumes. Finally we'll bring it all together by adding your characters to eye-popping backgrounds.

The second goal of this book is to learn to handle markers properly. There are many techniques and styles in applying marker as a painting method. Learning to layer and blend markers will help you create more accurate skin tones and costume colors. We'll also learn to mix markers with paint to create cool effects for your illustrations.

So whether you're just beginning or an experienced artist—grab a pencil, let your imagination go and start creating your own manga worlds!

Supittha "Annie" Bunyapen

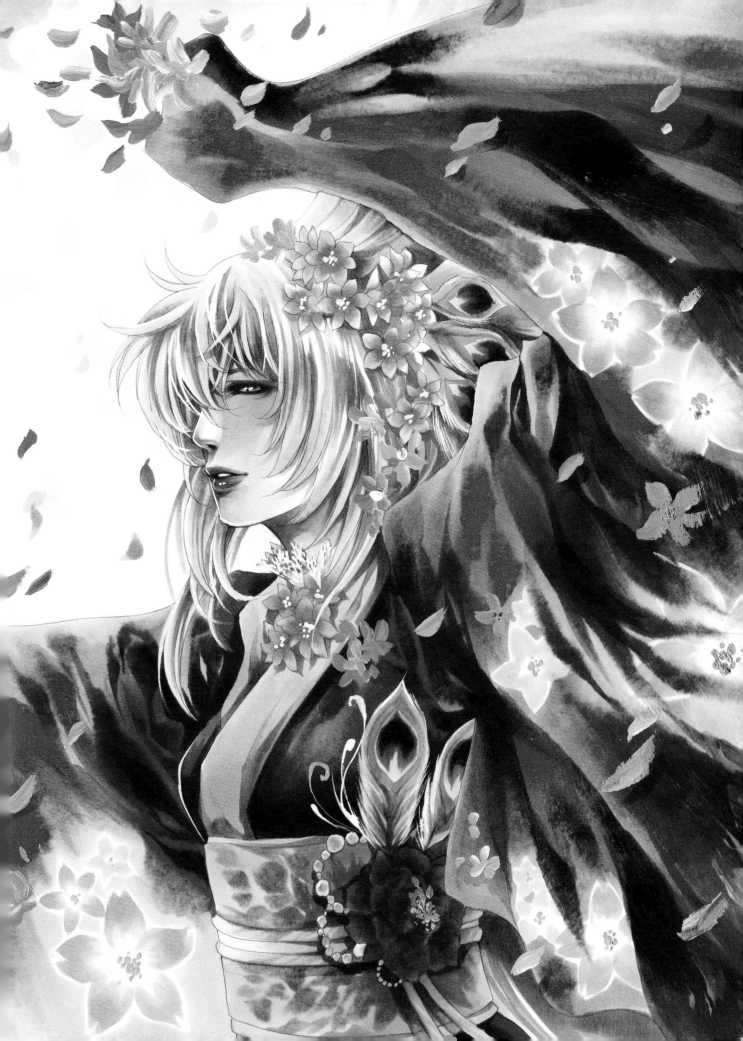

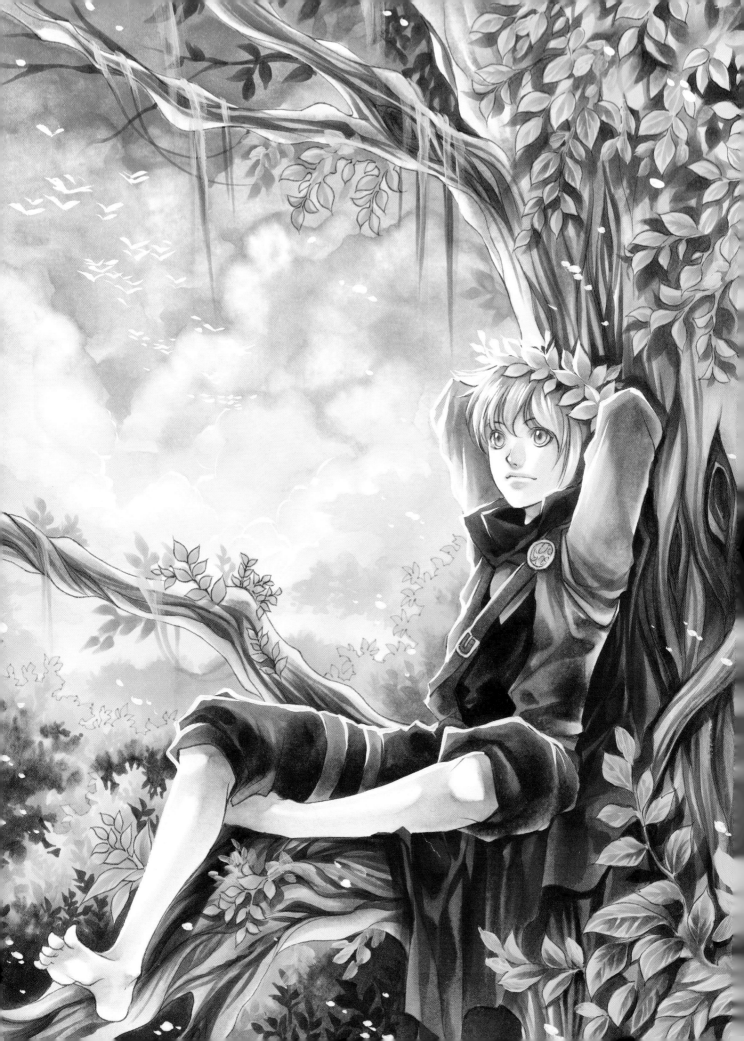

Tools and Materials

Deciding what tools and materials are right for you can be challenging and require a lot of time and experimenting. Tools can range in quality and price from super pricey to really cheap. But not all affordable tools are poor in quality if you know how to handle them well. The equipment and techniques listed in this chapter are what I've found to be useful in my art. My suggestions are only guidelines. Try different tools and practice a lot to get yourself on track for success.

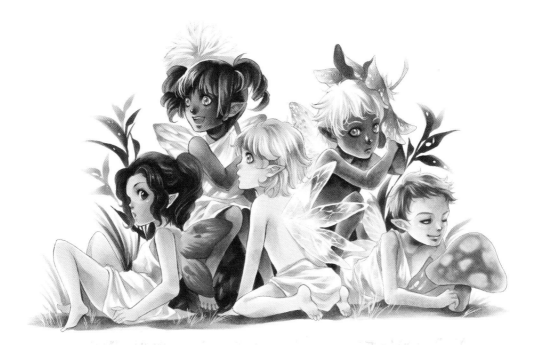

Drawing Tools

You don't need a big box of art supplies to be successful as an artist. Rather than struggle with tons of unfamiliar tools in the art store, all you need are these basic supplies. Don't get too hung up on names and brands; it's fine to use what you like and what is available.

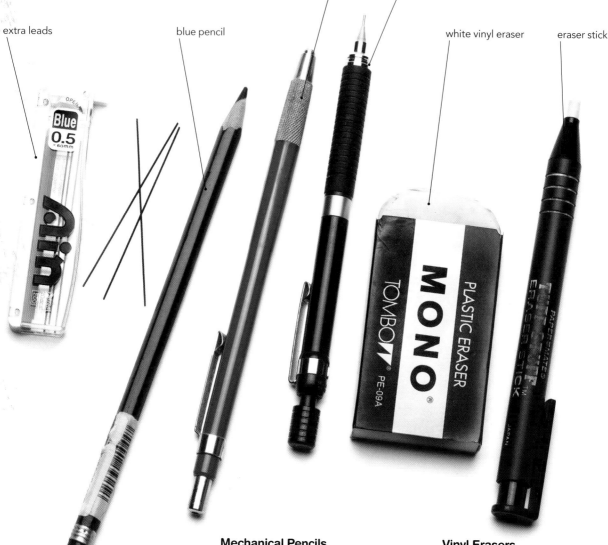

extra leads

blue pencil

lead holder

mechanical pencil

white vinyl eraser

eraser stick

Mechanical Pencils

Mechanical pencils are great for creating sharp pencil lines. They come in a variety of lead colors and thicknesses. The most basic is 0.5mm and can be found in most stores. Also try 0.3mm, 0.7mm and 0.9mm.

Stay away from darker leads like 4B, 6B or 8B to avoid dirty pencil traces after erasing. H, HB and 2B pencils provide good enough marks for drawing.

Blue Pencils

Blue pencils are good for preliminary sketches. I like Prismacolor Col-Erase pencils because they don't leave a mess when you erase them.

Vinyl Erasers

There are many shapes and brands of vinyl erasers. A Mono Tombow eraser is my top choice. It erases pencil traces effectively, even though its price is slightly higher than others. Pentel Hi-Polymer eraser is another brand I like.

Eraser Sticks

Eraser sticks are handy to erase delicate areas. They are pen-shaped and function similarly to mechanical pencils. Just click and use.

opaque
watercolor
and brush

white gel pen

white marker

Pigma Micron pen

Copic Multiliner

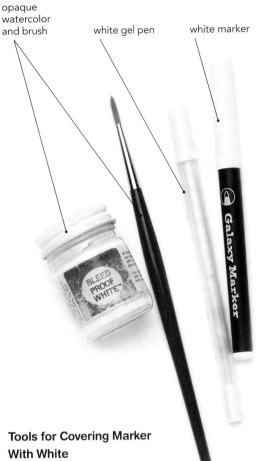

Tools for Covering Marker With White

White gel pens can be used for fast-drying, quick highlights and extra-small details. The ink flow is generally smooth, but be sure to close the cap after use, otherwise the ink will dry and clog the tip. Opaque watercolors such as Dr. Ph. Martin's Bleed Proof White also have great covering power for markers. When dry, you can color over it. It is not intended for mixing, though.

Choosing the Right Paper

There are many brands of marker paper to choose from, but in general, I prefer cardstock. It's high-quality enough for markers, plus it's inexpensive and easy to find in most stores. Choose at least 110-lb. (200gsm) cardstock for its thickness. If you can afford it, Deleter makes paper specifically for markers that varies in size and thickness, but with great absorbance.

Brush Pens

Pentel Color Brush is my favorite brush pen because the ink is not alcohol based, so it won't dissolve after you paint marker on top. Once it dries, it won't smudge or leave traces of ink on your markers' nibs.

Technical Pens

Use waterproof and marker-proof pens for inking and outlining your drawings. There are many brands out there that work well such as Copic Multiliner and Pigma Micron pens. These pens come with many choices of nibs and colors. They dry fast so you can quickly switch over to coloring with markers.

Markers

There are a lot of brands of markers out there and you can draw great manga with all of them! The best advice I have is to experiment with different brands to find what you like. You don't have to buy the most expensive markers, but keep in mind that different markers can provide different results. I use Copic markers in this book, but I'll tell you about a few other professional brands that are also great for coloring your manga characters.

techniques for fun results. There are four types of Copic markers that feature different styles of nibs (tips): Copic, Sketch, Ciao and Wide. Visit copicmarker.com/products/markers to learn about the different types of Copic markers available.

COPIC MARKERS

These markers are imported from Japan. They are alcohol based, nontoxic and fast-drying, and are great for trying out different

NEOPIKO AND PRISMACOLOR

Neopiko by Deleter and Prismacolor are also good marker brands. Neopiko markers are also alcohol based and have flexible nibs; they function pretty much like Copic markers, but are a little harder to find. Prismacolor markers come with broad nibs and are available in many colors, but they are not refillable.

Substitute Similar Colors

There are dozens of variations available for the main colors. Some are very similar and can be easily substituted for others. To save money, pick a few markers for each color instead of buying them all.

Copic Sketch Markers ↑
I prefer Copic Sketch Markers. They are double-ended with flexible brush nibs, and come in hundreds of color choices. Plus they're refillable, which is really great for your budget. Prices range from four to seven dollars on average for individual markers, or you can save and purchase a whole set.

For beginners on a budget, the Ciao Markers are a good alternative. They are the same nib as the Copic Sketch but in a smaller size, so they hold less ink. They also come in fewer color choices.

Neopiko Markers →
Neopiko markers are high-quality, professional-grade markers geared at manga artists. They are similar to Copic, but are alcohol based. To learn more or purchase Neopiko markers, visit deleter.com.

Visit impact-books.com/wonder-manga for a **free** bonus demonstration

Acrylic Painting Tools

Painting is a cool, fun way to add color to your manga illustrations. Acrylic is fast-drying and versatile, and can be colored over with marker when dry. Watercolor also dries fast. It is loose and transparent, and you can apply it in layers to build interesting colors. You can mix acrylic with water, but unlike watercolor, when the mixture dries, it becomes water-resistant. Experiment with paint in your characters and backgrounds. Mix and match with marker for unique results.

Acrylic Mediums →

Acrylic mediums can be used to varnish or to create texture on your final illustrations.

Acrylic clear gesso base—Apply over your illustrations. It dries as a clear, matte-like texture that can be painted over in watercolor or acrylic.

Gel medium—Similar to gesso, but it dries as a plastic-like texture.

Glazing medium—Use it directly from a bottle for varnishing, or mix it with fluid acrylics for adding extra colors to the final touch. Pricing can vary greatly, even for the same size containers.

Crackle paste—When dry, these pastes create cool cracking textures. You can mix them with a little paint for colorful results.

Acrylics ↓

Fluid acrylics contain more liquid and leave less pigment. They can be used by themselves or mixed with different acrylic mediums to intensify textures. Heavy body acrylics are rich in color and thick and smooth in consistency. When dry, they are water-resistant.

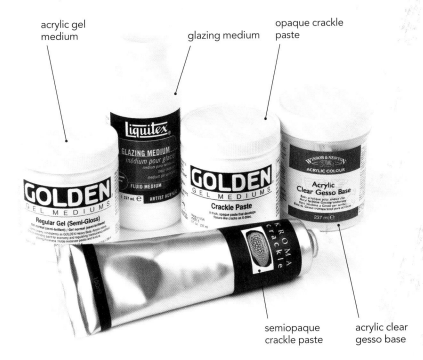

acrylic gel medium

glazing medium

opaque crackle paste

semiopaque crackle paste

acrylic clear gesso base

fluid acrylics

plastic painting knives for mixing

heavy body acrylics

Watercolor Painting Tools

Don't be intimidated by watercolors—they are great for creating really cool backgrounds for your manga characters. Watercolors are transparent and liftable after they dry when more water is applied. The quality of watercolors is based on price. Usually watercolor tubes are more expensive than cakes or pans, but produce nice, rich tones. Rather than buy an abundance of cheap colors, it's better to have a smaller selection of professional-quality paint. You can create beautiful mixtures with just a few basic colors.

Liquid Frisket

Liquid frisket (or masking fluid) can be applied on the surface to retain unpainted areas. When dry, markers or washes of paint can be applied on top. To remove, gently rub the masking with an eraser. Don't rub too vigorously or you might tear the paper's surface. When using frisket, make sure to always use old or inexpensive brushes. And don't leave the cap off for too long, or the liquid will harden and be difficult to use later on.

Basics of Brushes and Watercolor Paints ↓

Like watercolor paint, brushes vary in quality and price. Expensive brushes like natural sable are top-notch, though synthetic brushes work well with acrylic gesso and gel mediums. They cost less and are easy to clean. Always keep your acrylic and watercolor brushes separate.

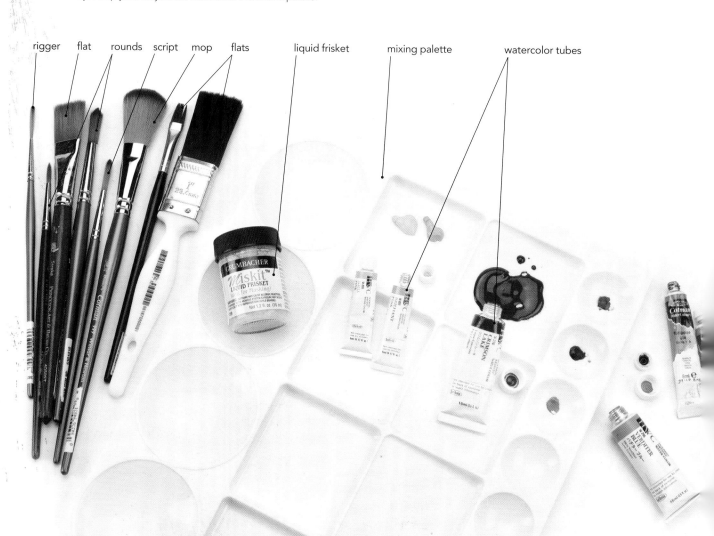

rigger flat rounds script mop flats liquid frisket mixing palette watercolor tubes

Cool Color Chart for Copic Markers

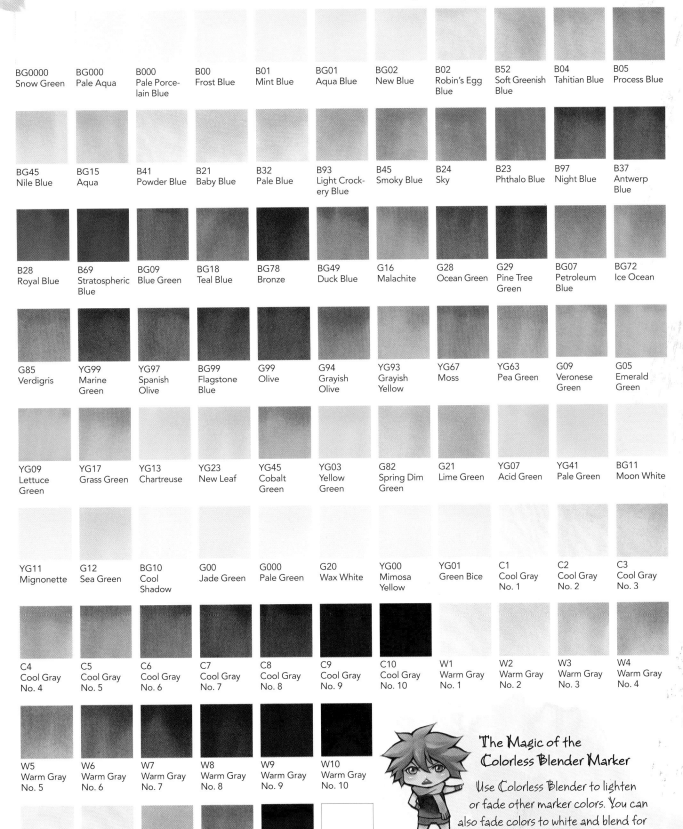

BG0000 Snow Green	BG000 Pale Aqua	B000 Pale Porcelain Blue
B00 Frost Blue	B01 Mint Blue	BG01 Aqua Blue
BG02 New Blue	B02 Robin's Egg Blue	B52 Soft Greenish Blue
B04 Tahitian Blue	B05 Process Blue	

BG45 Nile Blue — BG15 Aqua — B41 Powder Blue — B21 Baby Blue — B32 Pale Blue — B93 Light Crockery Blue — B45 Smoky Blue — B24 Sky — B23 Phthalo Blue — B97 Night Blue — B37 Antwerp Blue

B28 Royal Blue — B69 Stratospheric Blue — BG09 Blue Green — BG18 Teal Blue — BG78 Bronze — BG49 Duck Blue — G16 Malachite — G28 Ocean Green — G29 Pine Tree Green — BG07 Petroleum Blue — BG72 Ice Ocean

G85 Verdigris — YG99 Marine Green — YG97 Spanish Olive — BG99 Flagstone Blue — G99 Olive — G94 Grayish Olive — YG93 Grayish Yellow — YG67 Moss — YG63 Pea Green — G09 Veronese Green — G05 Emerald Green

YG09 Lettuce Green — YG17 Grass Green — YG13 Chartreuse — YG23 New Leaf — YG45 Cobalt Green — YG03 Yellow Green — G82 Spring Dim Green — G21 Lime Green — YG07 Acid Green — YG41 Pale Green — BG11 Moon White

YG11 Mignonette — G12 Sea Green — BG10 Cool Shadow — G00 Jade Green — G000 Pale Green — G20 Wax White — YG00 Mimosa Yellow — YG01 Green Bice — C1 Cool Gray No. 1 — C2 Cool Gray No. 2 — C3 Cool Gray No. 3

C4 Cool Gray No. 4 — C5 Cool Gray No. 5 — C6 Cool Gray No. 6 — C7 Cool Gray No. 7 — C8 Cool Gray No. 8 — C9 Cool Gray No. 9 — C10 Cool Gray No. 10 — W1 Warm Gray No. 1 — W2 Warm Gray No. 2 — W3 Warm Gray No. 3 — W4 Warm Gray No. 4

W5 Warm Gray No. 5 — W6 Warm Gray No. 6 — W7 Warm Gray No. 7 — W8 Warm Gray No. 8 — W9 Warm Gray No. 9 — W10 Warm Gray No. 10

B60 Pale Blue Gray — BV31 Pale Lavender — BV20 Dull Lavender — BV23 Grayish Lavender — BV29 Slate — 0 Colorless Blender

The Magic of the Colorless Blender Marker

Use Colorless Blender to lighten or fade other marker colors. You can also fade colors to white and blend for cool effects.

13

Warm Color Chart for Copic Markers

							Y15 Cadmium Yellow	Y17 Golden Yellow	Y18 Lightning Yellow	Y19 Napoli Yellow
Y000 Pale Lemon	Y00 Barium Yellow	Y11 Pale Yellow	Y04 Acacia	Y06 Yellow	Y02 Canary Yellow	Y13 Lemon Yellow				
Y35 Maize	YR21 Cream	Y23 Yellowish Beige	YR61 Yellowish Skin Pink	YR82 Mellow Peach	YR12 Loquat	Y38 Honey	YR65 Atoll	YR15 Pumpkin Yellow	YR04 Chrome Orange	YR16 Apricot
YR68 Orange	YR09 Chinese Orange	R08 Vermilion	R14 Light Rouge	R24 Prawn	R27 Cadmium Red	R46 Strong Red	RV29 Crimson	R37 Carmine	R59 Cardinal	R89 Dark Red
RV69 Peony	RV99 Argyle Purple	V99 Aubergine	E04 Lipstick Natural	BV17 Deep Reddish Blue	B79 Iris	FV2 Fluorescent Dull Violet	BV04 Blue Berry	B66 Clematis	BV13 Hydrangea Blue	BV08 Blue Violet
V09 Violet	V17 Amethyst	B63 Light Hydrangea	BV02 Prune	BV01 Viola	BV11 Soft Violet	BV00 Mauve Shadow	BV000 Iridescent Mauve	BV0000 Pale Thistle	V25 Pale Blackberry	V20 Wisteria
RV91 Grayish Cherry	RV93 Smoky Purple	V91 Pale Grape	V93 Early Grape	V95 Light Grape	V15 Mallow	V04 Lilac	V05 Marigold	V01 Heath	V12 Pale Lilac	V000 Pale Heath
RV0000 Evening Primrose	RV00 Water Lily	RV10 Pale Pink	RV02 Sugared Almond Pink	RV21 Light Pink	RV23 Pure Pink	RV06 Cerise	RV14 Begonia Pink	RV25 Dog Rose Flower	RV66 Raspberry	RV63 Begonia
RV55 Hollyhock	RV34 Dark Pink	RV09 Fuchsia	RV19 Red Violet	R83 Rose Mist	RV32 Shadow Pink	R32 Peach	RV13 Tender Pink	RV11 Pink	R85 Rose Red	R21 Sardonyx

R11
Pale Cherry
Pink

R02
Flesh

E93
Tea Rose

YR01
Peach Puff

E95
Flesh Pink

E000
Pale Fruit
Pink

YR0000
Pale Chiffon

YR000
Silk

E81
Ivory

E00
Skin White

E50
Egg Shell

E30
Bisque

E01
Pink
Flamingo

E02
Fruit Pink

E21
Baby Skin
Pink

E51
Milky White

E41
Pearl White

E42
Sand White

E43
Dull Ivory

E11
Bareley
Beige

E53
Raw Silk

E33
Sand

E13
Light Suntan

E15
Dark Suntan

E31
Brick Beige

E34
Orientale

E35
Chamois

YR30
Macadamia
Nut

YR24
Pale Sepia

E55
Light Camel

E99
Baked Clay

E97
Deep
Orange

E17
Reddish
Brass

E19
Redwood

E07
Light
Mahogany

E18
Copper

E57
Light Walnut

E59
Walnut

E23
Hazelnut

E87
Fig

E25
Caribe
Cocoa

E44
Clay

E29
Burnt Umber

E49
Dark Bark

100
Black

Tips for Coloring With Markers

- Always test your markers before you actually paint. There is a chance that even your favorite markers won't give you the same results as previously and can ruin your picture!

- For accurate results, always test your markers before you use them. Dried ink can make the marker pigment darker. If the ink runs out, refill it.

- Dried nibs cause less flow when you paint. Instead of having nice, smooth strokes, the dried nibs make rough and uneven strokes. If the nibs are too dry, replace them.

- Be aware of over-refilling your markers. They can leak if the nib gets too wet.

- Dirty nibs can spread unwanted pigment on your picture. It's rare, but it happens sometimes when markers paint over graphite sketches or smudge with different markers. If this happens, smudge the nib on some paper until it's clean.

Demonstration
LAYERING

Layering is a basic marker technique used to create volume in your pictures. Each time you layer a color on top of another, the color becomes gradually darker. Layering in families of colors is common, but you can also get creative with complementary colors for dynamic effects.

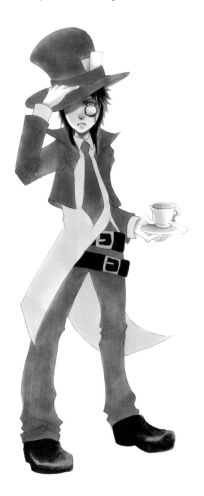

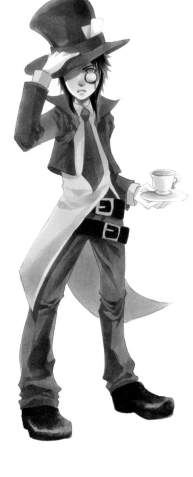

1 PAINT THE BASECOAT

Coat each area evenly with your first layer. Paint the hat, jacket and pants with Pale Olive. Use Grayish Olive to color the tie, and Pale Yellow on his shirt.

2 ADD THE SECOND LAYERS

Pick darker shades for your second layer. With Spanish Olive, paint folds of the fabric where you first painted with Pale Olive. Make sure not to overpaint. Leave some room for the first layer to show through, especially the parts that are close to the viewer. Apply the same method to the tie with Verdigris, and the shirt with Brick Beige.

Practice Layering Marker Colors

Before you get started, practice layering different colors to see what happens. Here I've layered green over brown to come up with my character's outfit color. Think about shadow colors and test on scrap paper before you start.

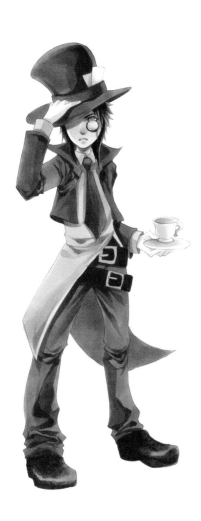

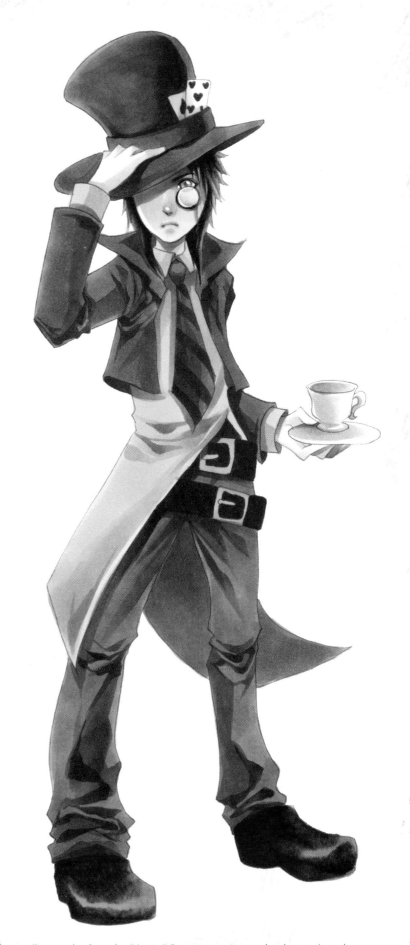

3 DARKEN DETAILS WITH THIRD LAYERS

To emphasize volume, paint the deeper shadows of the folds with Olive on the jacket. For the shirt, use Sand as the third layer. Coat the entire area of the shirt that is behind his pants since that part is the farthest away from the viewer. Darken his tie with Ocean Green.

4 FINALIZE DETAILS

If you want to keep pushing the deepest shadows on the jacket, pants and hat, use Warm Gray No. 6. Watch the amount of layers, otherwise the picture will be too overwhelmed with dark shadows. Use Light Grape for the deepest folds and farthest parts on his shirt.

To refine the other details, paint the cards and stripes on his tie with Warm Gray No. 6. Finally, finish up the overall image by marking highlights on the nose and eyes with a no. 2 round and white acrylic paint or a white gel pen.

Demonstration
BLENDING

Blending is a technique that allows you to intermix different colors together. Unlike layering, blending makes a smooth, nice gradient. It can be used in almost every aspect from your character's outfits, accessories and props to your backgrounds, such as skylines and terrains. Blending can be used to suggest distance. Simply use this technique on any area that recedes from the viewer.

MATERIALS

COPIC MARKERS
R89-Dark Red, YR12-Loquat, R08-Vermilion, Y23-Yellowish Beige, RV99-Argyle Purple, E34-Orientale, Y28-Lionet Gold

OTHER TOOLS
white acrylic paint and a no. 2 round brush (or white gel pen)

1 LAY THE FIRST LAYERS
For the areas that need to be blended, paint the first layers. Use Dark Red to paint on his coat, and leave some blank spaces at the tips and at the ends of the sleeves. With Loquat, paint the top half of the clock that the character is holding.

2 SMOOTH THE AREAS WITH SECOND COLORS
The easiest way to smooth colors is to paint a darker shade first, then blend with a lighter shade. This leaves less brushstrokes from markers. Pick Vermilion for the second color of his coat. Overlap it with the darker color, and you'll see these colors blending gradually. For the clock, paint Yellowish Beige towards the first paint as well.

3 ADD THE FINAL DETAILS
To suggest folds, use a darker shade like Argyle Purple to indicate the creases around his arm joints and waist. The clock needs to be a little shiny, so instead of using only one color layer on top, use two colors to create shadow. Use Orientale and Lionet Gold as a shadowy gradient at the back of the clock. For the side, use Lionet Gold to paint shadows and leave areas of the first gradient to show through. Add extra highlights with a no. 2 round and white acrylic paint or a white gel pen on his eyes and nose, the buttons of his pants and the side of the clock.

Bleeding and Sprinkling

Here are a few other basic techniques I like to use. These can be used to refine your illustrations and create cool patterns and effects. Of course, you can experiment more on your own and find what works for you.

Simple Blending

To blend, apply your first color to paper, usually the lighter color. While wet, overlap with another darker color or a color in the same family. Where the two colors meet, paint back over with the first marker. You can add more layers as you wish, each time going back over the wet layers with the previous lighter color to blend.

Bleeding

Bleeding is a useful technique if you want a watercolor look. I use this technique for underwater scenes, distant leaves in a forest and fabric patterns.

To create a piece of underwater seaweed, blend a cool green color with the Colorless Blender marker.

Sprinkling

The sparkle of stars and bubbles underwater can be created with sprinkling.

First apply a basecoat of the color of your choice. Using a refill container of Colorless Blender or any lighter colors, remove the cap and sprinkle on top of the basecoat. The sprinkling drops start to push away the basecoat, leaving behind faded spheres. If you don't have any marker refills, gently tap the nib on the paper. Repeat the method as much as you desire.

Markers and Other Media

Mixing markers with other media can create amazing finished results. Play around with the acrylic mediums and tools we talked about earlier in the chapter. Use blank paper and write down the different combinations you try with markers. Then when you want to try something cool on a drawing, you will know what to expect.

Acrylic Clear Gesso Base

Gesso is a primer that can be applied to a surface before painting. With markers, I prefer to use gesso after finishing an illustration to create different textures. Use a ½-inch (13mm) or 1-inch (25mm) synthetic brush to apply gesso over your illustration. While it is still wet, use a brush or comb to create bumpy, rough textures. Once the gesso dries, apply watercolor washes, markers or translucent paint on top. Try this for background textures, fabrics, tree bark and pavement.

Heavy Body Acrylic Paint

Acrylic paints can give a nice final touch for your picture, especially in subtle parts where it is very difficult for markers to complete, such as fur, feathers, strands of hair, small leaves and flower petals. The paints can be used directly from tubes or mixed with retarder medium for slower drying. Multiple layers of paints can create texture and depth.

Gel Medium

The difference between gel medium and glazing medium is their bodies. Gel medium is a translucent acrylic paint that can be used for glazing, coating, creating textures, and more. Gel medium has a thicker body once it dries.

Paint the gel medium on your picture. While it is still wet, use a flat brush to create any texture you desire. Once it dries you will have clear plastic textures. Markers on top of the dried medium bring out its textured appearance. This technique is good for water effects, especially surface ripples.

Glazing Medium and Fluid Acrylics

Glazing medium can change the mood of your picture. Once applied, it gives a clear, translucent layer over your illustration. Mix the glazing medium with your color choice of fluid acrylics (test the color of the mixture before). Since the medium tends to dry pretty fast, use a 1-inch (25mm) flat and apply quickly. Once the paint dries, add more layers, either in the same color or different.

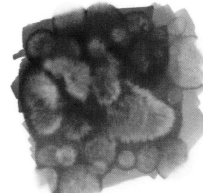

Rubbing Alcohol

If you are looking for a substitute for the Colorless Blender marker, rubbing alcohol is an inexpensive alternative. It's perfect for creating bubble effects. Sprinkle or drip rubbing alcohol over marker. The alcohol will fade the color areas it is dripped on and create bubble textures.

Visit impact-books.com/wonder-manga for a **free** bonus demonstration

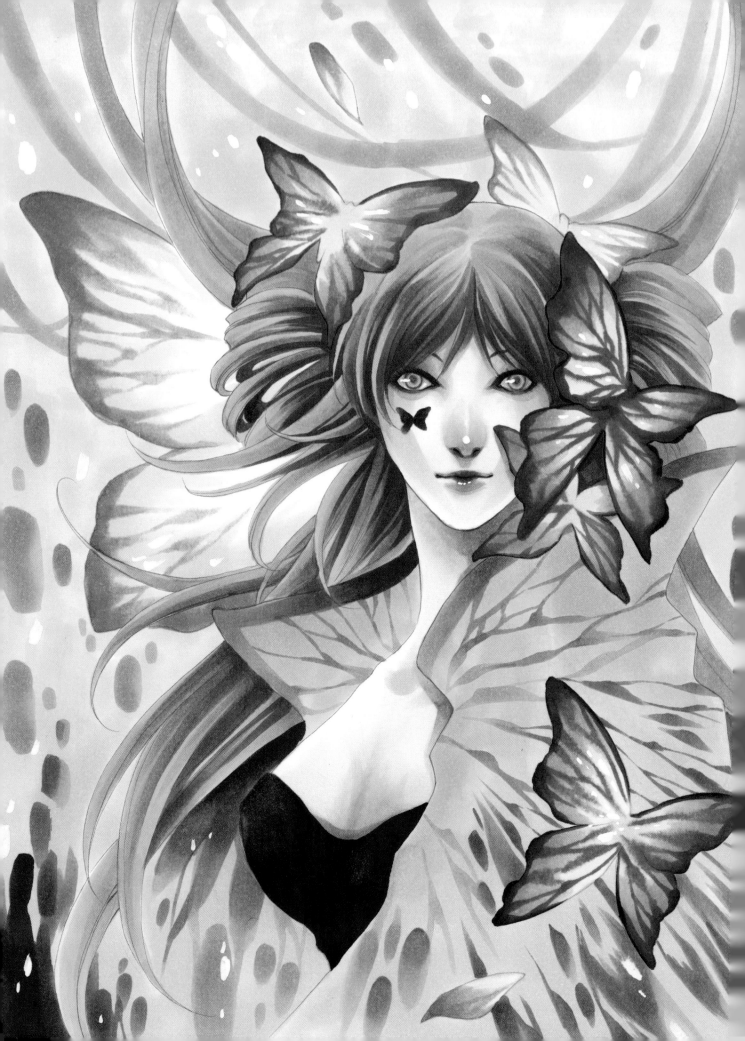

2

Drawing and Painting Heads

The face is the most important feature you create to make people recognize your characters. Think of each face you see as unique and individual. The smallest, most subtle changes in facial structure or skin color can change the look and expression of the character. In the world of manga, we have more freedom to create the look of our characters in any way we desire. Big glowing eyes, colorful skin tones, or round, chubby faces with hair dyed crazy colors—anything can happen when you let your imagination go wild.

This section features techniques for drawing and painting human heads. You will find the basics of proportion, and learn how age and gender can affect your character's appearance. We'll also look at how to create various skin tones through several demonstrations.

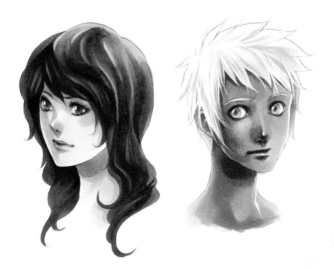

Drawing the Head

The face is the starting point to make your figures recognizable. It can indicate if your character is male or female, young or adult, and reveal traits of their personality.

In manga, although facial structures and features are different from reality, whether exaggerated or minimized, most retain realistic proportion to the human head. Proportion can even be adjustable once you learn the basics. Here are some simple steps for drawing a human face.

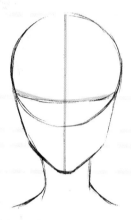 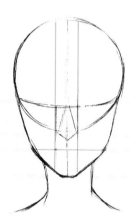 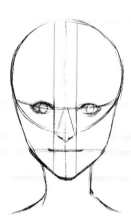 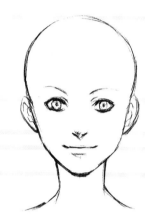

1 CREATE THE BASIC SHAPE

Draw a circle and place a vertical line down the center. Add a horizontal line, with a bit of a curve about two thirds from the top of the circle. Draw a jawline and chin under the circle.

2 ADD FEATURES PLACEMENT

Place the nose at the bottom of the circle. Create a triangle shape at the center, then add a vertical line on each side, meeting the triangle wings. Draw another horizontal line at the jawline.

3 START ADDING ROUGH FEATURES

The lines indicate where the facial structures should be placed. The eyes should not be drawn too far from the center of the face; they should align with the end of the nose's wings. Place the mouth at the lower horizontal line, but it can be adjusted in whatever ways you want to suit your character.

4 REFINE THE DETAILS

Erase all those horizontal and vertical lines, and the unnecessary curves or scratches that you no longer want.

Exaggerate or Minimize the Eyes

Not every character's face is drawn in the same way. Some artists tweak and exaggerate features to make a character look different to match a certain artistic style. For example, in shojo manga, the eyes are usually drawn bigger with smaller noses and mouths. The best way to find what style is right for you is to shift around or scale up and down the facial features. As long as everything stays in proportion and looks good, you are the hero!

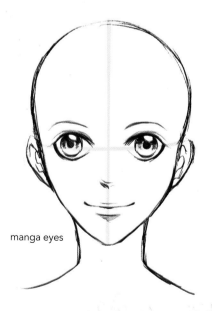 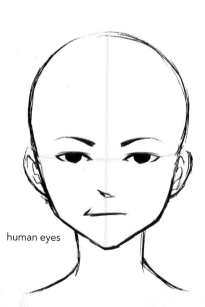

manga eyes human eyes

Facial Structure

Facial structure and proportion change as someone ages. Modifying the size of the features, such as the eyes, nose and mouth, helps your characters fit better with their age group. Kids and adolescents tend to have big eyes and round, soft facial features. Adults have stronger jaws, and more angular and detailed features.

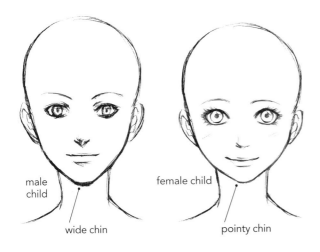

male child

female child

male adult

female adult

wide chin

pointy chin

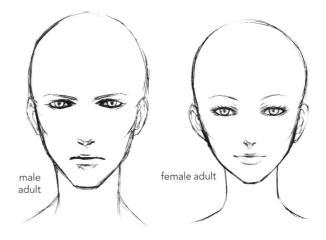

Male vs. Female Facial Structure and Features

Different genders can have different looks even at the same age. Generally, a female character can be drawn with a shorter face and a slight pointy chin. In contrast, a male character's face is more angular, with a strong jawline. Draw a male's chin wider and less pointy than a female's.

The features are as important as the facial structure. For females, enlarge the eye size and add eyelashes. Male characters will have flatter lips, while females' lips will often be fuller and sexier, especially the lower lip.

Adult vs. Child Eyes

Adults have smaller eyes than children, yet mature females still have bigger eyes than males. Compare the eyes of the child and adult figures.

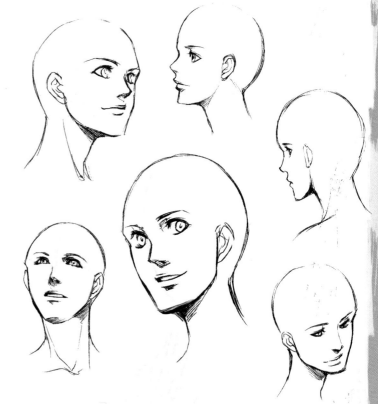

Study Different Angles of the Head

You can dramatically change a character's look by adjusting the angle of the basic features and the proportion. Study your face at different angles in the mirror and observe people around you.

Drawing Hair

When it comes to drawing manga hair, stylize reality rather than copy every detail. Plan the entire look by thinking about your characters' personality and style preferences. The following steps will show you how to draw a hairstyle. Always start with basics, then develop more details as you go along.

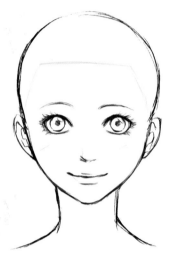

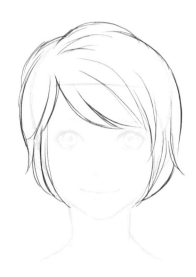

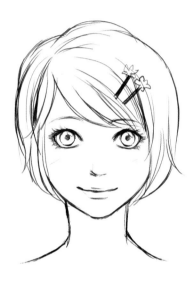

1 START WITH THE HAIRLINE

Draw the hairline on the forehead. Usually the hairline can be placed about halfway between the top of the head and the eyebrows.

2 DRAW A ROUGH SHAPE OF HAIR

Focus on drawing the rough shape of hair instead of making it look perfect. Roots of hair bangs should start from the hairline and follow the shape of the head.

3 ADD VOLUME AND ACCESSORIES

You can have a lot of fun refining details and adding accessories. Consider highlights and shadows of the hair while adding volume. Leave space for the parts that have highlights and define more subtle details on shadowy areas. The groups of individual strands will help the hair have a flawless look, but don't overdo it by drawing every strand.

Use Magazines for Hairstyle Reference

Look for cool and unique hairstyles in magazines. They are a great resource of inspiration for your manga characters.

Hairstyle and Color

From glamorous, high-body waves to wild spikes to green pigtails, there are millions of hairstyle choices for your characters. Stick with plain, natural styles, or go severe. Hair colors are just as diverse. Pick a color for your character and have fun with it!

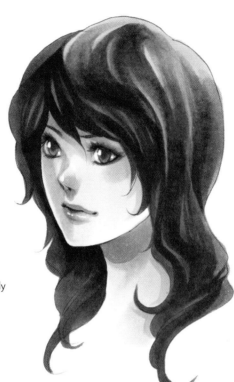

glamorous and high-body

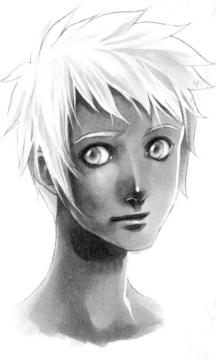

short and spiky

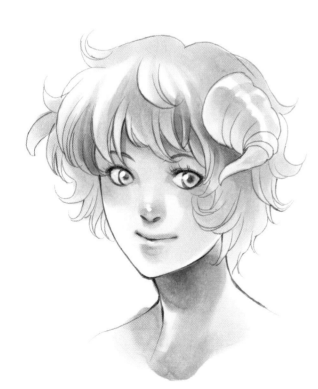

short and wavy

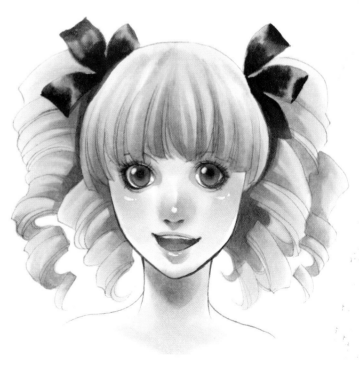

curly and cute

Skin Tone Basics

Manga skin tones can vary from natural to super extreme, from ivory pale to saturated colors, or whatever color you desire. There are no limits to picking the perfect skin tone for your character. Here are a few of the basic types of skin tones. Use these color combinations as a basis for creating your own skin tones in the future.

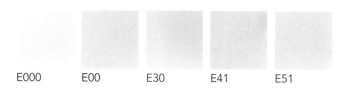

E000 E00 E30 E41 E51

Pale Skin

Pale skin tones can be achieved by E000-Pale Fruit Pink and E00-Skin White. If you prefer something less pink and more ivory, try E30-Bisque, E41-Pearl White, and E51-Milky White.

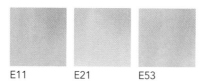

E11 E21 E53

Medium Skin

A medium tone is good if you don't want your characters too pale or too dark. Use E11-Bareley Beige, E21-Baby Skin Pink, and E53-Raw Silk.

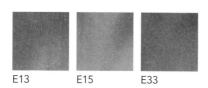

E13 E15 E33

Dark Skin

Dark skin can be achieved with E13-Light Suntan, E15-Dark Suntan and E33-Sand.

C3 C5 C7

Dark Gray Skin

Dark elves are recognized by their dark gray skin. Good marker choices include cool gray shades such as C3-Cool Gray No. 3, C5-Cool Gray No. 5, and C7-Cool Gray No. 7.

W3 W5 W7

Warm Grayish-Brown Skin

Warm gray shades also work really well, especially W3-Warm Gray No. 3, W5-Warm Gray No. 5, and W7-Warm Gray No. 7.

G00 B00 B32 BV000

Colorful Skin

Want your character to be unique? Blue, green or even purple skin can work for your character as long as it looks adorable. Some of my choices are G00-Jade Green, B00-Frost Blue, B32-Pale Blue, and BV000-Iridescent Mauve.

Painting Skin Tones

Picking the skin tone for your character is the easy part, but painting it is another story. There are three shades required: the basecoat, middle tone and shadow. Layering these shades will help your character look more natural. You may ask yourself, "How do I know which shade to add first?" The following exercises show some basic techniques for blending and layering skin tones. Although the two styles require the same markers, the results are different—when blending start with the darkest shadow tone, when layering begin with the lightest color. Which style you choose for your characters is your artistic choice.

BLENDING STYLE

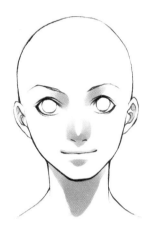 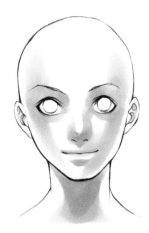 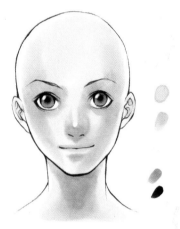

1 PAINT THE DEEPEST SHADOWS
Consider where the light source is hitting the skin and paint the deep shadows first.

2 ADD THE MIDDLE TONE
Let the middle color blend where it overlaps the dark shadows you already painted.

3 COAT THE WHOLE AREA WITH THE LIGHTEST SHADE
Add the lightest shade to wash out the shadows and blend all the colors together smoothly like watercolor. Here, I added the eye colors last.

LAYERING STYLE

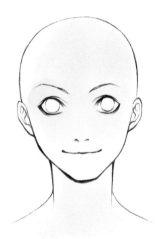 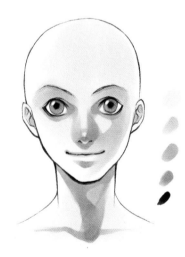

1 PAINT THE ENTIRE FIGURE
Coat the entire skin of your character with the lightest color.

2 ADD THE MIDDLE SHADOWS
Once the basecoat dries, paint the middle tone as your second layer. The middle tone will start creating dimension on the face—here it has helped shape the eyes, nose, cheeks, mouth and neck shadow.

3 GIVE A FINAL TOUCH WITH THE DEEPEST SHADOW
Consider what needs to be painted with the darkest shadow, such as under the neck, under the nose and the corners of the eyes. The darkest shadow will not fade like it does in the blending style; instead, it remains its original color.

Color and Mood

Rather than relying solely on facial expressions, a variety of shades can boost your characters' moods. The right color can illustrate your characters' expressions, whether they are happy, grumpy or sulking.

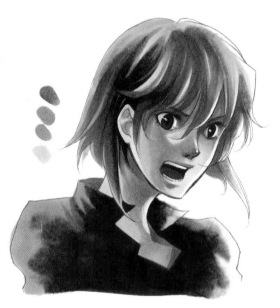

Warm Colors—Angry and High-Energy
Warm colors can be crimson, red, orange or yellow tones. The warm shades usually depict characters who are excited, angry or energetic.

Cool Colors—Sad and Calm
If your character is sad, calm or even depressed, cool colors can be a perfect match. In manga, the choices of cool colors range from green to blue. Lighter cool tones normally represent calmness or a subdued demeanor, whereas a few cool shades darker or with more intensity can depict depressing and mournful.

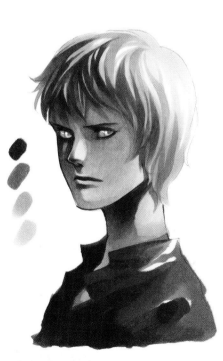

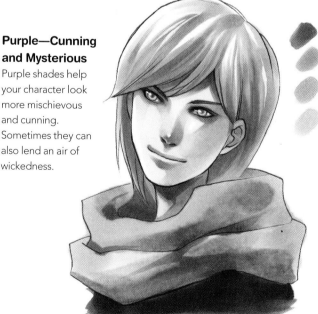

Gray—Serious and Determined
Gray shades help your characters look serious, gloomy or determined. The darker the gray shade is, the more intense your character will look. Some artists even use black for extreme emotion.

Purple—Cunning and Mysterious
Purple shades help your character look more mischievous and cunning. Sometimes they can also lend an air of wickedness.

Basics of Light

Another way to build up your character's dimension is to add extra light, or *reflected light*. Reflected light is the light that hits objects and characters that bounces the color back to your eyes. In manga settings, base these reflected colors on your backgrounds and general artistic preferences.

The Basics of Light and Shadow

Understanding how light hits an object is important to becoming a better artist. Here are the basics of how objects reflect light to form shadows.

Highlight—This is the brightest surface of the object and the area that the light source hits first.

Form shadow—This is the normal shadow. A form shadow is the area not facing the light source; its shade can vary but often contains the darkest dark of the object.

Reflected light—The light that is sometimes reflected from the surroundings. Usually it is placed opposite the highlight.

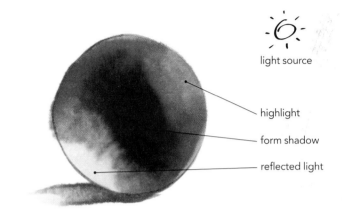

light source

highlight

form shadow

reflected light

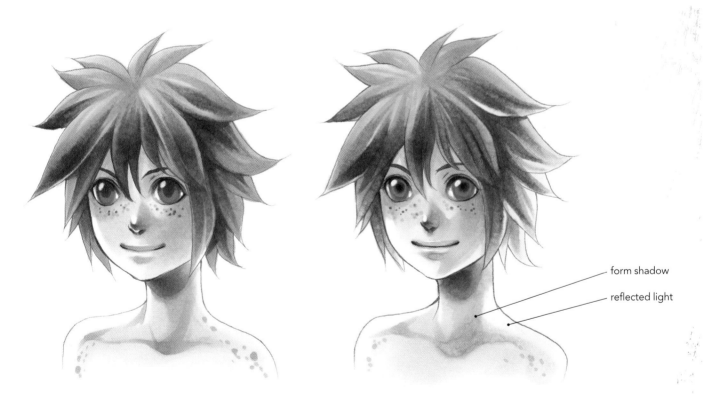

form shadow

reflected light

Reflected Light

In this comparison, reflected light drastically changes the dimension of the character. It draws attention to the shadow and makes the character look less flat. Reflective light can be applied to skin, strands of hair, clothes or props, just modify the color of reflected light to go along with the color theme of the background.

Demonstration
PAINTING LIGHT SKIN

A common skin tone for girls in manga is delicate and light in color. Painting light skin is a great starting point for learning to paint other types of skin colors. It's easier to adapt a light tone to dark than the other way around.

<div style="writing-mode: vertical">MATERIALS</div>

COPIC MARKERS
0-Colorless Blender, B01-Mint Blue, B24-Sky, C3-Cool Gray No. 3, E000-Pale Fruit Pink, E01-Pink Flamingo, E11-Bareley Beige, E13-Light Suntan, E55-Light Camel, G00-Jade Green, R11-Pale Cherry Pink, RV11-Pink, V93-Early Grape, Y23-Yellowish Beige, YG00-Mimosa Yellow

OTHER TOOLS
cardstock paper

pencil

eraser

brown or sepia and gray 005 (0.2mm) waterproof, fine-point technical pens (Pigma Micron or Copic Multiliner)

white acrylic paint and a no. 2 round brush (or white gel pen)

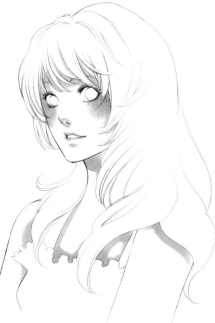

1 ADD THE FIRST COLORS TO CREATE FACIAL DEPTH
Once you've sketched your drawing on cardstock paper, ink the character with a brown or sepia 005 (0.2mm) waterproof technical pen. Use a gray technical pen for her eyes and clothes. For the deepest shadow, shade the character's skin with Bareley Beige around her eyes, under her chin, her lower lip and hair, and around her clothes to indicate where the shadow is. Also, add a touch of cheek blush with Pink and Pale Cherry Pink, and fade it smoothly with Colorless Blender.

2 CREATE THE MIDDLE SHADOW
Give her light skin volume by painting Pink Flamingo on her left cheek and arms. Leave some unpainted areas empty, especially at the tip of her nose.

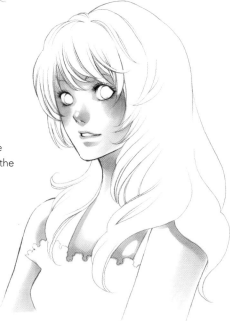

Less Is More

Keep things simple by working with minimal colors at the beginning, then add more colors later rather than throwing together every color you have at once. Use less at first and you're good to go!

Visit impact-books.com/wonder-manga for a **free** bonus demonstration

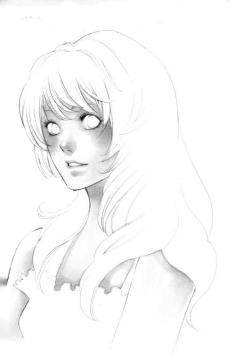

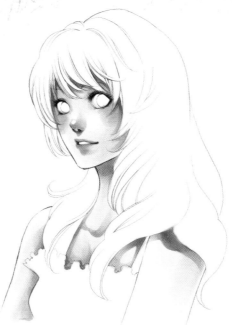

3 PAINT THE BASECOAT

Paint most of her flesh with Pale Fruit Pink, leaving some small areas for highlights on the right side of her cheek and arms.

4 ADD SKIN DEPTH AND DETAILS

Once the basecoat dries, bring out subtle depth and details. To make the eyes pop, paint Light Suntan on her lashes and the outer corner of her eye. Repaint the faded color around the eyes with Bareley Beige. Early Grape is also a good choice for adding distinct depth, but be careful not to overdo it. Also, add Pink and Pale Cherry Pink again on her lips to make them stand out.

5 COLOR THE HAIR

Add shadowy streaks on some areas with Light Camel. Coat most of the remaining hair with Yellowish Beige, making sure to leave some highlights. Once it dries, use Early Grape to intensify the shadowy streaks of hair.

6 FINISH THE EYES AND CLOTHES

Blonde hair goes well with light, bright colors such as blue and green. It can definitely make your girl more lively! Paint Mint Blue on the irises, and dot Sky at the center to mark the pupils.

Mimic these blues and greens in her clothes. Use Mint Blue, Jade Green and Mimosa Yellow to create tartans. Follow with Cool Gray No. 3 to create fabric creases. Finally, clean up the entire image with white acrylic paint and a no. 2 round or a white gel pen to her eyes, tip of her nose and lower lip.

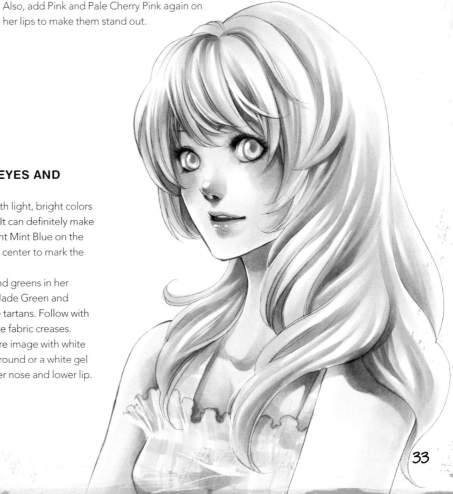

Demonstration
PAINTING TANNED OR ASIAN SKIN

Illustrations of Asian characters often depict narrow eyes and lightly-tanned skin. It is also common for Asian skin to have some yellow undertones. You can easily achieve these effects with just a few markers.

MATERIALS

COPIC MARKERS
0-Colorless Blender, C7-Cool Gray No. 7, C10-Cool Gray No. 10, E11-Bareley Beige, E13-Light Suntan, E15-Dark Suntan, E21-Baby Skin Pink, E29-Burnt Umber, E43-Dull Ivory, E50-Egg Shell, E57-Light Walnut, RV29-Crimson, RV99-Argyle Purple, V95-Light Grape

OTHER TOOLS
cardstock paper

pencil

eraser

brown or sepia 005 (0.2mm) water-proof, fine-point technical pens (Pigma Micron or Copic Multiliner)

white acrylic paint and a no. 2 round brush (or white gel pen)

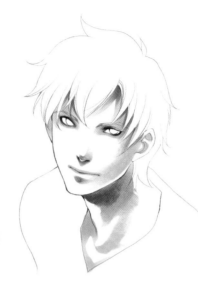

1 ADD THE FIRST COLORS TO CREATE FACIAL DEPTH

Sketch and ink your character with a brown or sepia 005 (0.2mm) waterproof technical pen. For the deepest shadow, shade the character's skin with Light Suntan and blend carefully with Bareley Beige. Add these first colors around the eyes and lips, under the lower lip, on the left side of his face, under his hair, and around his clothes. Use the Colorless Blender to fade the colors in some areas, if desired.

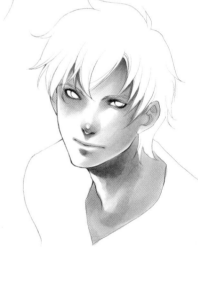

2 CREATE THE MIDDLE SHADOW

Since Asian skin requires yellow, use Baby Skin Pink as the middle tone. Paint almost all of the flesh, leaving some room for highlights.

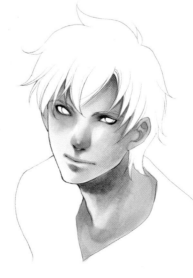

3 PAINT THE SKIN'S BASECOAT

Slowly coat all of the flesh with Egg Shell. The basecoat allows you to subtly blend different colors without leaving unnecessary streaks or marks.

4 DARKEN THE SKIN DETAILS AND SHADOWS

Always make the eyes the main focus of the character. Use both Dark Suntan and Light Grape, to darken the outer corner of each. Use these colors to deepen the shadows around his lips, under his nose, lower lip and hair, and around his clothes. A touch of Light Grape will produce the darkest darks of the deepest shadow, making your character look lively and keeping his flesh from looking too flat.

5 ADD THE HAIR'S MAIN COLOR

With Cool Gray No. 10, paint shadowy strands on his hair, but leave some highlight space on the right side of his head to indicate the light source. Use Colorless Blender to dilute some tips of the Cool Gray No. 10 paint streaks, especially those closer to the light source, and use to paint his eyebrows.

6 FINISH THE HIGHLIGHTS

For a sleek look for the hair, blend Cool Gray No. 7 at the tips of the Cool Gray No. 10 paint streaks and smooth the colors together. Add brown to the highlight areas with Dull Ivory as a basecoat to his hair.

7 ADD THE FINISHING DETAILS

Finish the eyes by adding Light Walnut on his irises, and when dry, follow with Burnt Umber for the pupils and the corner around the irises. To make his pupils pop, touch them up with more Cool Gray No. 10.

For the shirt, create the shadows of the folds and wrinkles with Argyle Purple. Dilute some of those streaks with Colorless Blender. Paint the entire shirt over the shadows with Crimson.

Add a touch of reflection with a no. 2 round and white acrylic paint or a white gel pen to his eyes and the tip of his nose.

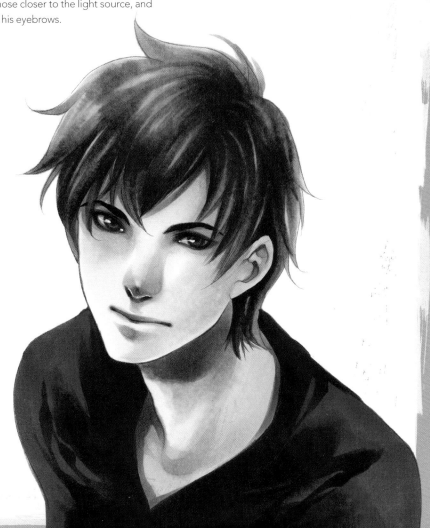

PAINTING DARK GRAY SKIN

Some alternative skin tones don't exist in real life, but do in the fantasy world. The dark gray skin of a drow or dark elf is exotic, but elegant enough to catch your attention.

MATERIALS

COPIC MARKERS

0-Colorless Blender, C1-Cool Gray No. 1, C3-Cool Gray No. 3, C5-Cool Gray No. 5, C6-Cool Gray No. 6, C8-Cool Gray No. 8, G000-Pale Green, Y35-Maize, YR14-Caramel

OTHER TOOLS

cardstock paper

pencil

eraser

gray 005 (0.2mm) waterproof, fine-point technical pen (Pigma Micron or Copic Multiliner)

white acrylic paint and a no. 2 round brush (or white gel pen)

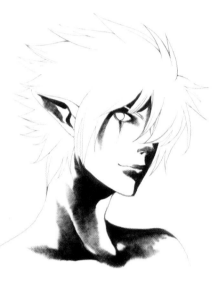

1 ADD THE FIRST COLORS TO CREATE FACIAL DEPTH

Sketch and ink the character with a gray 005 (0.2mm) waterproof technical pen. Since the light source comes from the left, paint the deepest shadows under the chin, inside his long elvish ear, on the shoulder blade, under the hair, under both the upper and lower lips, and on the left side of his face with Cool Gray No. 8. Use Colorless Blender to dilute and lighten some of the shadow areas, but be careful not to fade the Cool Gray No. 8 paint too much.

2 ADD THE MIDDLE TONES

Paint the middle tones with Cool Gray No. 5. Leave some highlights on the right side of the character's jawline, neck, shoulder blade and nose. Dilute the Cool Gray No. 5 color with Colorless Blender. No need to worry if some splotches occur when you blend the colors.

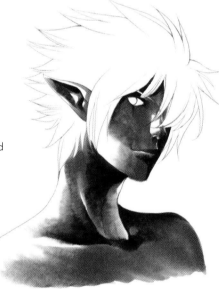

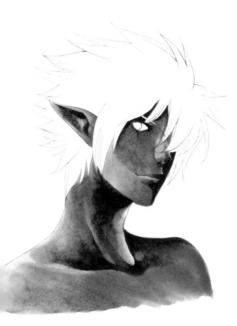 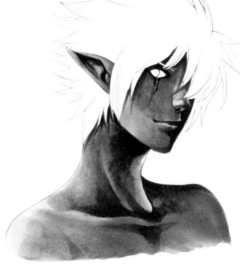 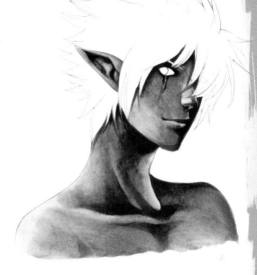

3 PAINT THE BASECOAT

Use Cool Gray No. 3 to coat all of the character's flesh. The basecoat that you paint on top will allow all colors to blend together neatly and reduce any splotches that previously occurred.

4 DARKEN THE DETAILS

After the basecoat dries, darken the shadowy areas with Cool Gray No. 6. Paint this color in the corners of his eye, inside his nostril, under the upper and lower lips, under the chin, inside his long elvish ear, under his neck, around his scar and on his shoulder blade.

Lighten up some areas with the tip of the Colorless Blender's brush nib to slightly paint a streak on his upper lip and the side of his nose. Don't overuse Colorless Blender or his skin will splotch again.

5 ADD SOME GREEN

Use Pale Green to coat over all his flesh. The green will complement the dark gray, creating a nice coolness for your character.

6 PAINT THE EYES, HAIR AND FINAL DETAILS

Use a bright color to make his eyes stand out against his dark skin. For his iris use Maize, and once dry, follow with Caramel for the pupils and the corners around the iris.

Shade the darkest shadows of the strands of hair with Cool Gray No. 3. Add some streaks at the center of the head and on his bangs. Leave the tips mostly white. Use Cool Gray No. 1 to blend the Cool Gray No. 3 streaks outward. Add some cool tones by painting Pale Green at the tips.

Use a no. 2 round and white acrylic paint or a white gel pen to finish off the picture. Dot a small mark on his eye and make a tiny fine highlight line on the side of his nose, scar, and eyebrow. Make single strands scattering all over his hair, adding a sense of flow and movement.

Demonstration
PAINTING COLORFUL HAIR

Who says hair must stick to the colors of nature? In manga, it's great to create exaggerated hair colors that you don't see generally in daily life. Don't limit yourself. Have fun and play around!

MATERIALS

COPIC MARKERS
0-Colorless Blender, B01-Mint Blue, B02-Robin's Egg Blue, B24-Sky, B95-Light Grayish Cobalt, C5-Cool Gray No. 5, C10-Cool Gray No. 10, E000-Pale Fruit Pink, E01-Pink Flamingo, E11-Bareley Beige, E13-Light Suntan, E18-Copper, G16-Malachite, 11-Pale Cherry Pink, R46-Strong Red, RV11-Pink, RV13-Tender Pink, RV93-Smoky Purple, V05-Marigold, V12-Pale Lilac, V95-Light Grape, YG01-Green Bice, YG17-Grass Green, YG21-Anise, YG23-New Leaf, YG41-Pale Cobalt Green, YR12-Loquat, YR21-Cream, YR24-Pale Sepia

OTHER TOOLS

cardstock paper

pencil

eraser

brown or sepia and gray 005 (0.2mm) waterproof, fine-point technical pens (Pigma Micron or Copic Multiliner)

white acrylic paint and a no. 2 round brush (or white gel pen)

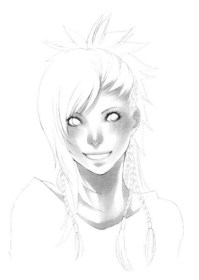

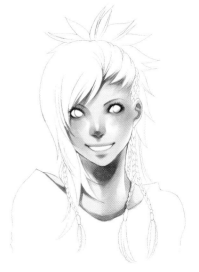

1 ADD THE FIRST COLORS TO CREATE FACIAL DEPTH

Sketch your character on cardstock paper and ink with a brown or sepia 005 (0.2mm) waterproof technical pen. Use a gray waterproof technical pen for her bangs, irises, eyes, clothes and half of her hair. Shade the deepest shadows with Bareley Beige around the outer corners of the eyes, under her chin, lower lip, hair and nose, on the tip of her nose and around her clothes. For the middle tone, paint Pink Flamingo on both sides of her cheekbones to her jawlines, the sides of her nose, under her hair and on her neck. Be sure to leave some unpainted spaces for the skin's final basecoat. Add some rosy cheek blush to the character with Pink and Pale Cherry Pink, and fade it smooth with Colorless Blender.

2 ADD THE MAIN SHADOWS

Paint all her flesh with Pale Fruit Pink. Leave some highlights around her cheekbones. Once the basecoat dries, use Light Suntan to darken the shadowy areas under her neck, inside her nostrils, under her lower lip, under the tip of her nose, under her hair and around her clothes. Before the Light Suntan dries completely, blend Smoky Purple to create depth.

3 PAINT THE NATURAL TONES FIRST

Start with the left side of her hair. Shade the darkest shadows of the strands of hair with Copper. Dilute the tips with Colorless Blender until the color gradually fades. Once it dries, use Pale Sepia to make streaks on top. Leave the tips of her hair unpainted.

 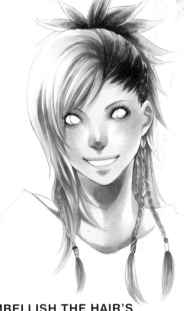

4 ADD GREENS

It's time to have fun! Choose bright, saturated colors for her hair dye. Coat her spiky hair at the back with Anise, and gradually blend together with Pale Cobalt Green. At the front bangs, paint streaks of Pale Green.

5 ADD BLUES

First paint Light Grayish Cobalt and Robin's Egg Blue to lay shadowy streaks on some individual strands behind her right jawline. Add more strands on her bangs and some of her braids. When dry, lay Mint Blue on top of the right side of her hair and her braids that we painted shadows on earlier.

6 EMBELLISH THE HAIR'S DETAILS

Paint the tips of her hair and braids with Pale Lilac, Loquat and Cream. Blend well with the greens and blues. Once dry, use Light Grayish Cobalt and Light Grape to deepen the shadows and make the strands more individual.

Paint the beads with colors that stand out against the braids, such as New Leaf, Loquat, and Green Bice. Paint the beads' stripes with darker colors such as Sky and Strong Red.

7 PAINT THE MAKEUP, CLOTHES AND WHITE DETAILS

Complement her face with colorful makeup. Use Marigold to paint her lashes. Follow with Tender Pink and Pale Lilac on the lids, outer eye corners and lips. Dot Light Suntan and Bareley Beige on her cheeks as freckles—but use sparingly! Add fine streaks of Copper on her eyebrows.

Lay stripes of Cool Gray No. 10 on her shirt, and gradually blend with Cool Gray No. 5. Use Grass Green on top of the remaining stripes with Green Bice.

For her eyes, use New Leaf on her irises. After the color dries, dot in the pupils with Malachite.

With a no. 2 round and white acrylic paint or a white gel pen, lighten up her eyes with a single dot on each iris. Place fine dots of white on her lips, the tip of her nose, and the hair beads. Finally, paint individual strands on her bangs and the tips of the braids.

EMPHASIZING EMOTION WITH SHADOWS AND HIGHLIGHTS

What if your character falls into depression, shock or awe? The easiest way to portray emotion is to draw a character with a clear expression and in a moody color. Always try to work within a family of colors for shadows and highlights, although throwing in a different color can really liven up your character's mood.

MATERIALS

COPIC MARKERS
0-Colorless Blender, B00-Frost Blue, B32-Pale Blue, B41-Powder Blue, B95-Light Grayish Cobalt, BG09-Blue Green, E11-Bareley Beige, E30-Bisque, E33-Sand, E34-Orientale, E50-Egg Shell, E53-Raw Silk, E59-Walnut, RV29-Crimson, YG23-New Leaf

OTHER TOOLS
cardstock paper

pencil

eraser

brown or sepia 005 (0.2mm) waterproof, fine-point technical pens (Pigma Micron or Copic Multiliner)

white acrylic paint and a no. 2 round brush (or white gel pen)

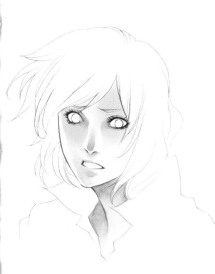

1 ADD THE FIRST COLORS TO CREATE FACIAL DEPTH

Sketch your drawing and ink it with a brown or sepia 005 (0.2mm) waterproof technical pen. Shade the deepest shadow with Bareley Beige around the outer corners of her eyes, under her chin, upper and lower lips, nostrils, the top of her nose, and chest near the shirt collar. Keep the light source and reflected light in mind by leaving a white area on both sides of her face from the cheekbones through the jawline and sides of her nose. For the middle tone and basecoat, blend the deepest shadow with Bisque and paint with Egg Shell.

2 PAINT THE HAIR AND CLOTHES

Because the main light source is from the left side of the character, shade the darkest streaks of the hair with Sand, leaving some unpainted space on the right side, especially at the tips of the strands. Paint fewer streaks on the left side and more on the right. Once the streaks are dry, paint a layer on top with Raw Silk, remembering to leave some approximate highlights.

Lay Walnut for the first layer of clothes. Make some folds and wrinkles by diluting areas with Colorless Blender, and leave some unpainted areas on both sides for highlights. On the left side, paint Orientale, coating on top of the darkest paint of Walnut. Do not worry about the right side yet.

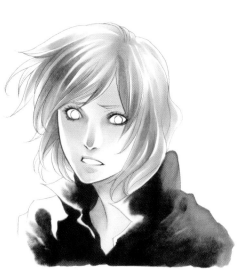

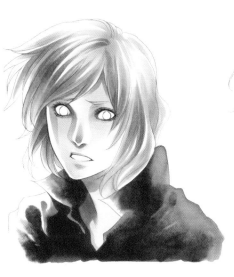

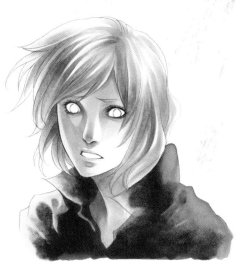

3 DARKEN THE SHADOWS

To emphasize the character's fearful look, lay Light Grayish Cobalt and Pale Blue on the shadowy areas. For the skin, paint the colors on the same spots that we painted the deepest shadows with Bareley Beige. Also apply the Light Grayish Cobalt and Pale Blue on the darkest streaks of the hair. On the clothes, paint Light Grayish Cobalt only on her right side where the unpainted spaces are left, but leave some spaces clear for the reflected light.

4 SMOOTH THE FLESH COLORS

Apply Powder Blue on top of the flesh areas and blend the blue shadows with the color of the natural skin.

5 ADD REFLECTED LIGHT

To enhance the character's expression, use a light blue color for the reflected light. With Frost Blue, paint those unpainted spaces at the right side of the character. Leave alone the highlights on the left.

6 REFINE THE DETAILS

If there are any places that require more shadow, repaint with Light Grayish Cobalt and Pale Blue. Add more layers of highlights on her hair with Egg Shell on her left side. Finish up the eyes by adding New Leaf on the irises, and once dry, dot Blue Green for the pupils and corners around the irises. Use Crimson for her tongue. Finally, use a no. 2 round and white acrylic paint or a white gel pen to add extra highlights. Place them on single strands of hair and in the light reflecting on her eyes and lower lip.

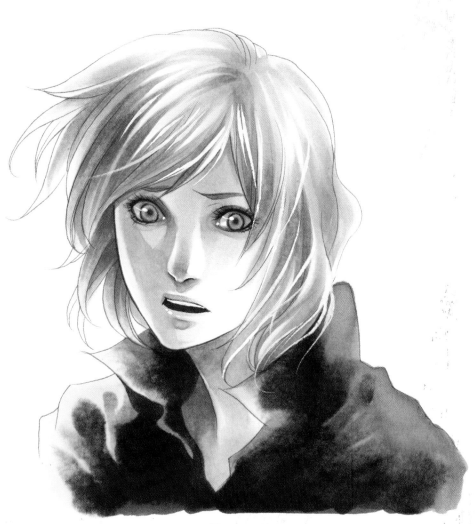

Demonstration
USING COMPLEMENTARY COLORS TO CREATE DRAMA

You can easily create drama and mood with shadows and reflecting light, but what about extreme opposite colors? Complementary colors can boost your picture's appeal, especially when depicting a fiery, berserk character.

MATERIALS

COPIC MARKERS

0-Colorless Blender, 100-Black, B24-Sky, B32-Pale Blue, BG11-Moon White, BG13-Mint Green, E11-Bareley Beige, E21-Baby Skin Pink, E51-Milky White, R08-Vermilion, R14-Light Rouge, YR02-Light Orange, YR04-Chrome Orange, YR21-Cream

OTHER TOOLS

cardstock paper

pencil

eraser

brown or sepia 005 (0.2mm) waterproof, fine-point technical pens (Pigma Micron or Copic Multiliner)

white acrylic paint and a no. 2 round brush (or white gel pen)

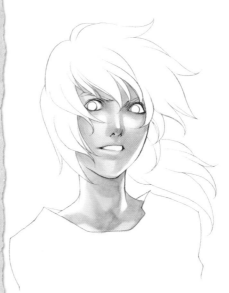

1 ADD THE FIRST COLORS TO CREATE FACIAL DEPTH

Ink your sketch with a brown or sepia 005 (0.2mm) waterproof technical pen. After cleaning up the pencil traces with an eraser, darken the deepest shadow with Bareley Beige around the outer corners of the eyes, under his chin and upper and lower lips, on the tip of the nose, inside his nostrils and on his shoulder. Consider the light source coming from the right and leave a lot of unpainted space on that side, as well as on the left for reflected light. Paint the middle tone on the sides of his face, from the cheekbones through jawlines, with Baby Skin Pink, and lay down a coat of Milky White on most of his skin except the tip of his nose, which will be reflected light.

2 PAINT THE HAIR AND CLOTHES

With Chrome Orange, paint the initial streaks of hair and continue layering with Cream. Leave the edges on his left unpainted. Use Black for his clothes and keep the unpainted spaces around his shoulders. Fade the folds and wrinkles by blending with Colorless Blender.

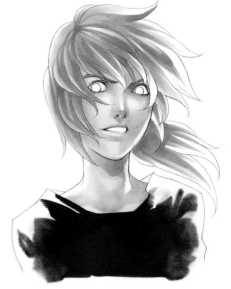

Make Your Characters Pop With Complementary Colors

Complementary colors are colors that are opposite each other on the color wheel. Common combinations are red and green, blue and orange, and yellow and violet. When they are placed next to each other, you can create nice, bright contrasts that make your characters come alive.

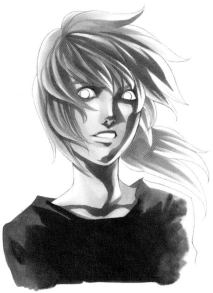 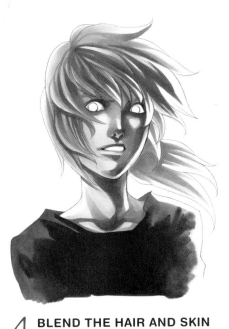 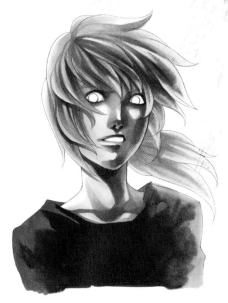

3 DARKEN THE SHADOWS

For the shadows choose any strong, dominant color that will go along with his berserk look. Lay Vermilion and Light Rouge as the shadowy streaks of the hair. Use the same colors for the cast shadows, such as under the tip of his nose and the left side of it, under the neck, under the upper and lower lips, and under the outer corner of the eyes. Once again, make sure to leave some room for the reflected light areas. Coat the right side of his shirt with Vermilion.

4 BLEND THE HAIR AND SKIN TONES

Blend Light Orange on top of the Vermilion and Light Rouge paints, then blend the colors together with the actual skin.

5 ADD REFLECTED LIGHT WITH OPPOSITE COLOR

Use complementary colors that contrast the cast shadow. If we mainly use red tones as the cast shadows, green tones are the perfect complementary match. Paint Moon White as the reflected light on the left of his hair and face. Don't forget to emphasize the light under the tip of his nose and under the lower lip. To create depth, use Mint Green to add the darkest shades on the nostrils and some strands of the hair. For the shirt, use Mint Green as the reflecting light.

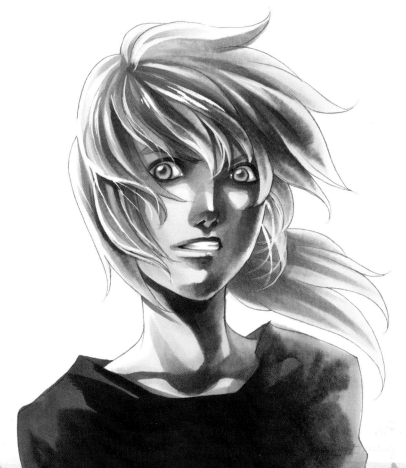

6 FINALIZE THE DETAILS

Any color that stands out from the entire image is good for the eyes. Paint Pale Blue on his irises, and mark the pupils with Sky. Finalize the details with a no. 2 round and white acrylic paint or a white gel pen. Add single strands of hair and the light reflection in his eyes.

Drawing Bodies and Poses

The human figure plays a major role in bringing your manga to life. Whether super realistic, semi-realistic or simplified, it's important to understand the core of human anatomy. Even in the fantasy realms where the proportions of most creatures are exaggerated, everything is still based on fundamental body structure. The more natural the figure looks, the more believable your character will be.

This section offers guidelines for drawing basic human anatomy and poses. It includes tips for drawing and painting casual clothing along with the tutorials. You'll also learn how differences in proportion can change how you perceive a character's personality and gender. Do you want your male to be frail or androgynous? Do you prefer your girl to be just one of the guys? It's all up to you. Just remember to start with the basics and add on features that suit your character as you go.

The Basic Human Body

What is the right proportion for your character? Does your character's body look wacky or unnatural? Body proportion and construction aren't as tough as you think. There are a few basic differences to be aware of between the genders and ages that will help you understand and draw the human body.

Manly Man or Pretty Boy?

Not every male character in manga is super masculine. Some males have a girlier look. Here are a few characteristics of pretty boys:

- Rounder faces with soft features, and longer hair
- Slender builds and smaller muscles
- Full lips, big eyes and long lashes

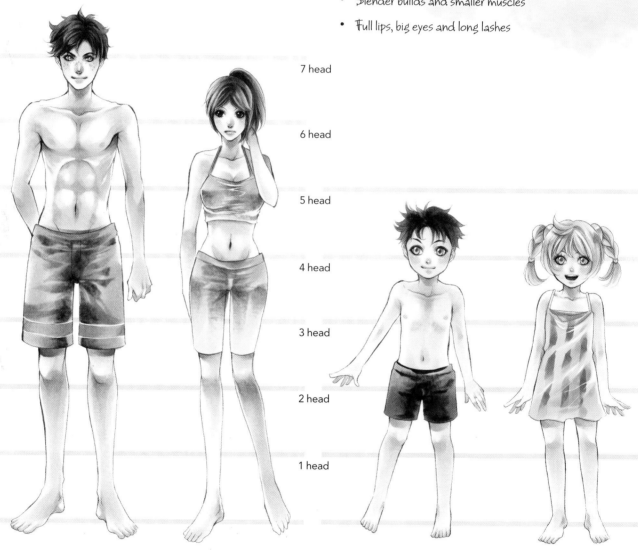

7 head

6 head

5 head

4 head

3 head

2 head

1 head

Male Adult Body vs. Female Adult Body

Normal adult figures are usually 7 to 8 heads tall (using the height of the head as a measurement), and females are usually shorter than males. Of course, the height for both genders is adjustable and should be based on your preference as an artist.

Male figures tend to look more masculine than females, while women tend to look smaller in comparison. A male's muscles and 6-pack are more visible compared to a female. Females usually don't have a 6-pack unless your character is super athletic. A female's body usually has more curves, especially at the breasts, waist and hips.

Kid Bodies

A typical kid is usually around 3 to 5 heads tall, depending on age. Head size is larger in proportion to other body parts. The younger a kid, the bigger the head.

Also, there isn't much difference between the body of a boy or a girl since their bodies aren't yet fully developed. They are usually drawn chubbier with less curves, regardless of gender.

Posing the Figure

Human bodies are extremely flexible. The structure of bones, joints and muscles allows for countless movements and poses.

Dynamic action poses are similar to simple poses, they just require more expressive bending and curving of the body parts. Instead of only drawing straight lines to indicate your figure's stance, use diagonal lines or curves on the shoulders and the hips to indicate motion. This also works with legs and arms. The flow of the hair and clothes should follow the body.

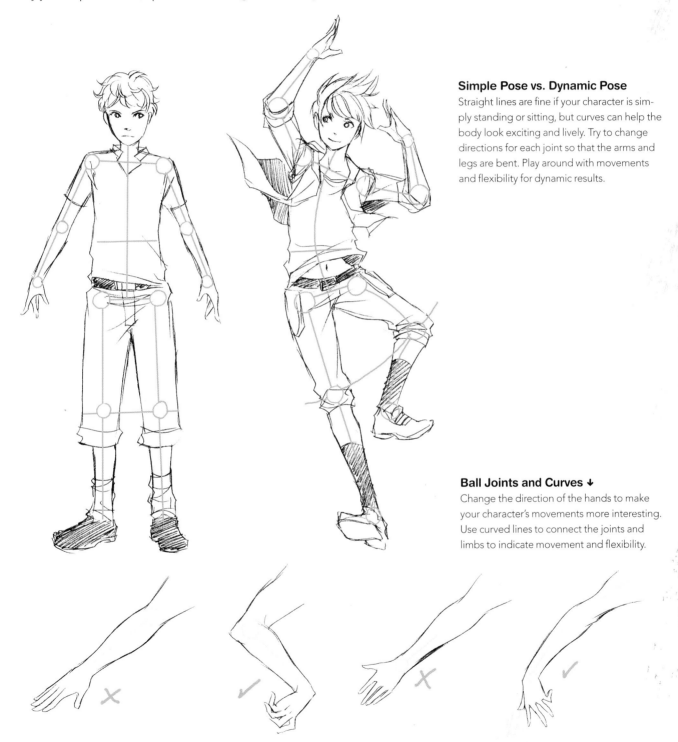

Simple Pose vs. Dynamic Pose
Straight lines are fine if your character is simply standing or sitting, but curves can help the body look exciting and lively. Try to change directions for each joint so that the arms and legs are bent. Play around with movements and flexibility for dynamic results.

Ball Joints and Curves ↓
Change the direction of the hands to make your character's movements more interesting. Use curved lines to connect the joints and limbs to indicate movement and flexibility.

Basic Poses

How you pose your manga characters suggests movement and action to the viewer. Poses in real life are the same in art. Drawing directly from observing people or magazines is a smart way to practice different poses. Here are some basic character poses and how the limbs and body parts fit together.

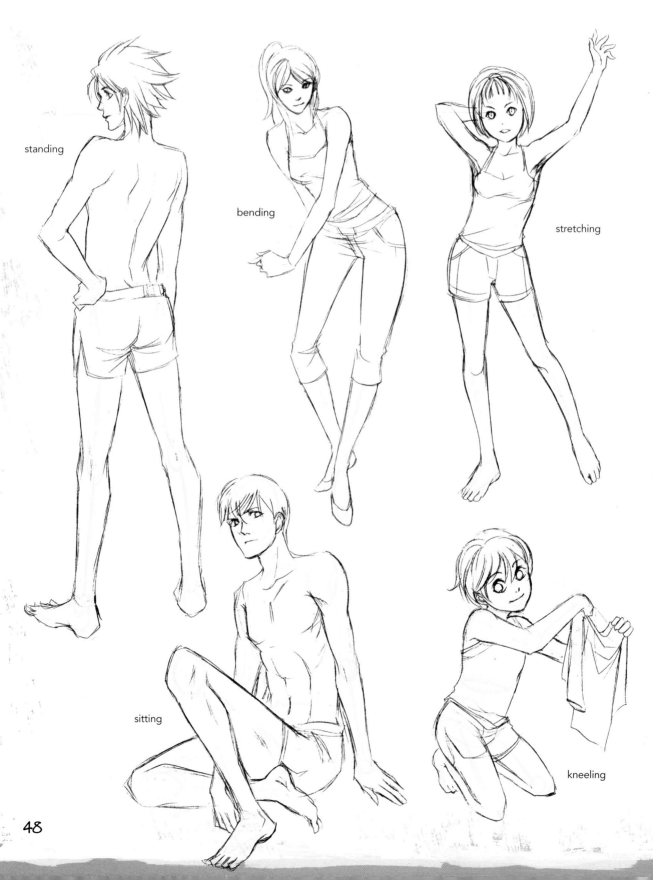

standing

bending

stretching

sitting

kneeling

Action Poses

Observe exciting and lively movements of characters in movies, sports and other resources to help you sharpen drawing dynamics and action. Make sure to accurately flow the hair and clothes.

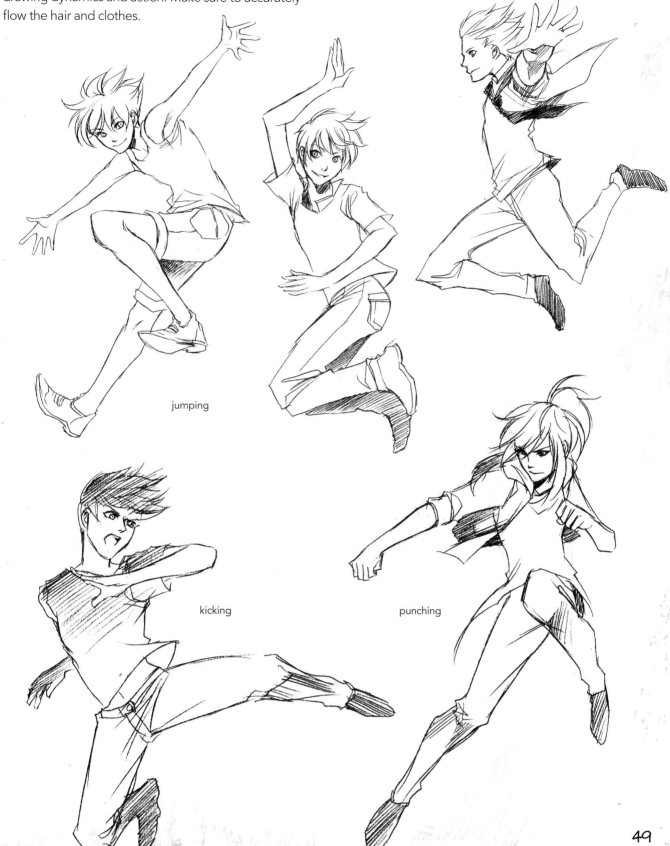

jumping

kicking

punching

Drawing a Simple Pose

Practice drawing skeletal figures to develop poses. Start with circles for the joints, lines for the limbs and basic shapes for the body parts. When your poses start to look realistic, sketch around them to form your character.

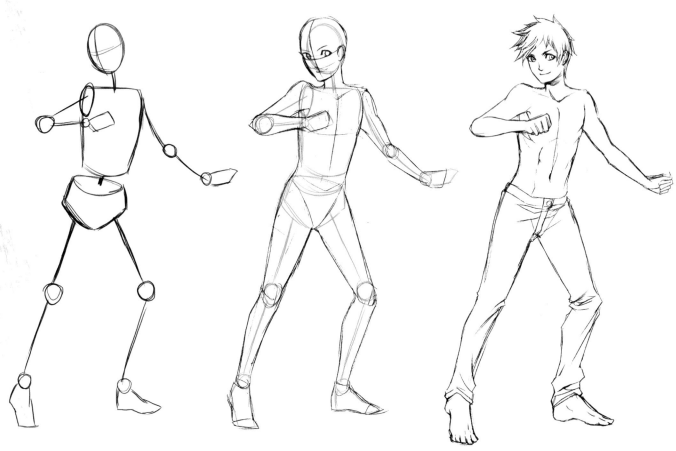

1 SKETCH A SKELETON POSE

With a pencil, draw a skeleton roughly in any pose you desire. Use circles to indicate the joints, sticks for the limbs and other basic shapes for the main body parts. Draw in whatever style you're comfortable with as long as you can see the pose clearly. Don't worry if your skeleton looks stiff and out of proportion at first. We will adjust the pose as we go along.

2 OUTLINE THE BODY

After you're satisfied with the pose you create, roughly draw around the skeleton to sketch the human figure. Create the body form with muscles and curves according to the gender and age of your subject. Adjust the structure, form or pose to fit better with the overall character.

3 REFINE THE FIGURE

Fill in whatever details you would like to see and erase the old sketchy lines. Or just ink the lines you want using tracing paper or a lightbox. Customize the entire figure with clothes, hair and other details to finish your character.

Visit impact-books.com/wonder-manga for a **free** bonus demonstration

Wrinkles

Though they are only a few lines, wrinkles help define the figure and indicate the type of fabric being worn.

Add Wrinkles to Suggest Movement
Sketch your wrinkles lightly at first wherever the fabric folds. Mimic your character's pose in the mirror to see where your clothes naturally bend and wrinkle.

Wrinkles usually appear at the joints but you can also apply wrinkles anywhere they don't disturb the overall look.

Movement and wind also affect the number and direction of wrinkles and creases.

Avoid Adding Too Many Wrinkles!
Adding too many wrinkles will cause your outfit to look too messy and will overwhelm the coloring process. If you encounter this problem, simple erase some of them.

Drawing Clothes

Whether you follow the New York fashion circuit or prefer everyday casual wear, clothes are essential for your manga characters. Dressing them can be challenging since you have to make the clothes believable enough for the art, but with these tips, it'll be a breeze. This exercise let's you express how fashionable you can be!

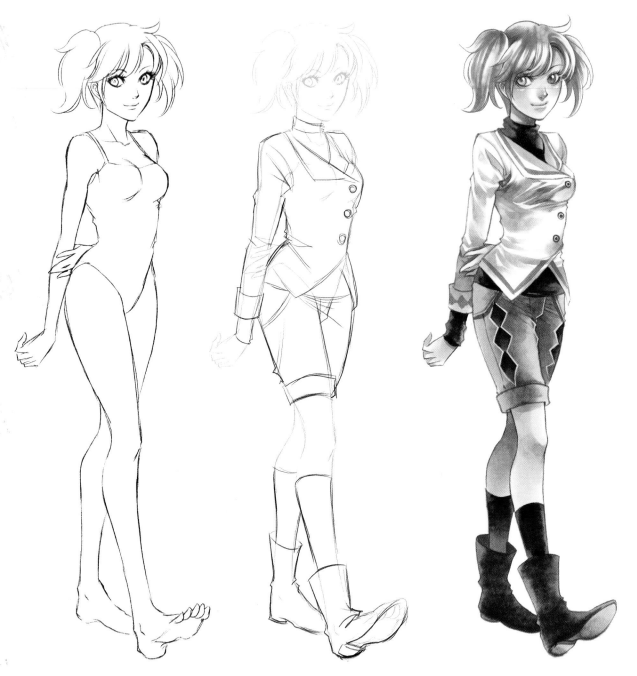

1 SKETCH THE FIGURE
Draw your character in your desired pose. No need to overload your drawing with details during this process, just draw your figure with a visible, clear pose.

2 ROUGH IN THE OUTFIT
Envision the overall style and type of outfit that fits your character. Follow the body curves and pose to create a rough outline of the outfit. Does the jacket need to be tight along the waist? Adjust the tightness or looseness of the clothing as needed.

3 ADD DETAILS AND COLOR
It's time to refine all details. To avoid the flat look of a paper doll, add creases and wrinkles on the clothing. Don't get too carried away! Keep your colors and patterns somewhat realistic.

Experiment With Styles and Colors

Design your wardrobe with the mixture of random styles and colors. Plan your character's outfits by thinking about your character's personality and other factors such as his or her occupation, hobbies and personal likes and dislikes.

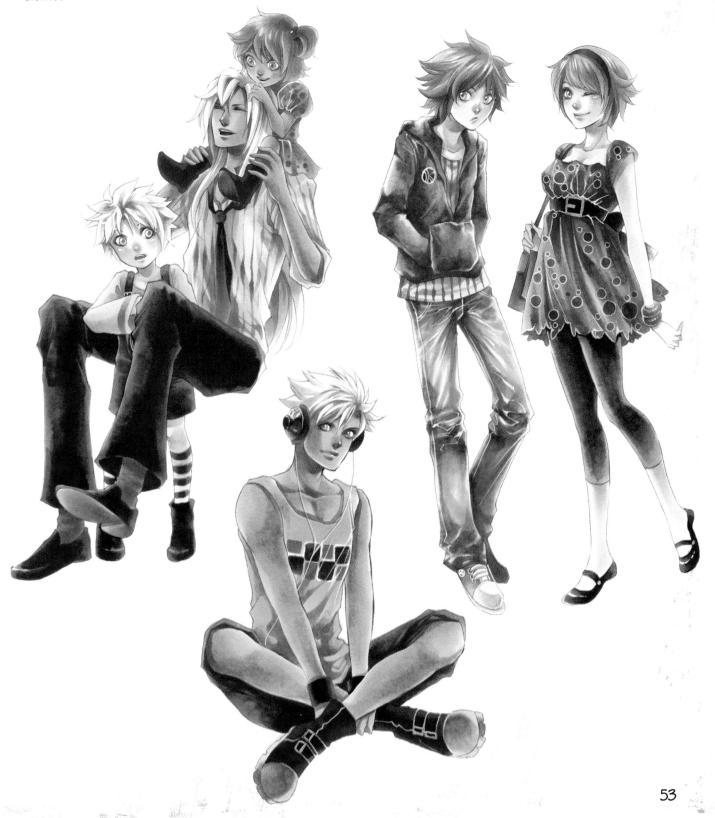

Foreshortening

Foreshortening is when an object or body part appears to come forward because receding lines are exaggerated in the foreground to be shorter and give the illusion of depth. Many artists use foreshortening to express dynamic moods or emotion. Foreshortening can be accomplished by altering the perspective of your character's basic poses like walking or standing, or body parts like hands, arms and legs.

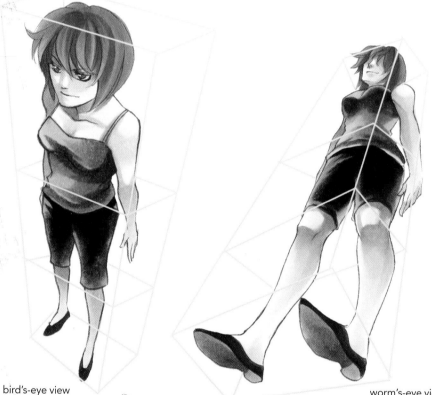

bird's-eye view

worm's-eye view

Bird's-Eye and Worm's-Eye Perspectives

Bird's-eye view is from a high angle, and worm's-eye view is from a low angle. The top half of an object or character in bird's-eye view is larger and wider than the bottom, which is minimized. Worm's-eye view is the opposite. The bottom half is blown up, especially a character's legs and feet. You can use a box shape drawn in perspective to guide your foreshortening shots. The line that divides half of the body helps you to know which part needs to be exaggerated.

In general, worm's-eye views give your characters a superior feel by helping her look tall and strong. Bird's-eye views can make your character appear smaller and weaker. These rules are flexible, depending on what you want to accomplish in your story.

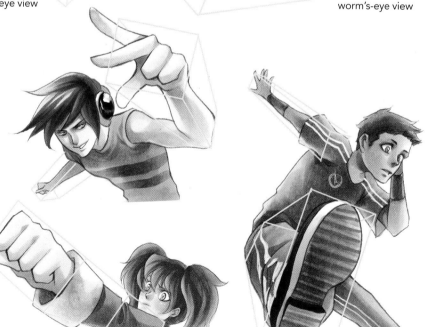

Foreshortened Action Poses

Don't be afraid to go dynamic with foreshortening! You can apply the same methods for full bodies on isolated parts like the legs and arms. Always remember to exaggerate the body parts that are closest to your eye and minimize the parts further away.

Demonstration
SUGGESTING DISTANCE WITH COLOR

Emphasize your foreshortened poses with color to create depth and distance. Color can help the entire picture appear less flat and bring out the main focus of your piece.

COPIC MARKERS
C5-Cool Gray No. 5, V93-Early Grape

MATERIALS

1 ADD DETAILS TO THE CLOSEST LIMBS

Start with a foreshortened character and color him as you wish. To create distance between limbs, refine details on the arm and leg that appear closer to the viewer. Establish fine drapes and wrinkles on the jeans and jacket of his left leg and arm. Leave the right-side limbs less detailed.

more details on closest limbs

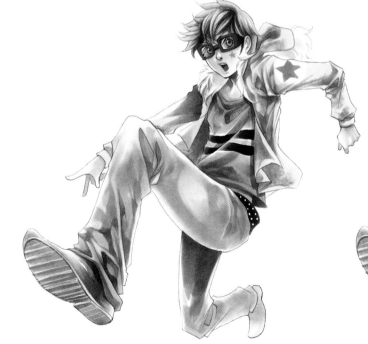

less details on farthest limbs

2 ESTABLISH DISTANCE WITH SHADOWS

Start working on the most distant limbs. Paint Cool Gray No. 5 on about a quarter of the right leg and arm. This will help the distant limbs appear closer near the main body and farther in the background.

3 SHADE THE ENTIRE AREA

Blend the whole drawing with Early Grape. Paint over the entire right leg and arm. The original colors of the jeans and jacket will still show through the areas, but in a way that creates depth.

Demonstration
LITTLE MISS SUNSHINE

Most kids have a natural, cheerful appearance—they are bright just as sunshine on a sunny day. Bring out the shine in your manga kid characters with bright and pastel colors.

MATERIALS

COPIC MARKERS
0-Colorless Blender, B00-Frost Blue, B21-Baby Blue, B93-Light Crockery Blue, B95-Light Grayish Cobalt, BG18-Teal Blue, E000-Pale Fruit Pink, E11-Bareley Beige, E30-Bisque, E33-Sand, E53-Raw Silk, E59-Walnut, G82-Spring Dim Green, G94-Grayish Olive, R11-Pale Cherry Pink, RV29-Crimson, RV34-Dark Pink, Y00-Barium Yellow, Y23-Yellowish Beige, Y28-Lionet Gold, YG00-Mimosa Yellow, YG23-New Leaf, YG67-Moss, YR21-Cream

DRAWING TOOLS
cardstock paper

pencil

eraser

brown, gray and blue 005 (0.2mm) waterproof, fine-point technical pens (Pigma Micron or Copic Multiliner)

white acrylic paint and a no. 2 round brush (or white gel pen)

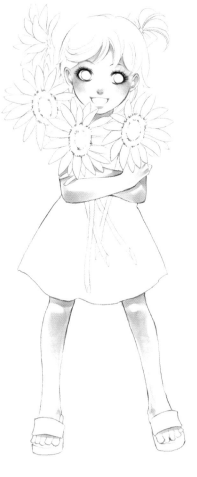

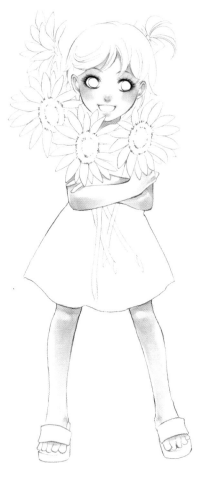

1 ADD THE DARKEST SHADOWS
Sketch your drawing on cardstock paper and ink with brown, gray and blue 005 (0.2mm) waterproof technical pens. Use brown for her skin, hair and sandals, sunflower petals and the outer corners of her eyes; use gray for the sunflower stems; and use blue on her eyes and dress.

Shade the deepest shadows with Bareley Beige around the outer corners of her eyes, under her chin, lower lip and hair, and on the tip of her nose. Color her cheeks with Pale Cherry Pink, then fade with Colorless Blender. Apply the same color on her elbows and knees.

For the middle tone, paint Bisque on her cheekbones, the sides of her nose, under her knees and the sides of both arms. Be sure to leave some unpainted spaces for the skin's final basecoat.

2 ADD THE BASECOAT
Coat most of her skin with Pale Fruit Pink. Leave some highlight areas on her nose, the sides of her legs and the top of her arms.

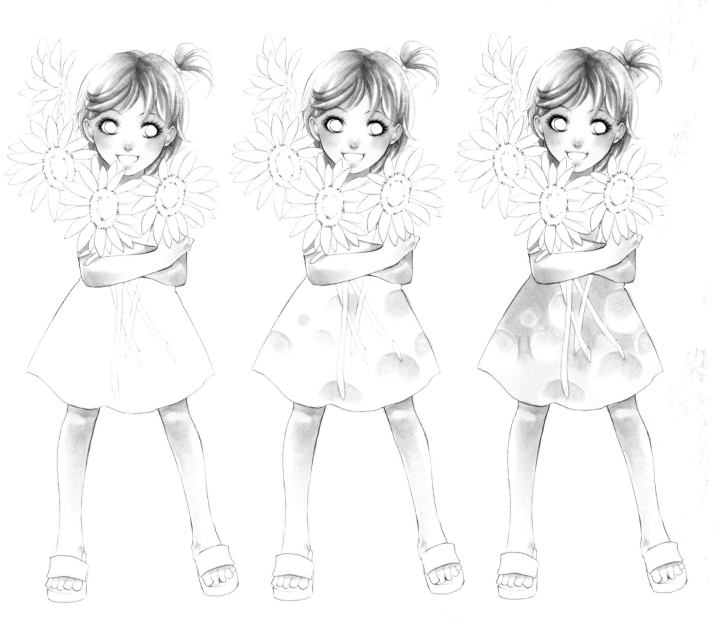

3 BRING THE HAIR TO LIFE

Shade the dark area of hair by painting Sand. Paint fewer streaks close to the top and dilute them with Colorless Blender until the color fades. Coat the entire hair with Raw Silk as the second layer. In addition, use Sand to refine the extra shadowy streaks as you desire.

4 CREATE A POLKA DOT PATTERN

Even a simple pattern can bring out the liveliness of your character! Paint the top half of the dot circles using Yellowish Beige. Before the color completely dries, use a lighter color like Barium Yellow to paint the rest of the circles and blend both colors together.

5 PAINT THE DRESS BASECOAT

Start painting with Baby Blue at the top of the dress and then follow with Frost Blue at the bottom of the dress. Apply the same colors on her ribbon.

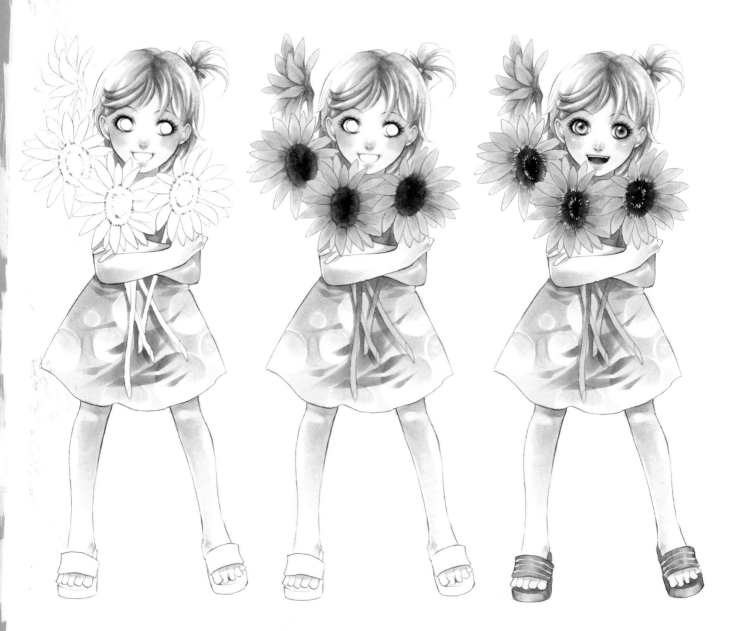

6 ESTABLISH SUBTLE FOLDS AND CREASES
Use Light Crockery Blue and Light Grayish Cobalt to create folds on her dress. Layer Lionet Gold on top of the yellow polka dot pattern to indicate the tips.

7 PAINT THE SUNFLOWERS
Paint the center of the flowers with Walnut and fade the color with Colorless Blender. Coat Sand on top until the colors blend nicely. Apply Sand at the inner parts of each individual petal and blend the color outward with Cream. Use New Leaf and Moss to finish the stems.

8 FINALIZE THE DETAILS
Use Spring Dim Green and Grayish Olive together for the sandal straps. Add shadowy areas of the sandal base with Sand, and coat the overall base with Yellowish Beige. Fill her irises with Mimosa Yellow, and after it dries, dot Teal Blue for the pupils and the corners around the irises. Use Crimson and Dark Pink for her mouth.

Touch up with a no. 2 round and white acrylic paint or a white gel pen. Mark a single dot on each iris. Also put fine dots on her lips, the tip of her nose and her cheeks. Add subtle stripes on the sandal straps. Do not forget to give some texture to the sunflowers. Draw fuzzy, broken outlines on the inner disks.

Demonstration
THE REBEL

Some people are born with strong personalities and command attention because of their rebellious nature. Even sitting, Louis still manages to make evident who he thinks is best. These steps show how using strong and dark colors make your boy characters oh-so-bad.

1 OUTLINE AND INK THE POSE

Sketch the composition with a pencil on cardstock paper, then ink the character with brown and gray 005 (0.2mm) waterproof technical pens. Use a brown pen for his facial features, hair and inner long sleeves. Use a gray pen for the rest, including the entire outfit, socks and combat boots. Emphasize the wrinkles and creases where the joints are, but don't draw too many.

2 CREATE THE SKIN TONE

With Light Suntan, paint the darkest shadows around the outer corners of his eyes, his lips, under his lower lip, the left side of his face, under his hair, and around his clothes. Fade the color with Colorless Blender on the left side of his face, and other areas if necessary. Apply Bareley Beige for the middle tone and follow with Bisque for the basecoat. Emphasize the outer corners of his eyes and his nostrils by using Light Walnut.

COPIC MARKERS
0-Colorless Blender, 100-Black, B00-Frost Blue, B95-Light Grayish Cobalt, C1-Cool Gray No. 1, C2-Cool Gray No. 2, C3-Cool Gray No. 3, C4-Cool Gray No. 4, C5-Cool Gray No. 5, C6-Cool Gray No. 6, C7-Cool Gray No. 7, E11-Bareley Beige, E13-Light Suntan, E30-Bisque, E31-Brick Beige, E35-Chamois, E41-Pearl White, E57-Light Walnut, R08-Vermilion, RV99-Argyle Purple, Y23-Yellowish Beige, Y35-Maize, YR14-Caramel

OTHER TOOLS
cardstock paper

pencil

eraser

brown and gray 005 (0.2mm) waterproof, fine-point technical pens (Pigma Micron or Copic Multiliner)

white acrylic paint and a no. 2 round brush (or white gel pen)

MATERIALS

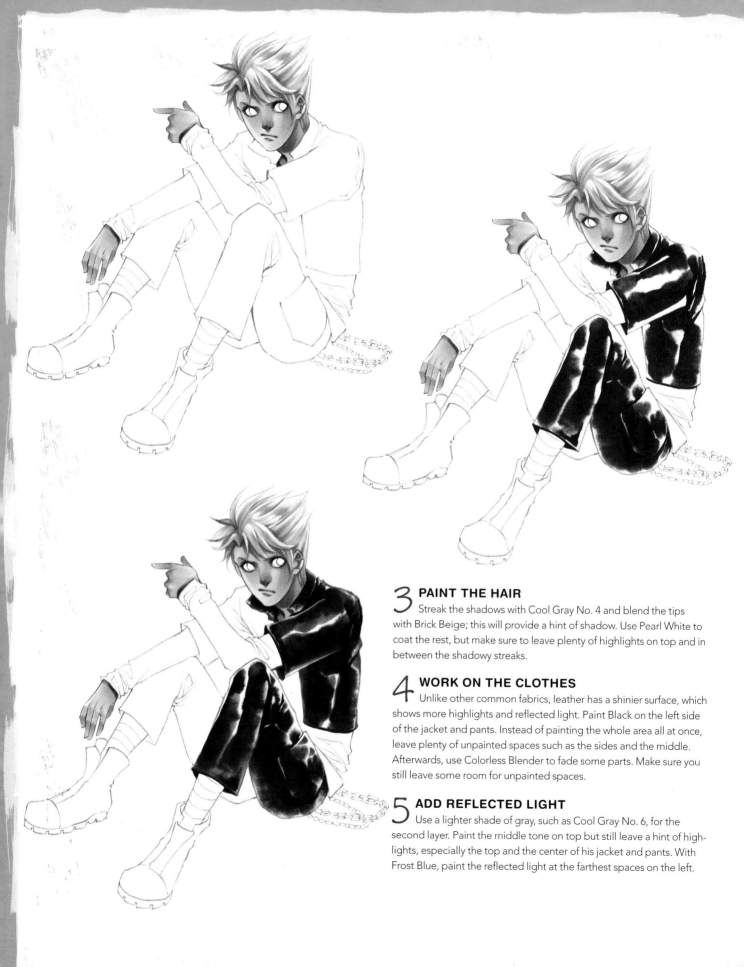

3 PAINT THE HAIR

Streak the shadows with Cool Gray No. 4 and blend the tips with Brick Beige; this will provide a hint of shadow. Use Pearl White to coat the rest, but make sure to leave plenty of highlights on top and in between the shadowy streaks.

4 WORK ON THE CLOTHES

Unlike other common fabrics, leather has a shinier surface, which shows more highlights and reflected light. Paint Black on the left side of the jacket and pants. Instead of painting the whole area all at once, leave plenty of unpainted spaces such as the sides and the middle. Afterwards, use Colorless Blender to fade some parts. Make sure you still leave some room for unpainted spaces.

5 ADD REFLECTED LIGHT

Use a lighter shade of gray, such as Cool Gray No. 6, for the second layer. Paint the middle tone on top but still leave a hint of high-lights, especially the top and the center of his jacket and pants. With Frost Blue, paint the reflected light at the farthest spaces on the left.

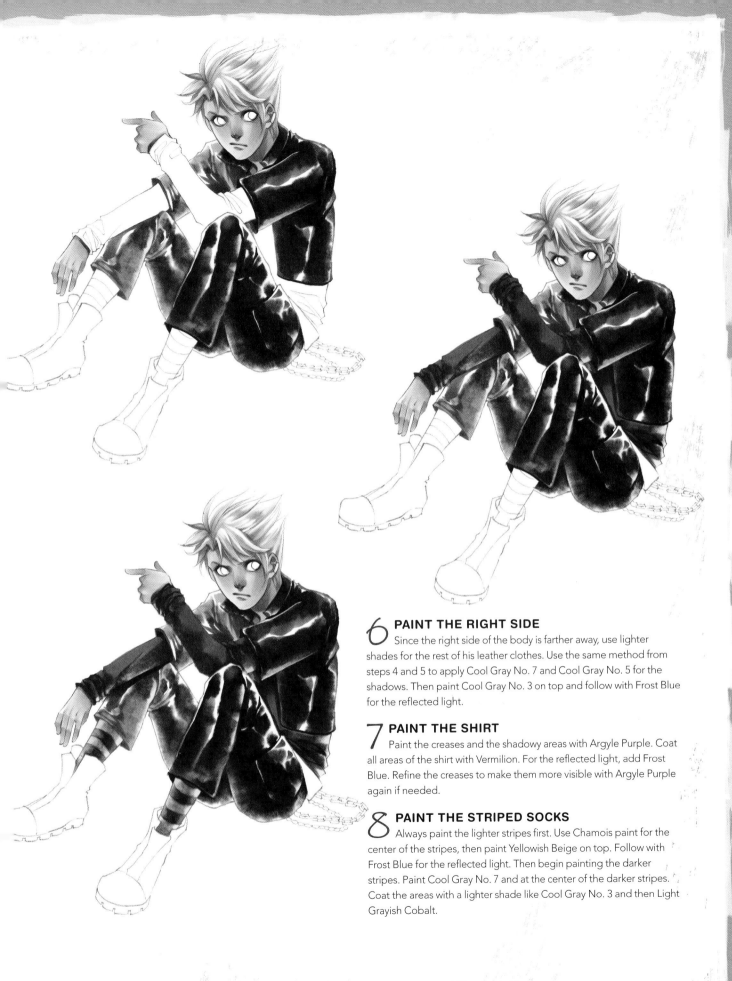

6 PAINT THE RIGHT SIDE

Since the right side of the body is farther away, use lighter shades for the rest of his leather clothes. Use the same method from steps 4 and 5 to apply Cool Gray No. 7 and Cool Gray No. 5 for the shadows. Then paint Cool Gray No. 3 on top and follow with Frost Blue for the reflected light.

7 PAINT THE SHIRT

Paint the creases and the shadowy areas with Argyle Purple. Coat all areas of the shirt with Vermilion. For the reflected light, add Frost Blue. Refine the creases to make them more visible with Argyle Purple again if needed.

8 PAINT THE STRIPED SOCKS

Always paint the lighter stripes first. Use Chamois paint for the center of the stripes, then paint Yellowish Beige on top. Follow with Frost Blue for the reflected light. Then begin painting the darker stripes. Paint Cool Gray No. 7 and at the center of the darker stripes. Coat the areas with a lighter shade like Cool Gray No. 3 and then Light Grayish Cobalt.

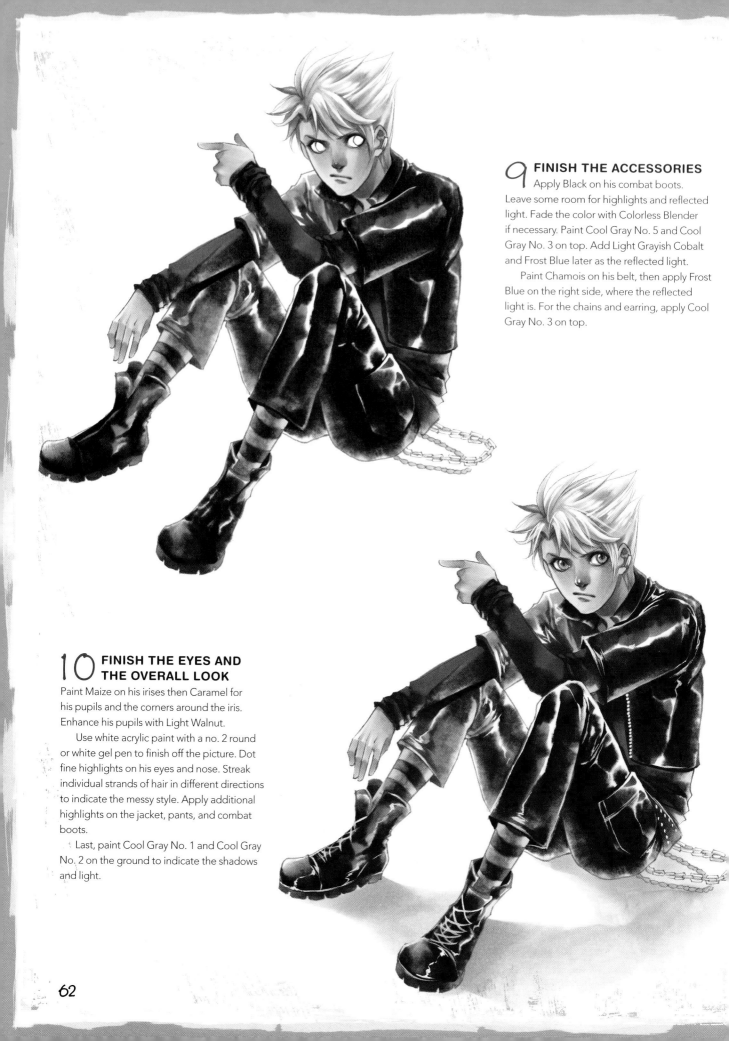

9 FINISH THE ACCESSORIES

Apply Black on his combat boots. Leave some room for highlights and reflected light. Fade the color with Colorless Blender if necessary. Paint Cool Gray No. 5 and Cool Gray No. 3 on top. Add Light Grayish Cobalt and Frost Blue later as the reflected light.

Paint Chamois on his belt, then apply Frost Blue on the right side, where the reflected light is. For the chains and earring, apply Cool Gray No. 3 on top.

10 FINISH THE EYES AND THE OVERALL LOOK

Paint Maize on his irises then Caramel for his pupils and the corners around the iris. Enhance his pupils with Light Walnut.

Use white acrylic paint with a no. 2 round or white gel pen to finish off the picture. Dot fine highlights on his eyes and nose. Streak individual strands of hair in different directions to indicate the messy style. Apply additional highlights on the jacket, pants, and combat boots.

Last, paint Cool Gray No. 1 and Cool Gray No. 2 on the ground to indicate the shadows and light.

Demonstration
CASUAL AND COOL

Casual outfits can consist of anything you want. As long as you can mix and match to fit your character and it doesn't look over-the-top, anything can be everyday style. Don't focus too much on high fashion trends. Think about the overall look and colors that go with your characters' different moods and personalities.

COPIC MARKERS

0-Colorless Blender, B63-Light Hydrangea, B93-Light Crockery Blue, B95-Light Grayish Cobalt, B97-Night Blue, BG09-Blue Green, BG13-Mint Green, BG18-Teal Blue, BG49-Duck Blue, BV00-Mauve Shadow, BV11-Soft Violet, C2-Cool Gray No. 2, C6-Cool Gray No. 6, C10-Cool Gray No. 10, E11-Bareley Beige, E13-Light Suntan, E18-Copper, E21-Baby Skin Pink, E30-Bisque, E33-Sand, E43-Dull Ivory, E51-Milky White, E71-Champagne, E99-Baked Clay, W5-Warm Gray No. 5, W6-Warm Gray No. 6, W8-Warm Gray No. 8, Y23-Yellowish Beige, YG13-Chartreuse

OTHER TOOLS

cardstock paper

pencil

eraser

brown or sepia and gray 005 (0.2mm) waterproof, fine-point technical pens (Pigma Micron or Copic Multiliner)

white acrylic paint and a no. 2 round brush (or white gel pen)

MATERIALS

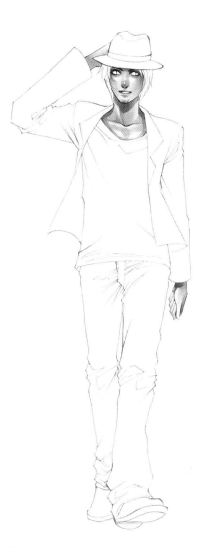

1 OUTLINE THE POSE AND INK

Begin sketching the walking pose with a pencil on cardstock paper. Make wrinkles visible on his jacket and jeans. Ink the character with a brown or sepia 005 (0.2mm) waterproof technical pen on his facial features, hair and skin. Use a gray 005 (0.2mm) waterproof technical pen for the rest of the details.

2 COLOR THE SKIN

His skin color is in between normal and tanned, so use deep colors that aren't too dark. Use Bareley Beige for coloring the darkest shadows, like around the outside of his eyes, his lips, under his lower lip, his hair, shoulder blade and any areas close to the clothes. Paint Baby Skin Pink for the middle tone, then coat the entire skin with Milky White. Darken the shadows with Light Suntan.

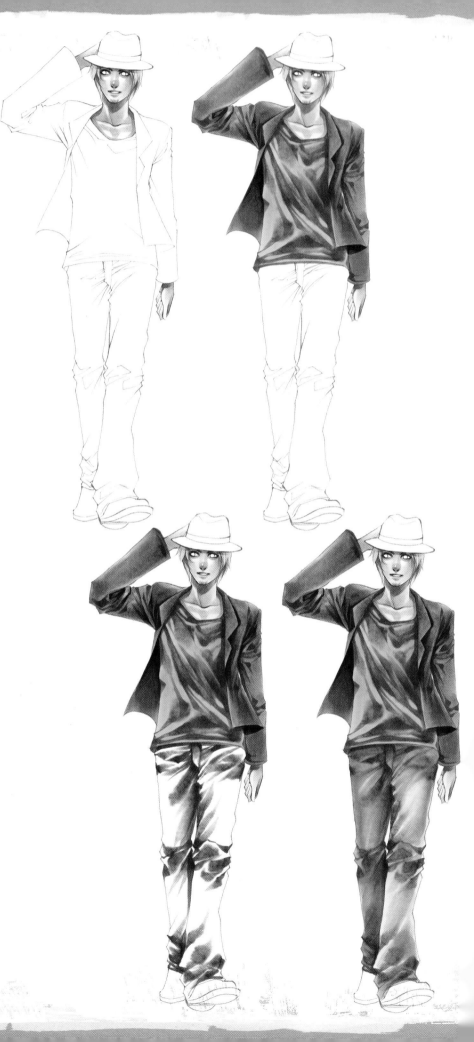

3 PAINT THE HAIR
Paint the basecoat with Yellowish Beige and streak the shadows by using Baked Clay.

4 PAINT HIS SHIRT AND JACKET
From what you see, his personality is more relaxed and easy going, so avoid using strong colors. With the shirt, first establish the shadows with Blue Green and Duck Blue. Use Colorless Blender to soften some of the shadowy strokes. Coat Mint Green on all of the shirt areas. After the colors dry, emphasize the wrinkles by painting streaks of Blue Green and Teal Blue.

Think earthy, warm colors for his wool jacket. Paint Warm Gray No. 6 on the shadows, then fade the color with Colorless Blender. Apply Champagne on top of the jacket. Once all the colors dry, paint the wrinkles with Warm Gray No. 6 and Warm Gray No. 8. Darken the bend wrinkles at his joints.

5 CREATE THE SHADOWS ON HIS JEANS
For his jeans, first use Night Blue for shadows. Create tension and puffed wrinkles, especially at the groin and the legs of the jeans. Soften some of the wrinkles with Colorless Blender.

6 PAINT THE JEANS
Paint Light Crockery Blue on his left leg, which is moving toward the viewer. On the other leg, coat both Light Crockery Blue and Light Grayish Cobalt and blend them together. The deep shade of Light Grayish Cobalt will give depth to the right leg at the back.

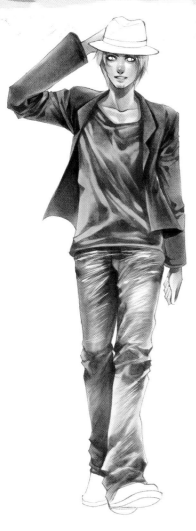

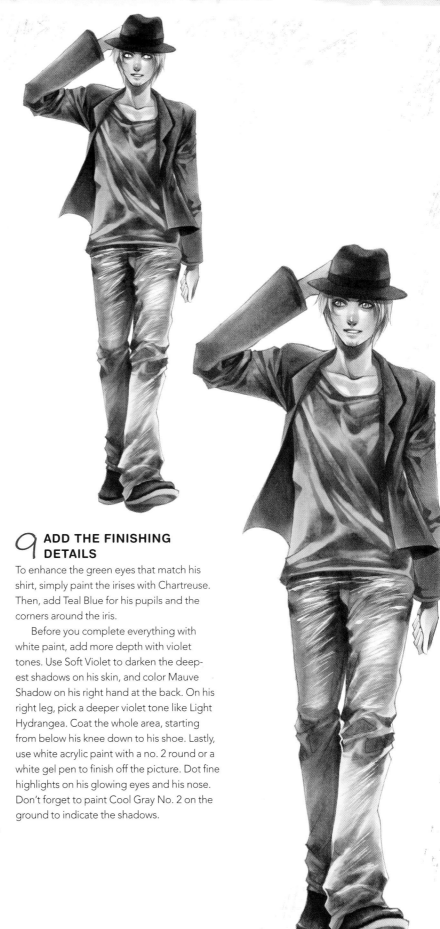

7 GIVE THE JEANS SOME TATTERS

Casual jeans can be ragged or tattered, if you do not need them to be perfectly neat. Apply small streaky lines with Light Grayish Cobalt on the jeans. Afterward , use white acrylic paint and a no. 2 round to paint dry, small hatching lines. Be careful to add only appropriate amounts of tatters. Overdoing it will cause the jeans to look rather worn out.

8 COLOR THE HAT AND SHOES

Start off with the leather shoes. Apply Copper on the areas and leave some room for the highlights. Use Sand to color on top as the basecoat. Color Bisque on the base shoes and add shadows with Dull Ivory and Warm Gray No. 5.

Treat the hat with the same method you've done with the shoes. Color the shadows of the hat with Copper, then paint Sand on top. For the hat strap, use Cool Gray No. 10 and Cool Gray No. 6.

9 ADD THE FINISHING DETAILS

To enhance the green eyes that match his shirt, simply paint the irises with Chartreuse. Then, add Teal Blue for his pupils and the corners around the iris.

Before you complete everything with white paint, add more depth with violet tones. Use Soft Violet to darken the deepest shadows on his skin, and color Mauve Shadow on his right hand at the back. On his right leg, pick a deeper violet tone like Light Hydrangea. Coat the whole area, starting from below his knee down to his shoe. Lastly, use white acrylic paint with a no. 2 round or a white gel pen to finish off the picture. Dot fine highlights on his glowing eyes and his nose. Don't forget to paint Cool Gray No. 2 on the ground to indicate the shadows.

Demonstration
GLAMOROUS STAR

A well-detailed gown and luxurious accessories can be the great matches that give your character the attitude of fame and fortune. But what about her features, pose, outfit and props? She'll do what's necessary to look the part.

MATERIALS

COPIC MARKERS
0-Colorless Blender, BG18-Teal Blue, BV00-Mauve Shadow, C3-Cool Gray No. 3, C6-Cool Gray No. 6, C10-Cool Gray No. 10, E000-Pale Fruit Pink, E11-Bareley Beige, E17-Reddish Brass, E93-Tea Rose, R14-Light Rouge, R32-Peach, R46-Strong Red, RV29-Crimson, RV99-Argyle Purple, V04-Lilac, V09-Violet, V12-Pale Lilac, V15-Mallow, V91-Pale Grape, V93-Early Grape,V95-Light Grape, Y23-Yellowish Beige, Y38-Honey, YG13-Chartreuse, YR0000-Pale Chiffon, YR14-Caramel

OTHER TOOLS
cardstock paper

pencil

eraser

brown or sepia 005 (0.2mm) waterproof, fine-point technical pens (Pigma Micron or Copic Multiliner)

white acrylic paint and a no. 2 round brush (or white gel pen)

rubbing alcohol

1 ESTABLISH THE POSE AND INK
Draw the character with a pencil on cardstock. Establish the figure, then create her evening gown. The drapes and folds should follow the body curves and gravity. Ink the character with a brown or sepia 005 (0.2mm) waterproof technical pen and erase all pencil traces.

2 PAINT THE SKIN
For her eye blush, use Peach and Tea Rose on her cheeks then fade the colors with Colorless Blender. Paint shadowy areas under her lower lips, on her right shoulder, and on parts that are close to the gown with Bareley Beige. Use Pale Fruit Pink for the middle tone and Pale Chiffon for the basecoat. After all colors dry, enhance the depth of the skin with Pale Grape by painting on the deepest shadows. Add Crimson on her lips and nails.

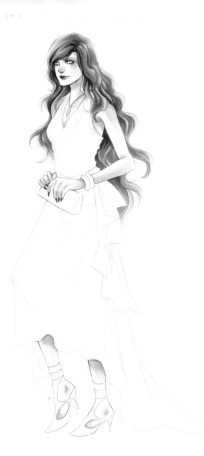

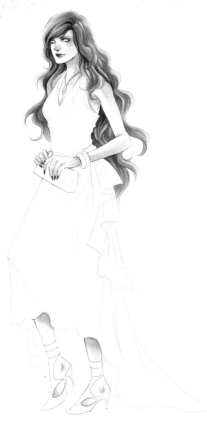

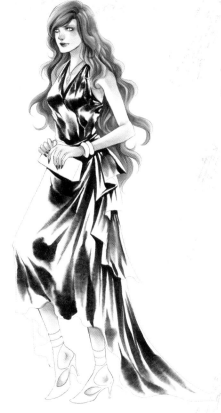

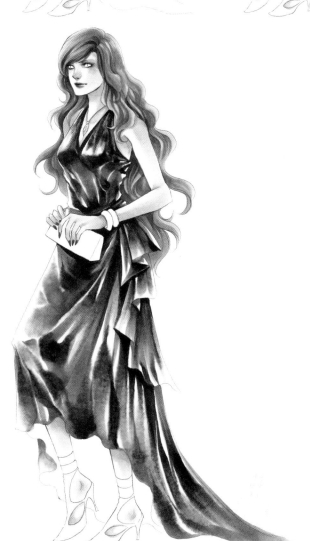

3 PAINT THE HAIR

For the first shadowy streaks, paint Caramel and leave some room for highlights. Apply Honey as the second layer. Finish up the highlights by coating the entire hair area with Yellowish Beige. Wait until all the colors dry, then darken the wavy streaks with Reddish Brass and Caramel. Emphasize the darkest streaks, like the ones behind her face and back.

4 GIVE EXTRA DEPTH TO THE HAIR

The lower hair should be more subtle than the top. Paint Mauve Shadow at the lower areas to create depth and distance for the hair.

5 CREATE CREASES AND FOLDS

Pair up the complementary color of her orange hair with a purple dress. With Violet, paint the shadowy creases and drapes on the gown. Soften some areas and the edges of the creases with Colorless Blender.

6 APPLY THE MIDDLE TONE TO THE GOWN

Using Mallow, paint on top of the shadowy creases, careful not to overpaint the entire gown. Soften the color with Colorless Blender if desired.

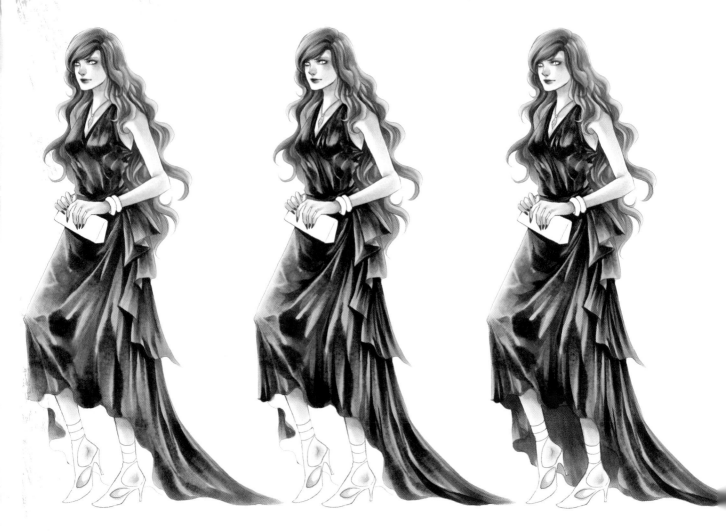

7 **PAINT THE GOWN**
Coat the entire dress with Pale Lilac. The basecoat will blend all colors nicely.

8 **ADD MORE CREASES**
Apply additional creases by painting streaks using Violet and Mallow.

9 **PAINT THE INSIDE OF THE GOWN**
Avoid using the same colors for the inside of the gown that you used for the front. Instead, blend Light Grape and Early Grape together to create a nice gradation. The colors are less saturated but still in the same violet color family, so they won't distract from the other colors.

Study Celebrities

Fashion magazines are great for finding photo references. Study the poses and outfits of the stars to get ideas for your characters.

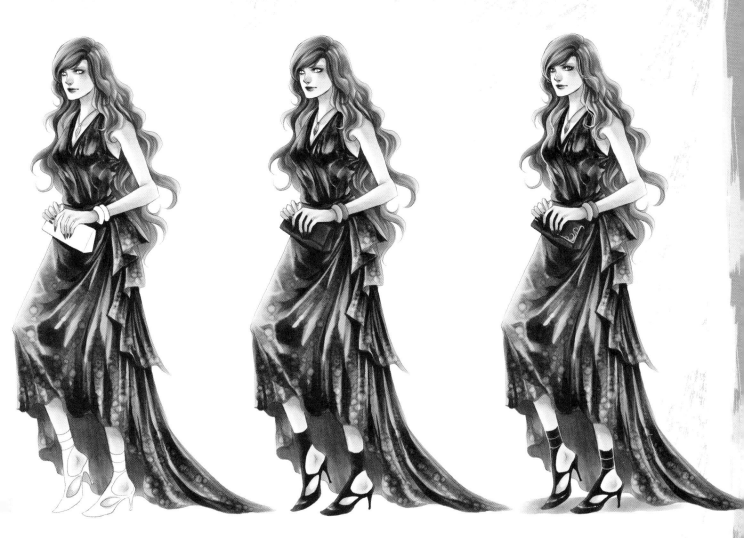

10 CREATE SPARKLING TEXTURE

Dot Colorless Blender or sprinkle rubbing alcohol on the gown. The sprinkles will fade the colors and give a nice touch of sparkling texture.

11 PAINT THE ACCESSORIES

Paint the tip of the leaf necklace with Light Rouge then shade the rest with Yellowish Beige. Use Yellowish Beige and Pale Lilac for the basecoat of the bracelets. After the colors dry, paint Honey and Lilac for shadows.

For the wristlet, apply the deepest shadows with Argyle Purple first. Afterward, use Strong Red as the second layer, then paint Light Rouge on top as the basecoat. Mix Cool Gray No. 10 and Cool Gray No. 6 together for her heels.

12 PAINT THE EYES AND COMPLETE THE DETAILS

With Chartreuse, paint the color on her irises. After the color dries, add dots for the pupils with Teal Blue. Finish all touch-ups and extra highlights with a no. 2 round and white acrylic paint or a white gel pen. Finally, paint the shadows on the ground with Cool Gray No. 3.

Demonstration
THE FIGHTER

Most people aren't born to be fighters, but sometimes fights are unavoidable. Even a calm, responsible straight-A student like Alex has to defend himself. It's not just the bodies that are dynamic. Clothes and accessories must flow along with the body. It's important to add the right amount of wrinkles to suggest movement so your character doesn't look stiff and rigid.

MATERIALS

COPIC MARKERS
0-Colorless Blender, B23-Phthalo Blue, BG09-Blue Green, BG11-Moon White, BG13-Mint Green, BG18-Teal Blue, BG78-Bronze, E11-Bareley Beige, E13-Light Suntan, E21-Baby Skin Pink, E30-Bisque, E33-Sand, E44-Clay, E53-Raw Silk, E55-Light Camel, R08-Vermilion, R89-Dark Red, V12-Pale Lilac, V17-Amethyst, V91-Pale Grape, V93-Early Grape, V95-Light Grape, Y19-Napoli Yellow, Y28-Lionet Gold, YG13-Chartreuse, YG41-Pale Green, YR02-Light Orange

OTHER TOOLS
cardstock paper

pencil

eraser

brown and gray 005 (0.2mm) waterproof, fine-point technical pens (Pigma Micron or Copic Multiliner)

white acrylic paint and a no. 2 round brush (or white gel pen)

A Temper to Match the Hair?

Not every redhead is hotheaded, of course, but red is a good color choice to depict someone with a fiery temper.

1 DESIGN THE POSE
Sketch the composition with a pencil on cardstock. Creases and wrinkles should flow in the same direction the body is moving, but due to the force of sudden motion, his messenger bag is moving the opposite way. Ink the sweater with a gray 005 (0.2mm) waterproof technical pen and the rest of the sketch with a brown one.

2 COLOR THE SKIN
Apply Bareley Beige on shadowy areas such as the knuckles, under his neck, his lips, and the corner of the outer eye. Paint Baby Skin Pink as the middle tone and coat with Bisque. Darken some selective shadowy areas by painting Light Suntan. With Pale Grape, coat his right fist that is pulling behind his body.

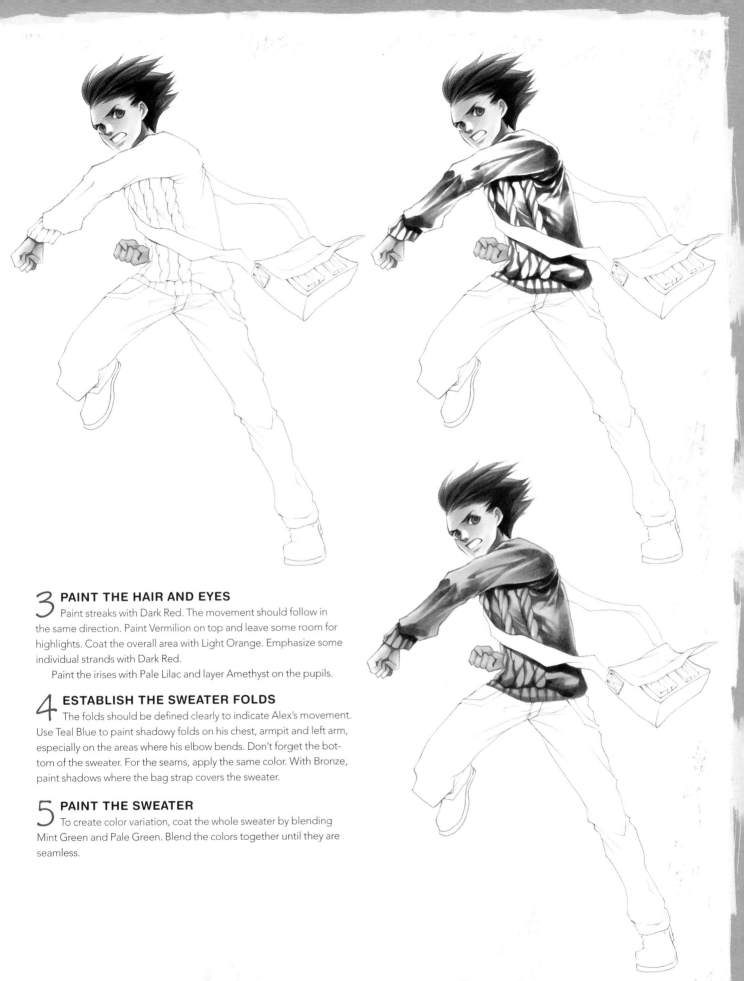

3 PAINT THE HAIR AND EYES

Paint streaks with Dark Red. The movement should follow in the same direction. Paint Vermilion on top and leave some room for highlights. Coat the overall area with Light Orange. Emphasize some individual strands with Dark Red.

Paint the irises with Pale Lilac and layer Amethyst on the pupils.

4 ESTABLISH THE SWEATER FOLDS

The folds should be defined clearly to indicate Alex's movement. Use Teal Blue to paint shadowy folds on his chest, armpit and left arm, especially on the areas where his elbow bends. Don't forget the bottom of the sweater. For the seams, apply the same color. With Bronze, paint shadows where the bag strap covers the sweater.

5 PAINT THE SWEATER

To create color variation, coat the whole sweater by blending Mint Green and Pale Green. Blend the colors together until they are seamless.

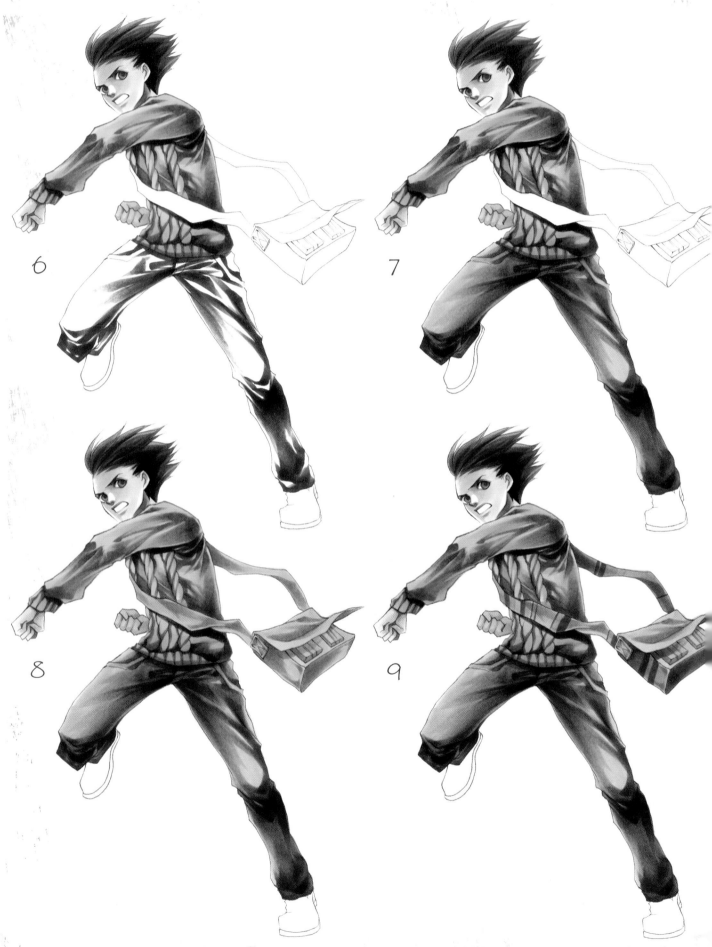

6 WRINKLE THE PANTS

Establish tension wrinkles in the groin area and other folds with Clay. Soften some of the streak edges by using Colorless Blender.

7 COMPLETE THE PANTS

With Sand, lay the second layer on top of those shadowy wrinkles; leave some room around the edge of the pants and knee area at his left for highlights. Use Raw Silk to coat on top of the pants. Darken the shadowy wrinkles with Clay to become more crisp.

8 PAINT THE MESSENGER BAG

Create shadows at the side and bottom of the messenger bag. Add shadowy wrinkles on the straps with Lionet Gold. Lay another layer on top by coating Napoli Yellow over the entire area.

9 REFINE DETAILS ON THE BAG

For extra shadows, paint Light Grape over the bottom of the bag. Paint Early Grape on the side and the strap that hangs at the back. After the colors dry, create extra stripy patterns on the bag with Chartreuse and Phthalo Blue so it won't look too bland.

10 PAINT THE SHOES AND ADD HIGHLIGHTS

Apply Blue Green on his shoes but leave some space on the toes for highlights. Paint Moon White on top. For the soles, use Light Camel. With a no. 2 round and white acrylic paint or a white gel pen, make a single dot of white highlight for each eye.

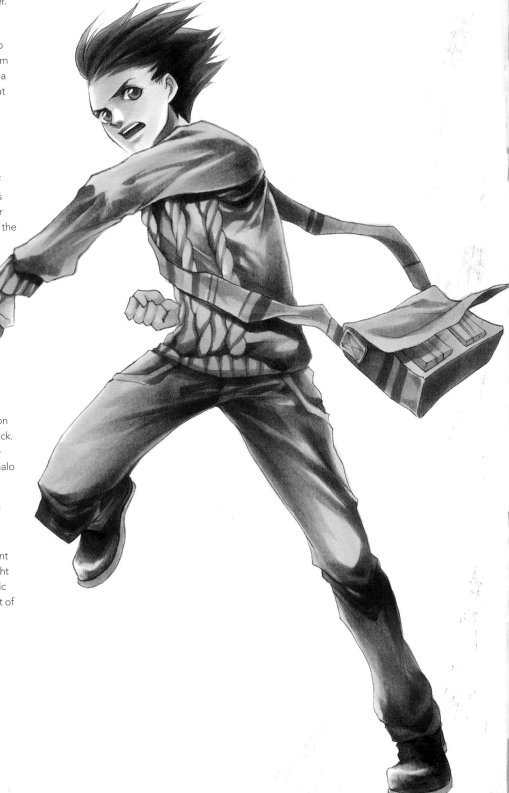

Demonstration
SUMMER BREEZE

In summer, there's nothing better than enjoying the outdoors, jumping high into the sky and feeling the summer breeze. Expressive gestures such as raising the arms and bending back the knees help convey your character as excited and lively.

MATERIALS

COPIC MARKERS
0-Colorless Blender, B000-Pale Porcelain Blue, B00-Frost Blue, B24-Sky, B32-Pale Blue, B39-Prussian Blue, B41-Powder Blue, B45-Smoky Blue, E11-Bareley Beige, E13-Light Suntan, E21-Baby Skin Pink, E33-Sand, G09-Veronese Green, R08-Vermilion, R14-Light Rouge, R89-Dark Red, V95-Light Grape, Y17-Golden Yellow, YG01-Green Bice, YR12-Loquat, YR21-Cream, YR24-Pale Sepia

OTHER TOOLS
cardstock paper

pencil

eraser

Col-Erase blue pencil

brown or sepia 005 (0.2mm) water-proof, fine-point technical pens (Pigma Micron or Copic Multiliner)

white acrylic paint and a no. 2 round brush (or white gel pen)

1 DESIGN THE POSE AND BACKGROUND
Sketch the composition with a pencil on cardstock paper. Ink the character with a brown or sepia 005 (0.2mm) waterproof technical pen.

For the background, sketch the clouds' outline with a Col-Erase blue pencil. The Col-Erase blue pencil is a very handy tool since it's easy to erase without leaving waxy traces on your paper.

2 PAINT THE CLOUDS
Leave about ¼ to ½ inch (6mm to 13mm) from the outline you have drawn for the clouds highlight, and paint some Powder Blue. Use plenty of Colorless Blender to blend out the color for puffy effects.

Complete the clouds by blending Pale Porcelain Blue downward to the bottom of the picture over the Powder Blue. Leave some unpainted space for highlights. Use Colorless Blender for more blurry, puffy effects if you desire.

Cloud Do's and Don'ts

Even basic clouds have form created with shadows and shading. Painting clouds with just simple bubble shapes and white color will make them look too flat and boring.

do use a variety of colors for shadows and shading

don't draw simple bubbles and only use white

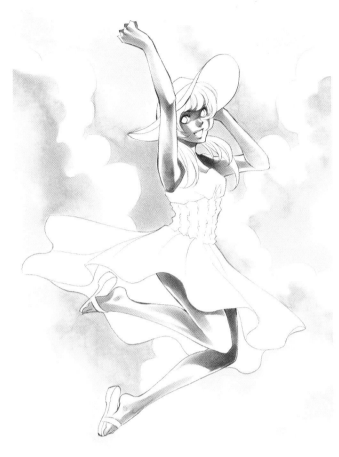

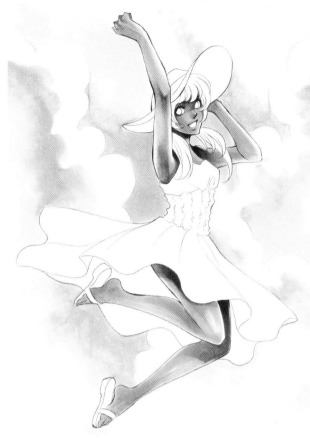

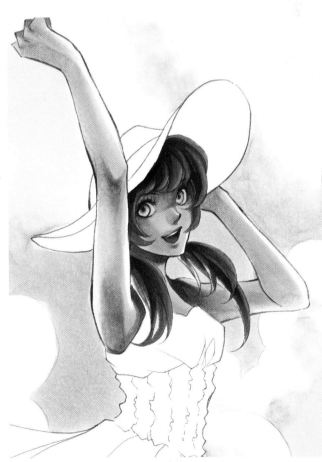

3 CREATE SHADOWS ON HER SKIN

Apply Light Suntan for shadows on her skin. Emphasize the darkest areas: her thighs where the flowing skirt covers, and under her hair, chin and armpits. Paint the middle layer with Bareley Beige. Blend the color with Light Suntan together until they fade well.

4 APPLY THE BASECOAT TO SKIN

Paint Baby Skin Pink on top of her skin and leave some room for reflected light. After the color dries, use Light Grape to darken the deepest shadows. Just pick the parts you need to emphasize the most, such as her left thigh and under her chin.

For reflected light, match the color with the sky. Add Pale Porcelain Blue at the right side and the bottom of her arms. Soften the color nicely until it blends with the skin. Apply the same method on her legs.

5 PAINT THE HAIR AND EYES

Create shadowy streaks for the hair with Dark Red and lay Vermilion on top. Coat the area with Light Rouge, except on some strands on the right side of the ponytails. Add details and darken strands with Dark Red. For the unpainted strands, use Frost Blue to create reflected light.

To make her eyes stand out from her red hair, use opposite colors such as green shades. Paint Green Bice for her irises and layer Veronese Green for the pupils.

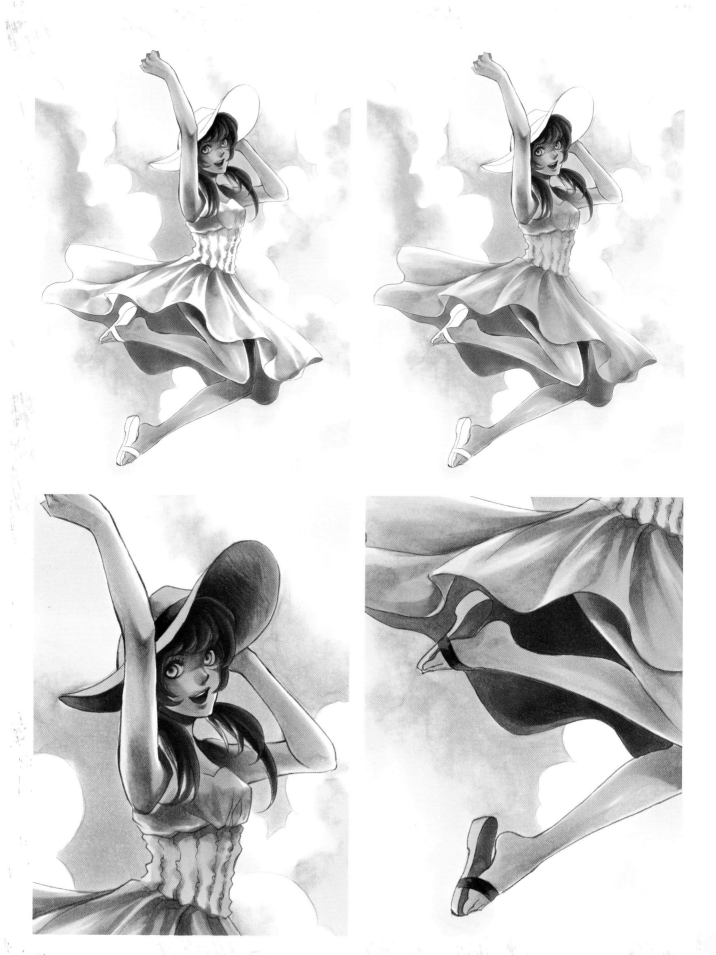

Visit impact-books.com/wonder-manga for a **free** bonus demonstration

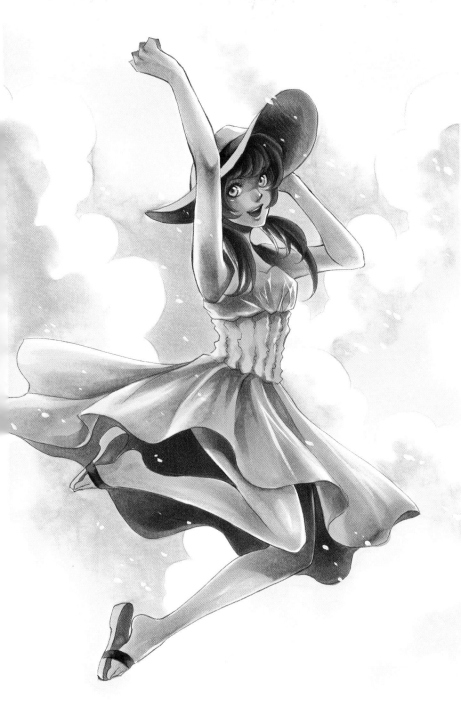

6 ESTABLISH FOLDS IN THE CLOTHING

Make folds and creases by using Pale Sepia. Soften the edges of the folds with Colorless Blender. Use the same color to paint inside the dress flowing behind the character's legs.

7 APPLY BASECOAT AND REFLECTED LIGHT TO THE DRESS

Paint a basecoat of Golden Yellow all over the dress, leaving some untouched at the right. Use Frost Blue on the untouched areas. Blend the dress colors together with Golden Yellow.

Use Smoky Blue and Pale Blue to define a layer of shadows inside her dress. This will make her legs stand out from the dress, since the colors of the skin and dress are too similar. To create shadows with a hint of blue, use Pale Blue on the folds and creases.

8 FINISH THE HAT

Lay Loquat on the inside. After it dries, paint Pale Blue on top. With Pale Blue, draw tiny hatching lines facing outward to the edge. For the outside, paint Sand at the center and coat the area with Cream. Combine Prussian Blue and Sky for the strap.

9 PAINT HER SANDALS

Blend Prussian Blue and Sky together for the sandal straps. Use Pale Blue and Sand together on the base of the sandal and paint Cream on the sides.

10 ADD FINISHING TOUCHES

With a no. 2 round and white acrylic paint or a white gel pen, give the picture a final touch-up. Place extra highlights on her eyes and dress, and also sprinkle multiple dots over the picture.

Demonstration
BROTHERHOOD

When you have more than one character in your scene, you have to decide which character you want to emphasize most to suggest the correct distance. Combine what we learned in the previous character demos to paint these two brothers.

Despite their girlish figures, the two kung-fu brothers are so tough nobody dares mess with them.

MATERIALS

COPIC MARKERS

0-Colorless Blender, 100-Black, BV0000-Pale Thistle, BV000-Iridescent Mauve, BV15-Dull Lavender, BV23-Grayish Lavender, C2-Cool Gray No. 2, C5-Cool Gray No. 5, C7-Cool Gray No. 7, E11-Bareley Beige, E13-Light Suntan, E17-Dark Suntan, E21-Baby Skin Pink, E25-Caribe Cocoa, E30-Bisque, E35-Chamois, E51-Milky White, E57-Light Walnut, E97-Deep Orange, E99-Baked Clay, R14-Light Rouge, R46-Strong Red, RV99-Argyle Purple, V91-Pale Grape, V93-Early Grape, V95-Light Grape, Y17-Golden Yellow, YR14-Caramel, YR15-Pumpkin Yellow, YR21-Cream, YR24-Pale Sepia

OTHER TOOLS

cardstock paper

pencil

eraser

gold marker pen (Sakura Pentouch Gold 0.7mm)

brown or sepia 005 (0.2mm) waterproof, fine-point technical pens (Pigma Micron or Copic Multiliner)

white acrylic paint and a no. 2 round brush (or white gel pen)

1 DESIGN AND INK

With a pencil, design the overall composition on cardstock and make sure that the front character has a more expressive pose. Use a brown or sepia 005 (0.2mm) waterproof technical pen to ink the sketch, then erase all extra pencil marks.

2 PAINT THE SKIN AND EYES OF THE FIRST FIGURE

For his tanned skin, use Bareley Beige on the shadows. Apply Baby Skin Pink for the middle tone and follow with Bisque as the basecoat. After all colors are dry, darken the shadows except on the legs with Light Suntan. To enhance his golden-yellowish eyes, paint Golden Yellow on his irises and dot the pupils with Deep Orange.

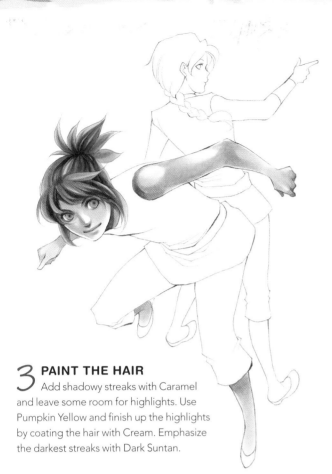

3 PAINT THE HAIR

Add shadowy streaks with Caramel and leave some room for highlights. Use Pumpkin Yellow and finish up the highlights by coating the hair with Cream. Emphasize the darkest streaks with Dark Suntan.

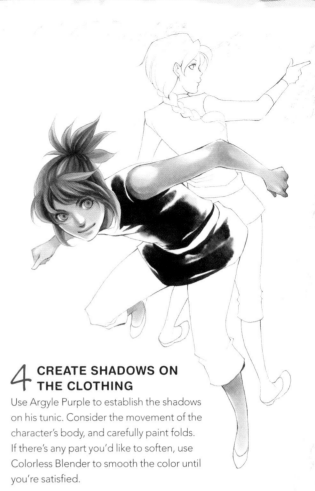

4 CREATE SHADOWS ON THE CLOTHING

Use Argyle Purple to establish the shadows on his tunic. Consider the movement of the character's body, and carefully paint folds. If there's any part you'd like to soften, use Colorless Blender to smooth the color until you're satisfied.

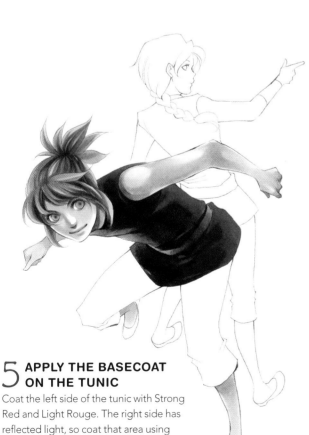

5 APPLY THE BASECOAT ON THE TUNIC

Coat the left side of the tunic with Strong Red and Light Rouge. The right side has reflected light, so coat that area using Light Grape. Use Caribe Cocoa to paint the middle of his waistband, then follow with Chamois on the left of the band and Early Grape on the right.

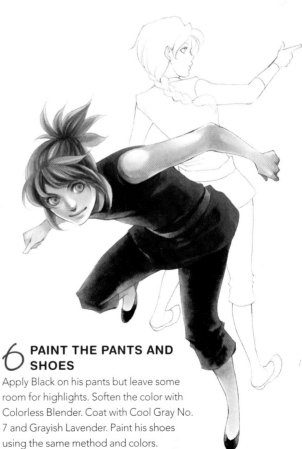

6 PAINT THE PANTS AND SHOES

Apply Black on his pants but leave some room for highlights. Soften the color with Colorless Blender. Coat with Cool Gray No. 7 and Grayish Lavender. Paint his shoes using the same method and colors.

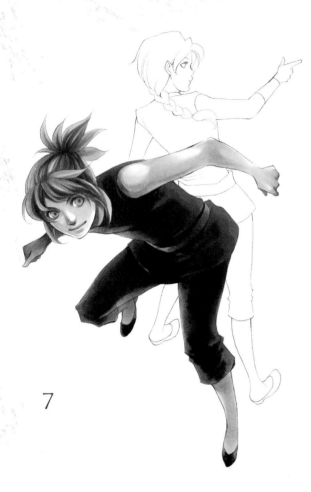

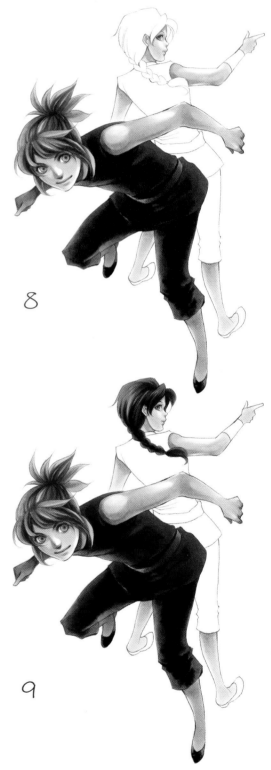

7 CREATE DISTANCE WITH COLOR AND REFLECTED LIGHT ON THE SKIN

His right arm and leg have been pushed backward due to the composition. To create distance, coat Early Grape on his skin. Blend Light Grape and Early Grape together on his right arm. Even though his left leg isn't pushed back as much as his right, this area still needs Pale Grape on top. Don't coat the entire area, just blend the color up from the bottom to his knee so his original skin color will still show through.

 The reflected light hits mostly on his right, so use Iridescent Mauve on that side of his face, nose and hair, and the bottom side of his left arm.

8 PAINT SKIN AND EYES OF SECOND FIGURE

Move on to the second figure. Apply Bareley Beige on shadowy areas. Paint Bisque as the middle tone and Milky White for the basecoat. Use the same colors that you painted earlier for his brother. Paint Golden Yellow on his iris and mark a dot as the pupil with Deep Orange. Use Pale Thistle at his jawline and the bottom side of his right arm to create reflected light.

9 PAINT THE HAIR

Create hair streaks with Light Walnut. Leave some unpainted space and use Baked Clay as the second layer, painting on top of those shadowy streaks. Lay Pale Sepia on top of the whole hair, and smooth colors together for a nice, silky feel. Make the strands of hair more noticeable by painting Light Walnut on top of the shadowy streaks.

10 FINISH HIS OUTFIT

You don't have to refine every sharp detail on him like you did for the first character. Keep it simple. For his tunic, use Caramel as shadows. Blend with Colorless Blender, then coat the entire tunic with Cream. Fill the left side of it with Early Grape. Use Cool Gray No. 5 to paint the center of his wristband and waistband, then lay Dull Lavender on top of both.

 Use Cool Gray No. 7 for the shadows on his pants and shoes. Finish them by coating Dull Lavender on top.

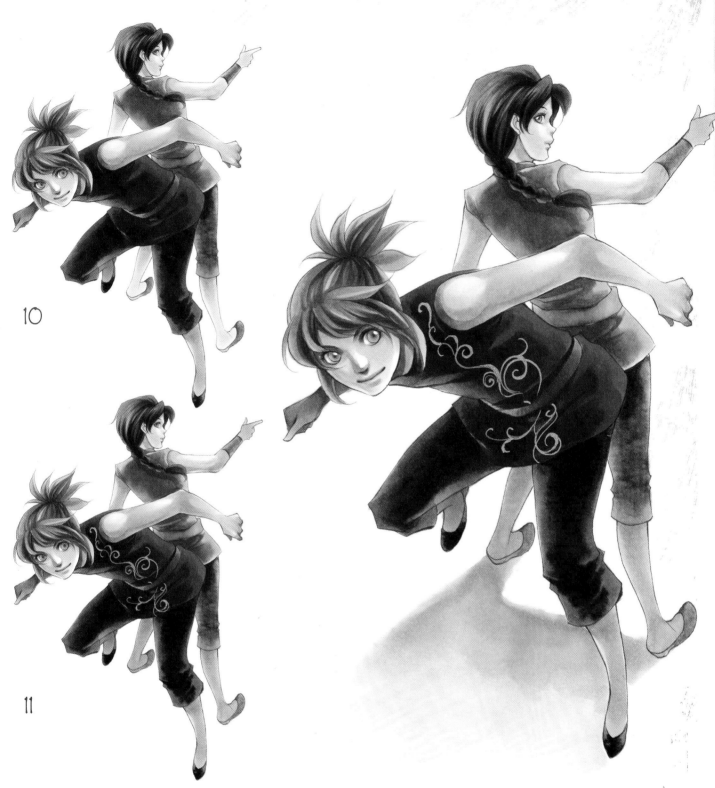

10

11

11 CREATE DISTANCE AND DRAW SWIRLY PATTERNS

Paint Pale Grape on top of his legs and arms, except for the top of his upper arms. On his back, use Light Grape to paint the shadow cast by his braid.

With a gold marker pen, create swirly patterns on the front figure's tunic for a nice finishing touch.

12 FINISH THE PICTURE

Mark the highlight on the eyes with a no. 2 round and white acrylic paint or a white gel pen. Blend Dull Lavender and Cool Gray No. 2 on the ground to indicate cast shadows.

4

Fantastical Costumes

When you have a beautiful setting, you need dynamic characters to fill it.
This section covers fantasy costumes and gives you some ideas to help spice
up your imagination. Whether your inspiration is from nature or history, don't
limit yourself to the choices in this book. Use all aspects of your life to imag-
ine and create fascinating costumes for your characters.

Create a Fantasy Costume

Fantasy costumes can be inspired by anything. Elaborate patterns and rich colors make clothing look lively, while torn fabric and deep colors tone down the character and give a mysterious feel. Remember that costumes always reflect your characters' personalities, culture and heritage, so keep those things in mind when creating their attire.

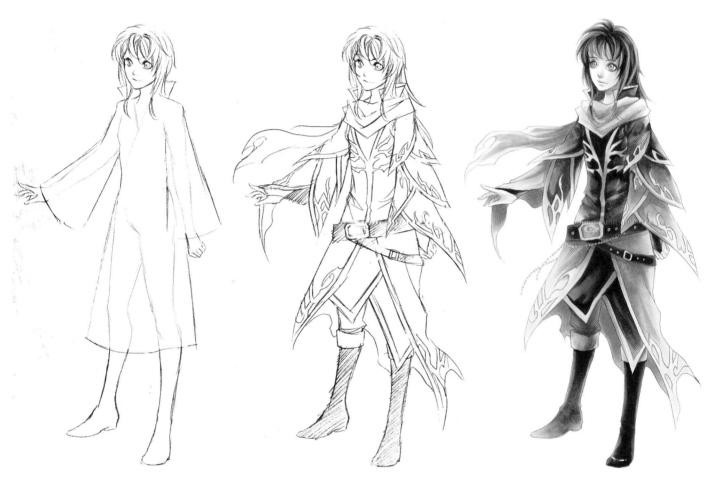

1 START WITH THE BASIC SHAPES

Rough out the shapes the clothes will make over the character's frame. Use the shapes as a guideline for the overall look for the character.

2 DEVELOP THE DETAILS

Design the shapes to be more complex. Asymmetrical shapes will help the clothes look lively. Add to or reduce the shapes as necessary. Refine details and add extra accessories on the clothing to make it look fancy.

3 FINALIZE AND COLOR

Rich colors provide contrast and provide insight into the character's social status and personality.

Gathering Inspiration

Designing fantasy costumes is like working on a scrapbook—you pull all ideas together into one big place. Here are some brainstorming ideas to help you open your mind and think up some cool fantasy costumes!

Get Back to Nature

Mother Nature is one of the best sources for fantasy inspiration. Flowers, leaves, wild animals and all natural creatures are great subjects to base your costumes on. Think about the most recognizable trait of the subject and apply it to your character's costumes. You can simplify, alter or exaggerate the trait to create unique costume details.

Using Photo References
Take pictures of things in nature to use for inspiration. The baby blue color and poofy shape of these hydrangeas are a perfect mix for petite faeries and little girls.

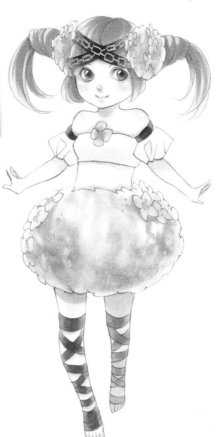

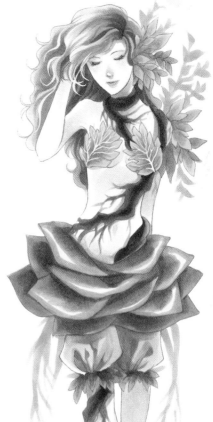

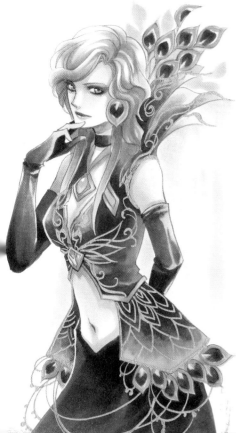

Branches, Leaves and Flowers
For an earthy character, branches and leaves work well. The rose-shaped skirt gives this dryad an organic, natural feel.

Peacock Feathers
Peacock feathers are elegant and sophisticated. Use them as part of a dress along with a golden pattern on the fabric.

85

Cultural Heritage

Traditional costumes in different nations or cultures can effectively represent a character's background or setting. Research patterns, colors, styles and types of fabrics used in different cultures and use them to inspire your fantasy costume designs. You can borrow or modify specific styles or even combine different cultural aspects to enhance your characters' backgrounds.

Free Spirit
Here I paired Thai-inspired military armor with elven traits for a cool ornamental look.

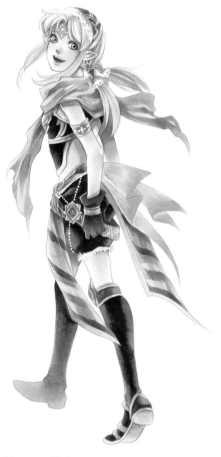

The Shaman ←
Bright colors go well with tribal-inspired patterns. I used feathers and a mask to depict the occupation of a shaman.

Villainous King ↓
Here I combined a creepy ram skull and torn cape with gold patterns and embroidery inspired by ancient Thai culture. The elaborate details within the patterns give our king a mysterious vibe.

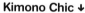

Kimono Chic ↓
Here I added lace and played around with the patterns to make the kimono-inspired look more stylish.

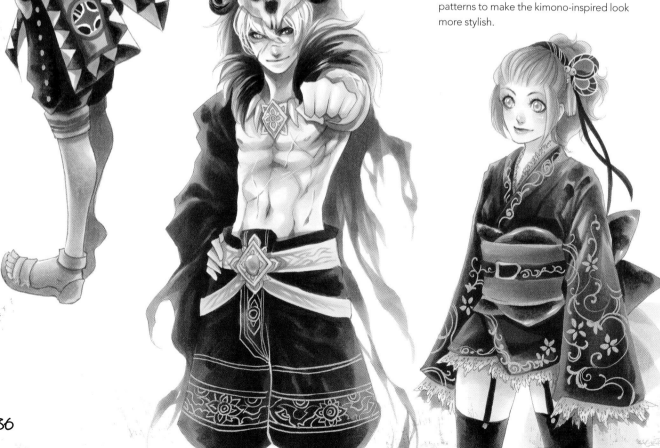

Costume Accessories

You can spice up a simple outfit with any number of accessories—fancy, elegant, elaborate or plain. Use real accessories you see in magazines or create your own—have fun and be creative.

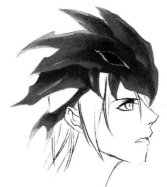

Wreaths
Wreaths made of natural elements such as branches, leaves, petals and roots make great headpieces.

Chokers ↑
Neck adornments can be thick or thin, simple or embroidered with beads and seashells. Chokers can be accessories for all ages and genders since they go with most costumes.

Warrior Helmets →
Heroic or evil, the color of the helmet should match the overall costume. Unmatched designs and colors can confuse the story you're trying to convey.

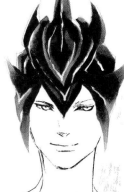

Scarves
Luxurious or torn scarves can imply different moods and backgrounds.

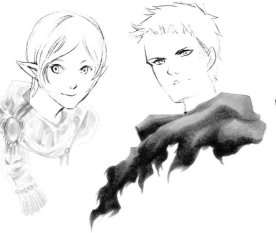

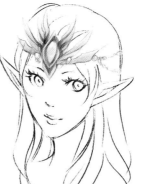
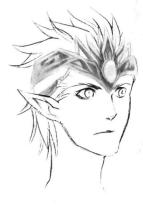

Crowns and Tiaras
Elven headdresses can be inspired by crowns and tiaras. They are ornate with decorative structures and natural gems.

Necklaces ↑
Gems and pearls commonly adorn necklaces, but don't be afraid to create your own with other materials.

Headbands →
Unlike crowns and tiaras, headbands mix in more materials. Styles can be simple with colorful patterns, or super marvelous with beads and feathers.

Demonstration
LIONEL, WARRIOR KING

Select the fantasy costume elements and colors by thinking about what kind of materials would be available to your characters. For example, this wild and free-spirited warrior might create his clothing from the feathers and hides of wild animals to show his prowess in hunting and fighting, and to blend into his environment.

MATERIALS

COPIC MARKERS
0-Colorless Blender, B24-Sky, B28-Royal Blue, B63-Light Hydrangea, BG01-Aqua Blue, BV00-Mauve Shadow, BV000 Iridescent Mauve, BV11-Soft Violet, BV23-Grayish Lavender, C2-Cool Gray No. 2, E11-Bareley Beige, E15-Dark Suntan, E18-Copper, E19-Redwood, E21-Baby Skin Pink, E30-Bisque, E31-Brick Beige, E33-Sand, E34-Orientale, E43-Dull Ivory, E44-Clay, E49-Dark Bark, E57-Light Walnut, E59-Walnut, E97-Deep Orange, E99-Baked Clay, R08-Vermilion, R14-Light Rouge, R27-Cadmium Red, R89-Dark Red, RV99 Argyle Purple, V93-Early Grape, V95-Light Grape, Y17-Golden Yellow, Y23-Yellowish Beige, Y28-Lionet Gold, YR14-Caramel, YR24-Pale Sepia

DRAWING TOOLS
cardstock paper

pencil

eraser

brown or sepia 005 (0.2mm) waterproof, fine-point technical pens (Pigma Micron or Copic Multiliner)

white acrylic paint and a no. 2 round brush (or white gel pen)

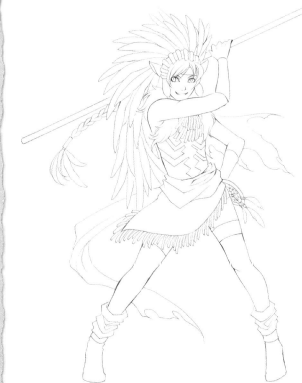

1 CREATE THE POSE
Lionel is confident and straightforward, and even when his stance is relaxed he is ready for battle.

With a pencil, sketch a pose and costume based on his personality and fierce demeanor. Make his headdress cascade to his waist. Use a brown or sepia 005 (0.2mm) waterproof technical pen to ink the sketch, then clean up the lines with an eraser.

2 PAINT THE SKIN
Lionel lives outdoors and engages himself with nature. Because of that, there's no light or pale tones in his skin tone. Use Bareley Beige on the shadowy areas. Then apply Baby Skin Pink as the middle tone and coat with Bisque. Darken the deepest shadows with Early Grape. For reflected light on his skin, paint Iridescent Mauve on the left side of his face, the bottom of his arms, and the right side of his legs.

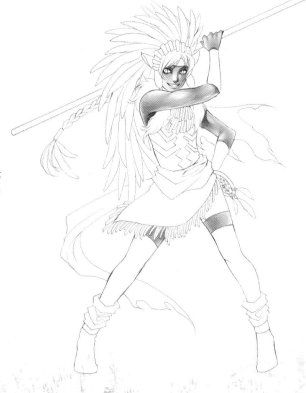

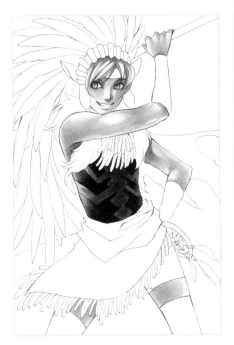
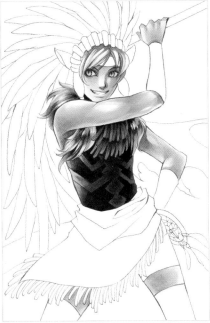
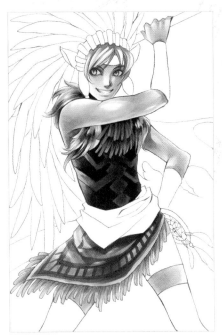

3 START THE HAIR, EYES AND BREASTPLATE

To depict his golden hair, paint shadowy streaks with Lionet Gold.
Apply Yellowish Beige as the second layer and leave shiny highlights
at the center of the strands. Use Yellowish Beige for his irises and Pale
Sepia for the pupils.

The costume doesn't need to be overly elaborate. In fact, Lionel
prefers easy functionality and movement, along with simple patterns
and colors. For his breastplate, paint Dark Bark and soften the color
with Colorless Blender. On his left side, coat the area with Baked Clay.
Meanwhile, for his right side, blend Baked Clay outward with Light
Hydrangea. Use Dark Red for shadows on the pattern, and coat on
top with Vermilion. Blend the edge of Vermilion at the right side with
Mauve Shadow.

4 PAINT THE FUR AND FRINGE

Create long strokes with Light Walnut on the fur and soften the
strokes by painting another layer on top with Dull Ivory. This second
layer will make the fur look soft and sleek. To give the golden shine,
coat the fur with Yellowish Beige. The woven fringing on his chest is
simple in color. Paint Light Walnut at the top of the fringing, and blend
colors downward with Dark Suntan and Sand.

5 COLOR THE SHAWL

Add to the shadows on the shawl and fringe and create wrinkles
and creases. Soften the color with Colorless Blender, then coat the hide
with Brick Beige. Refine those wrinkles with Light Grape. Add Light
Grape to intensify the creases. After this dries, add the red stripe pat-
terns with Cadmium Red. Use Sky to add lines along the sides of the
reddish stripes and another extra line at the top.

6 PAINT THE SHORT PANTS, LEGGINGS AND ARMBANDS

Apply Dark Bark at the center of his pants, leggings and armbands.
Soften the color with Colorless Blender and be careful not to overdo
until the color spreads off the areas. Paint Baked Clay on top of the left
side. On the right side, use Light Hydrangea instead.

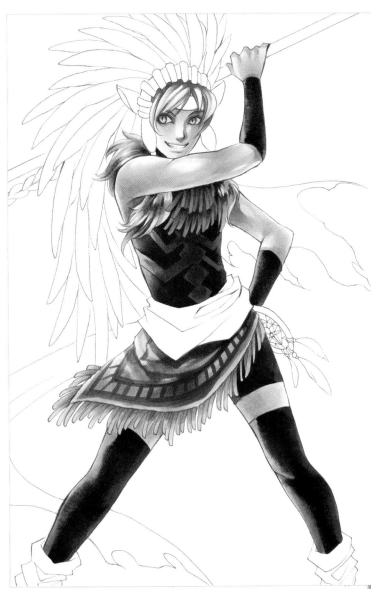

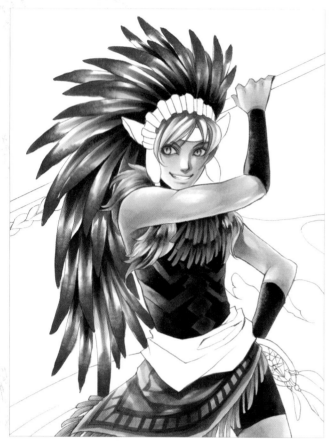

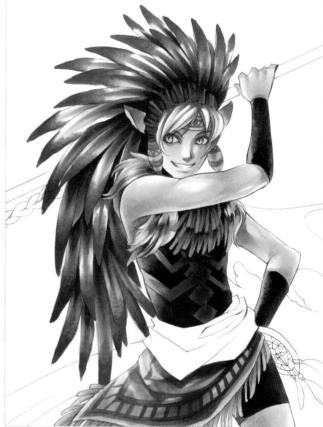

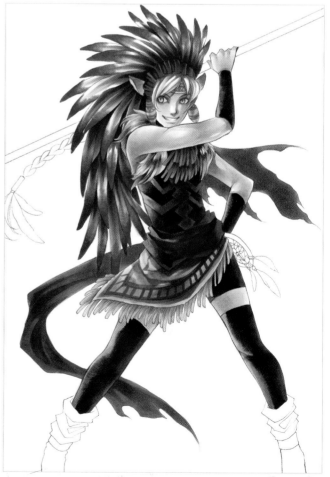

7 BEGIN WORKING ON THE HEADDRESS

Use strong but earthy tones for the headdress, starting with the feathers. Paint Cadmium Red at the tail of each feather. Make single strokes with Copper, and smooth them with Dark Suntan. Leave the middle of the feathers unpainted.

8 FINISH THE HEADDRESS AND ACCESSORIES

To suggest shadows and distance for the feathers, paint Light Grape and Early Grape on the feathers at the bottom. Use Dark Red to create fine shadows on the cap, then follow with Light Rouge on top. Blend Caramel and Brick Beige on the lion ears that stick out from the cap. With Sand, paint shadows on both his headband and decorative beads. Coat the areas with Golden Yellow. Design stripes and zigzag patterns on both objects with Light Rouge and Sky.

9 PAINT THE SCARF AND CAPE

For the scarf, start working on the part that wraps around his waist first. To make creases, paint shadowy streaks with Argyle Purple and soften the edges with Colorless Blender. Use Light Rouge to coat on top. Leave some room at the right for the reflected light, and then paint Soft Violet. Start from the area that is close to his waist. Blend Grayish Lavender, Light Grape, and Light Rouge together on the scarf at the back. For the cape, blend Grayish Lavender and Light Grape on the area.

10 PAINT THE BRAID, DREAMCATCHER AND ACCESSORIES

Use Lionet Gold to paint shadows on his braid, and then coat on top with Yellowish Beige. To portray the braid in the distance, paint Early Grape on a few sections of braid, starting with the sections closest to the feathers.

Paint Golden Yellow on the beads and make bluish stripes with Sky. The feather colors can be different from those in the headdress. Paint the tail with Light Rouge and follow with Sky and Aqua Blue. Leave the bottom parts unpainted.

Paint Redwood and Deep Orange for the ring. Apply Royal Blue at the tail of the feathers and blend with Sky and Aqua Blue. Apply Sky and Aqua Blue for the beads.

11 FINALIZE THE DETAILS

Use Sand to paint shadows on his boots. Apply Brick Beige on top and darken additional shadows with Light Grape. Pick deeper tones for the boot straps. Paint Walnut at the center of the straps and coat the entire area with Dark Suntan. For his staff, add Clay at the center. Apply Orientale on top as its highlight and Soft Violet at the bottom for reflected light.

Finally, paint Cool Gray No. 2 on the ground to indicate his cast shadow. With a no. 2 round and white acrylic paint or a white gel pen, refine the finishing details such as reflecting light in his eyes, some single strands of hair and fur at the collar.

Demonstration
BELEN, THE ELF ARCHER

In the fantasy realm, there's a difference between pixies and elves—and that difference is the way they dress. Playful pixies wear casual costumes while elves dress more elegantly to depict their noble personalities. Even their props or weapons carry that sense of grace, so don't be afraid to embroider elven attire and props with extra delicate patterns because that's the way elves like to be.

Belen's pose should remain elegant and the design minimal yet luxurious enough to portray her as an elf.

MATERIALS

COPIC MARKERS

0-Colorless Blender, BG18-Teal Blue, BG49-Duck Blue, BG72-Ice Ocean, BG99-Flagstone Blue, BV20-Dull Lavender, BV23-Grayish Lavender, C2-Cool Gray No. 2, E11-Bareley Beige, E29-Burnt Umber, E30-Bisque, E42-Sand White, E50-Egg Shell, E99-Baked Clay, G20-White Wax, G21-Lime Green, G82-Spring Dim Green, G85-Verdigris, G94-Grayish Olive, RV93-Smoky Purple, V93-Early Grape, Y000-Pale Lemon, Y00-Barium Yellow, Y17-Golden Yellow, Y23-Yellowish Beige, Y28-Lionet Gold, YG00-Mimosa Yellow, YG11-Mignonette, YG23-New Leaf, YG25-Celadon Green, YG95-Pale Olive, YG99-Marine Green, YR0000-Pale Chiffon

OTHER TOOLS

cardstock paper

pencil

eraser

gold marker pen (Sakura Pen-touch Gold 0.7mm)

brown or sepia 005 (0.2mm) water-proof, fine-point technical pens (Pigma Micron or Copic Multiliner)

white acrylic paint and a no. 2 round brush (or white gel pen)

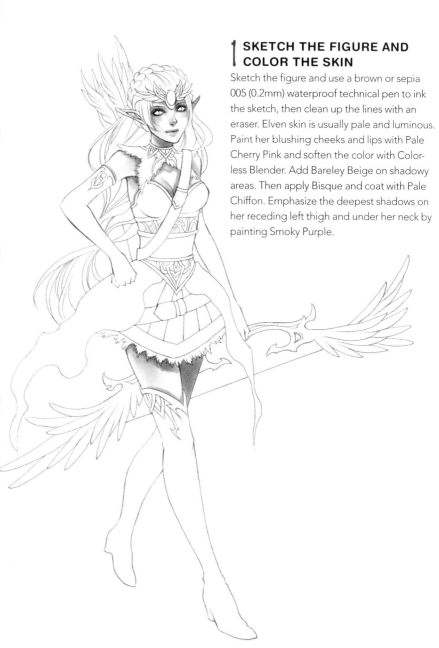

1 SKETCH THE FIGURE AND COLOR THE SKIN

Sketch the figure and use a brown or sepia 005 (0.2mm) waterproof technical pen to ink the sketch, then clean up the lines with an eraser. Elven skin is usually pale and luminous. Paint her blushing cheeks and lips with Pale Cherry Pink and soften the color with Color-less Blender. Add Bareley Beige on shadowy areas. Then apply Bisque and coat with Pale Chiffon. Emphasize the deepest shadows on her receding left thigh and under her neck by painting Smoky Purple.

Visit impact-books.com/wonder-manga for a **free** bonus demonstration

2 PAINT HER HAIR AND EYES

Add Lionet Gold on the hair for shadowy streaks, then apply Yellowish Beige and leave shiny highlights at the center of the strands. If there's any area you'd like to push the shadows, repaint Lionet Gold. For her emerald eyes, use New Leaf for the irises and Teal Blue for the pupils.

3 FINISH THE HEADDRESS

The jewel on the headdress can be matched to Belen's eye color. Darken the center and the side of the jewel with Teal Blue. Add New Leaf on top of that and leave the top of the jewel for the highlight. On the golden metal parts, add Spring Dim Green at the tip of the points. Layer Barium Yellow on top, then smooth the green shade together with the yellow. Apply Lionet Gold for shadows.

4 PAINT HER BODICE

From the scalloped edges of the lace, blend Spring Dim Green, Mignonette, and Barium Yellow. With Ice Ocean, apply a bunch of dots to create the lacy effect. Darken the shadowy areas under her breasts, the blank spaces in between the decorative patterns and the center of her belly with Marine Green. Soften the color with Colorless Blender, then coat with Pale Olive. Add Golden Yellow on the decorative patterns and apply shadows with Lionet Gold.

5 COLOR THE SKIRT AND BELTS

On the skin, blend Grayish Olive downward with Lime Green. Darken shadows on the pleats and under the belt with Verdigris. For the stripe at the bottom, blend Flagstone Blue and Grayish Lavender. Blend Yellowish Beige and Barium Yellow together for the lace trim at the skirt's bottom.

Apply Burnt Umber at the center of the belt, then layer on top with Baked Clay.

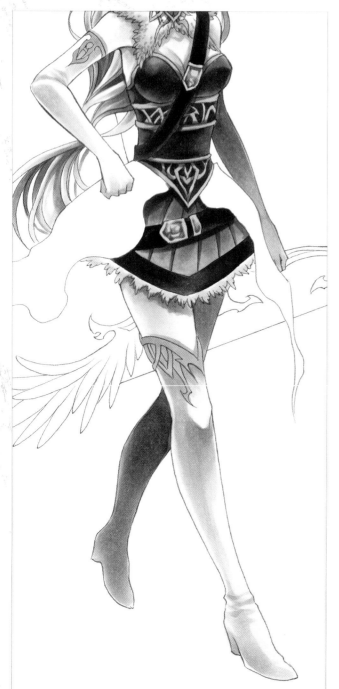

6 PAINT THE GLOVES AND BOOTS

Start with her right glove and boot. With Sand White, paint selective shadows and make sure you leave enough highlights. Coat with Egg Shell. Afterwards, color the decorative patterns with Golden Yellow and darken shadows with Lionet Gold. For the left side, use Sand White to paint the whole areas without leaving blank spaces. To suggest distance, layer on Grayish Lavender and Early Grape.

7 WORK THE SEE-THROUGH FABRIC

The see-through fabric covers up parts of her skirt and some strands of her hair. To depict colors underneath, paint Lime Green at the top of the see-through fabric, and leave some space away from the corners. Follow the same method with Sand for the belt, Verdigris for the darker stripe at the bottom, and Barium Yellow for the lace. Use Colorless Blender to blend the paints. Be careful not to soften the colors too much.

8 PAINT THE SEE-THROUGH FABRIC

Blend Pale Lemon and White Wax together over the fabric. Paint the additional parts at the back with Lime Green and Early Grape. Blend them together.

9 COLOR THE BOW AND ARROWS

Blend Duck Blue and New Leaf on the longest feathers on the bow. For the medium and shortest ones, gradient Celadon Green and Mimosa Yellow. Use Yellowish Beige to paint on the handle. After the color dries, refine shadows and elaborate details with Lionet Gold. With Colorless Blender, put a bunch of dots on each feather to create extra texture.

Paint the arrows with Lime Green on the tips of the fletching. Add another layer of Dull Lavender on top. Use Grayish Lavender for the quiver behind her back.

10 FINALIZE ALL DETAILS

To add more decorative patterns, draw swirls on her attire with a gold marker pen. Paint Cool Gray No. 2 on the ground to depict the cast shadow. With a no. 2 round and white acrylic paint or a white gel pen, create reflecting light on her nose, cheeks, lips and eyes.

5

Textures, Backgrounds and Perspective

Great backgrounds are essential to creating fun and convincing stories for your manga characters. There is a variety of techniques and media that can help you transform your plain white backgrounds into magical worlds. This section covers the basics of backgrounds—from perspective and character placement to atmosphere and texture—and shows you how to bring it all together with six spectacular demonstrations.

Backgrounds and Scenery

Whether your story takes place indoors or out, establishing backgrounds is essential to conveying the story of your characters and where they belong. Backgrounds tell the viewer information about who your character is and what's going on around them. Different backgrounds require varying amounts of details. Other aspects that you need to consider are time of day, season, weather and characteristics typical of different regions (mountains, oceans, trees, snow and ice). Backgrounds are integral to your characters, so spend the extra time making your backgrounds right.

Beaches
Nothing says summer like a breezy beach scene. Add old-fashioned bathing attire for a vintage feel.

Cityscapes
Cities can be packed with countless buildings, traffic and people. Use various structures and building heights to make your city look believable and visually striking. Use photo references of cities from around the world to draw realistic scenes.

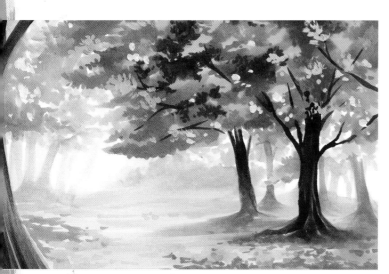

Gardens and Forests
Gardens and forests are the easiest way to depict natural scenery. The color variation of trees and foliage through the seasons can convey different moods in your stories. This autumn scene with orange and yellow leaves reveals a warm and positive setting for your characters.

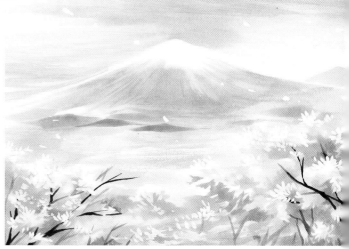

Mountains
Mountains are often seen at the horizon of your painting. The amount of details you should include in your mountains is based on their distance. Don't recreate everything—hazy details with plain colors will do the job unless they are really close in the foreground.

Character Placement

You've worked hard on your background only to realize your character doesn't fit. What a shame! No matter how many characters you have in your drawings, you can keep them all in the right proportion by aligning them with a horizontal line through the same section of their bodies.

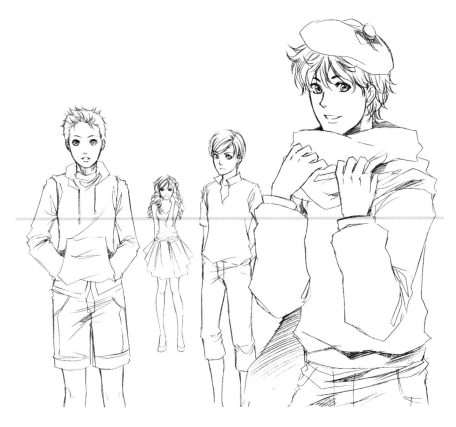

Character Do

Each character should be intersected by a horizontal line on the same level. For example, if you place your first character intersected by the line on his waist, everyone else should have the line running through their waist, too. Intersecting this line lower or higher will change the height of a character.

Exception: When a character is on a different level, or in a different position such as sitting or lying on the floor, the line may not cross them in the same place—or at all.

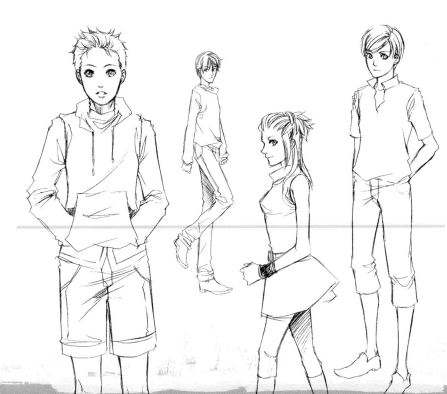

Character Don't

Not paying attention to placement will result in an unbalanced drawing and leave your characters looking as if they're floating in space.

Basic Perspective

Have you ever noticed how the road merges into one point at the horizon? Or how buildings look smaller as they recede? In fundamental perspectives, grids and vanishing points are the basis for creating three-dimensional drawings. Perspective tricks your eyes with the illusion of depth and distance. Understanding perspective is essential to making your backgrounds believable.

One-Point Perspective

One-point perspective converges to a single point. It is commonly seen in drawings of hallways and streets. Use grids as your guideline for the ground and the character's setting. The placement of the vanishing point can be anywhere you choose.

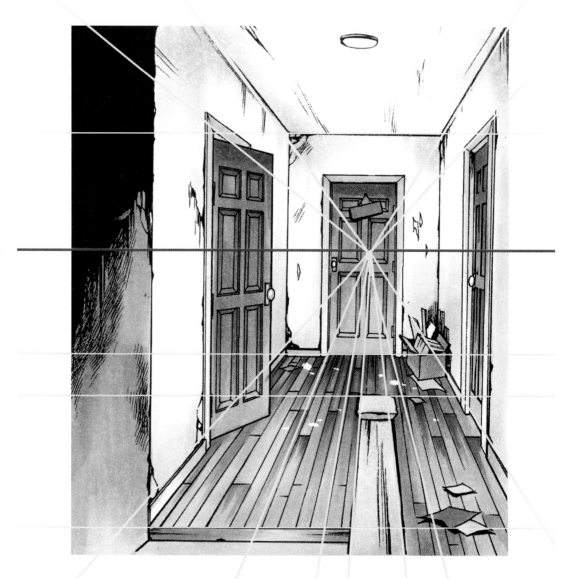

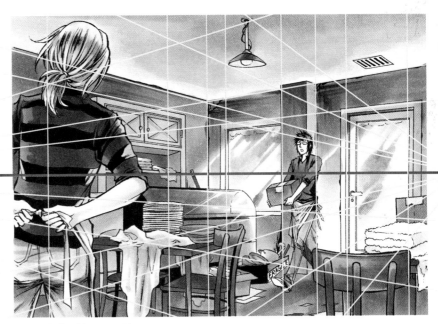

Two-Point Perspective

This type of perspective works when you place another vanishing point on the horizontal line. Here there are two points where the lines of the grid will merge.

Three-Point Perspective

Three-point perspective offers a dramatic view and an increased sense of space. To accomplish this, draw a vertical line that intersects your horizontal plane. Set the third point along that vertical line. Be careful not to place the vanishing points too close to each other or your scene will look too cramped.

Demonstration
PAINTING A SPRING LAKE BACKGROUND

You can play up the distance using color and detail to indicate a deep or shallow perspective.

MATERIALS

COPIC MARKERS
0-Colorless Blender, B000-Pale Porcelain Blue, BG09-Blue Green, BG10-Cool Shadow, BG11-Moon White, BG18-Teal Blue, BG72-Ice Ocean, E25-Caribe Cocoa, E33-Sand, E42-Sand White, E49-Dark Bark, E57-Light Walnut, G000-Pale Green, G12-Sea Green, G21-Lime Green, G29-Pine Tree Green, G82-Spring Dim Green, Y23-Yellowish Beige, Y28-Lionet Gold, YG63-Pea Green, YG67-Moss, YG91-Putty, YR61-Yellowish Skin Pink

OTHER TOOLS
cardstock paper

pencil

eraser

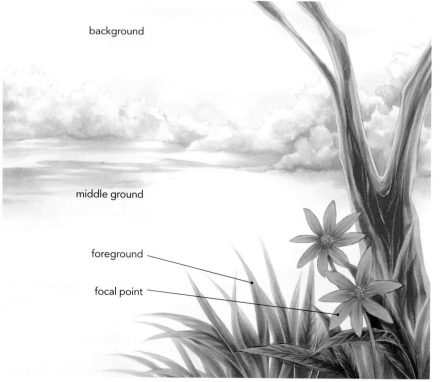

background

middle ground

foreground

focal point

Close Objects Have More Detail
Farther subjects contain a lot less detail than what's closer to your eyes. It's important to choose which subject is your focal point before you start, so you can give all aspects of your background the right amount of detail.

1 SET THE SCENE
Establish the background. Start coloring the farthest subject—in this case, the sky. Blend Pale Green and Pale Porcelain Blue from the top until the colors reach the foliage. Roughly paint the foliage with Moon White.

2 WORK THE MIDDLE GROUND

The middle ground requires more details and color values. Add shadows into the foliage with Moss, and smooth those shadows for a hazy effect with Colorless Blender. Paint another layer on top with Pea Green and coat all of the foliage with Sea Green. Use Ice Ocean to paint dark shadows at the bottom of the foliage. Simply paint the ground with Ice Ocean and Putty.

Establish the reflection of the foliage on the water by painting Lime Green, and soften the color with Colorless Blender until the color become less vivid. For the water, apply Cool Shadow and leave some highlights for water ripples. Paint random shadowy streaks at the top of the lake with Ice Ocean.

3 PAINT THE FOREGROUND

The foreground subjects definitely need more details than the middle ground. Begin to work with the tree bark; use Light Walnut to establish the bark texture. Add vertical streaks in the texture with different colors—Caribe Cocoa and Sand—for more details and values. Entirely coat the bark with Putty. Add some greenish paints with Ice Ocean in the texture. Give details and intensify the bark texture with Dark Bark.

The foreground grass should have darker colors than the foliage in the middle ground. Paint Blue Green at the bottom of each individual leaf and stroke upward until it almost reaches the edges. Smooth with Teal Blue and Pea Green through the end of the edges. After the colors dry, draw smaller veins with Teal Blue for clear details.

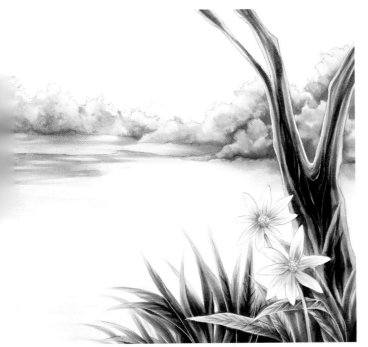

4 COMPLETE THE FOCAL POINT

It's important to give the most detail to the focus of your painting. For the flowers, gradate Sand White at the bottom and Yellowish Beige to the tip of each petal. Use Lionet Gold to create small, detailed streaks on the petal. Paint Yellowish Skin Pink for pollen and darken small details with Lionet Gold.

To make the leaves at the front gain more attention, paint the colors lighter than the grass in the foreground. Apply Pine Tree Green at the bottom of each individual leaf and stroke upward until it reaches about the middle of the leaf. Smooth with a combination of Moss and Spring Dim Green to the edges. Use the same colors on the stems. Draw small veins with Pine Tree Green. The details of the veins should be more detailed and clear than the grass behind.

Demonstration
CREATING A LIGHT-FILLED ATMOSPHERE

Glowing effects are ideal for suggesting a dreamy atmosphere. A soft and warm light from a lantern will make the whole picture look magical. We've already learned how to achieve these delicate effects with a handful of Colorless Blender or rubbing alcohol sprinkled on the picture. Each drop of it will fade the previous colors, and create spots that lighten up the atmosphere.

You can also use this on blues and greens to create bubbles in water.

MATERIALS

COPIC MARKERS
0-Colorless Blender, B000-Pale Porcelain Blue, B01-Mint Blue, B24-Sky, BG18-Teal Blue, C7-Cool Gray No. 7, E07-Light Mahogany, E21-Baby Skin Pink, E30-Bisque, E31-Brick Beige, E34-Orientale, E50-Egg Shell, E55-Light Camel, E93-Tea Rose, E95-Flesh Pink, E97-Deep Orange, E99-Baked Clay, R14-Light Rouge, R37-Carmine, R83-Rose Mist, RV02-Sugared Almond Pink, RV10-Pale Pink, RV99-Argyle Purple, Y00-Barium Yellow, Y23-Yellowish Beige, Y28-Lionet Gold, YG01-Green Bice, YR02-Light Orange, YR21-Cream, YR24-Pale Sepia

OTHER TOOLS
cardstock paper

pencil

eraser

brown or sepia and blue 005 (0.2mm) waterproof, fine-point technical pens (Pigma Micron or Copic Multiliner)

white acrylic paint and a no. 2 round brush (or white gel pen)

rubbing alcohol

1 PAINT THE COLOR BASE
Design the sketch and ink with a brown or sepia 005 (0.2mm) waterproof technical pen. Use Barium Yellow to paint over the entire image. The paint strokes do not have to be neat and perfect, so you can use a larger nib to cover a larger area.

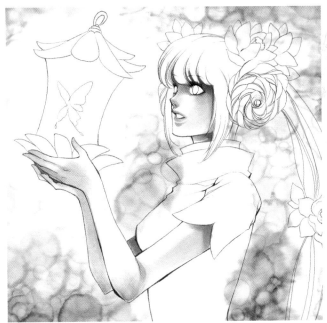

2 PAINT THE SECOND LAYERS

To add variation, choose colors that are in families for the second layer. For this demo, colors that range from yellows to browns are good choices. Paint the background with multiple colors, such as Brick Beige, Orientale, Light Camel, Flesh Pink, Yellowish Beige and Pale Sepia. To achieve the glowing effect of the lantern, leave the surrounding areas around the lamp and the character light. You can paint by either using brush nibs or broad nibs, and the paint strokes don't need to be painted perfectly.

3 CREATE GLOWING EFFECTS

Sprinkle Colorless Blender or rubbing alcohol all over the entire picture. Each drop of Colorless Blender will create spots while also making any imperfect streaks from earlier blend and disappear.

4 ADD MORE GLOW

Drop a couple drops of Egg Shell and Yellowish Beige at the corners of the picture, and then keep sprinkling Colorless Blender on the picture.

5 PAINT HER SKIN

Wait until the colors completely dry, then paint the character's blushing cheeks and lips with Tea Rose and soften the color with Colorless Blender. Apply the same color on her elbows and fingers. For the shadowy areas, add Baby Skin Pink under her bangs, neck and lower lip, on her right arm, and under the sleeve. Then apply Bisque as the middle tone and coat with Egg Shell as the basecoat. Intensify the deepest shadows with Baby Skin Pink.

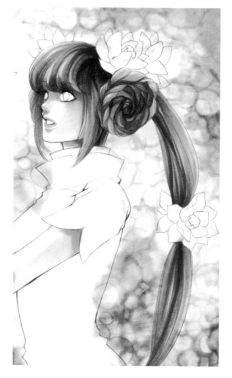
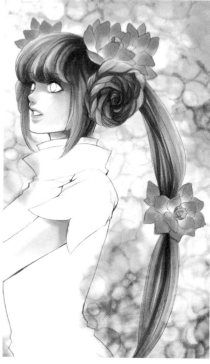

6 WORK ON THE HAIR

To complement her caramel hair, first apply Baked Clay on the hair and braids for shadowy streaks. Use Deep Orange as the second layer and leave some room for shiny highlights at the top of the head, and the sides of the braids. Coat the hair with Yellowish Beige to create highlights. After the colors dry, darken the shadowy streaks with Baked Clay.

7 COLOR THE LOTUS FLOWERS

Start painting the outer tips of the lotus with darker pink. Use Rose Mist to paint the outer tips of the petals, and blend the color inwards with a lighter color such as Sugared Almond Pink or Pale Pink. For the stamen, paint Cream. Create shadows with Lionet Gold.

8 PAINT THE DRESS

Strong, reddish colors will help the character stand out. Create the shadows caused by wrinkles with Argyle Purple. Since the light source comes from the lantern, emphasize the shadows on the right side of the dress. While the color isn't completely dried, soften the edges of the shadows with Colorless Blender. Paint the second layer with Carmine and continue coating the entire dress with Light Rouge. After you finish painting the dress, sprinkle a handful amount of Colorless Blender on the dress for extra texture.

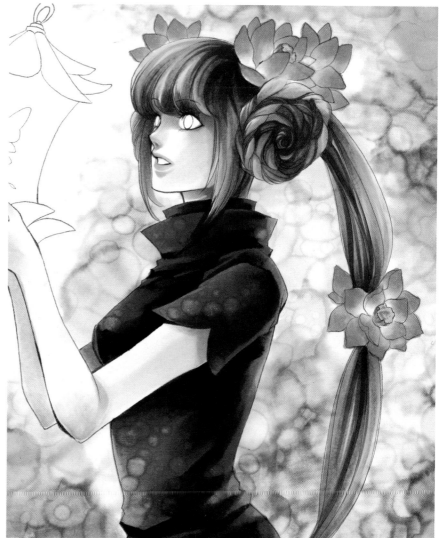

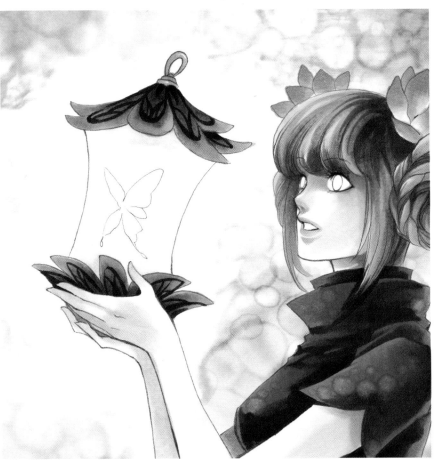

9 FINISH THE LANTERN

Use Light Mahogany on the inner parts of the top and bottom of the lantern. Blend with a lighter color such as Light Orange and Pale Sepia for the outer parts. To keep the patterns sharp and crisp, wait until the colors of the top and bottom completely dry, and then draw the patterns with Cool Gray No. 7.

10 PAINT THE BUTTERFLY

Paint Sky at the outer corners of the butterfly wings and blend with Mint Blue inward. To add subtle patterns on the wings, use a blue 005 (0.2mm) waterproof technical pen to draw on them.

With Pale Porcelain Blue, paint the color around the butterfly. Try to keep the paint within the lantern area. Afterwards, dab Colorless Blender for spotty, glowing effects.

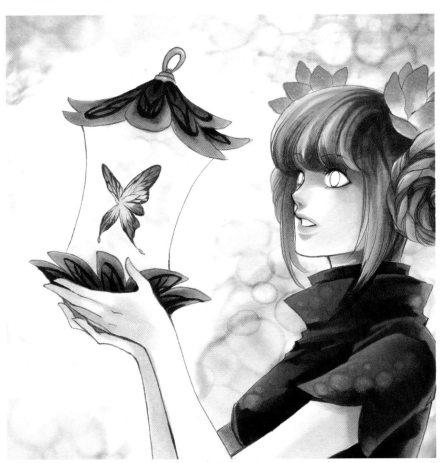

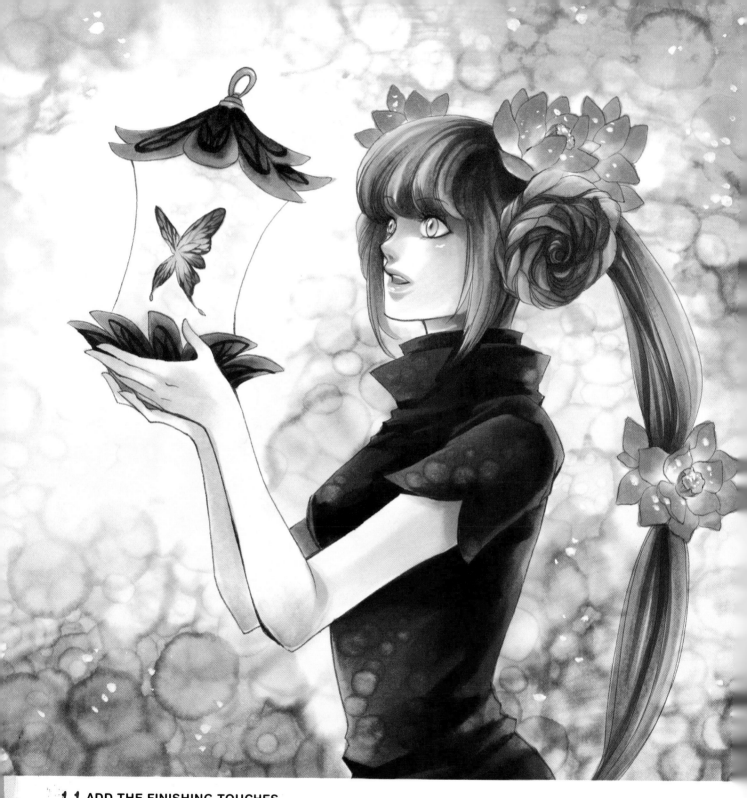

11 ADD THE FINISHING TOUCHES

Finish off with bright green for the eyes, using Green Bice for the irises and Teal Blue for the pupils. With a no. 2 round and white acrylic paint or white gel pen, create reflecting light on her nose, cheeks, lips and eyes. Randomly sprinkle white paint on the background for more sparkling glow.

Demonstration
DEEP OCEAN SCENE

We've learned how to use Colorless Blender or rubbing alcohol to create bubbles, but that's not the only technique we can use to apply texture to the background. Throughout this tutorial, the following steps will teach you how to use glazing medium and masking fluid (liquid frisket) with markers.

COPIC MARKERS
0-Colorless Blender, B00-Frost Blue, BG13-Mint Green, B23-Phthalo Blue, B32-Pale Blue, B52-Soft Greenish Blue, B93-Light Crockery Blue, B95-Light Grayish Cobalt, BG11-Moon White, BG13-Mint Green, BG49-Duck Blue, BG72-Ice Ocean, BV20-Dull Lavender, E21-Baby Skin Pink, E30-Bisque, E35-Chamois, E44-Clay, E50-Egg Shell, E97-Deep Orange, G00-Jade Green, V04-Lilac, Y00-Barium Yellow, Y23-Yellowish Beige, Y26-Mustard, Y28-Lionet Gold, Y38-Honey, YG41-Pale Cobalt Green, YG93-Grayish Yellow, YR21-Cream

DRAWING TOOLS
cardstock paper

pencil

eraser

gray 005 (0.2mm) waterproof, fine-point technical pen (Pigma Micron or Copic Multiliner)

PAINTING TOOLS
Turquoise fluid acrylic paint

white acrylic paint and a no. 2 round brush (or white gel pen)

1-inch (25mm) flat

masking fluid (liquid frisket)

worn-out no. 2 round

glazing medium

rubbing alcohol

rubber cement eraser

1 BLEND THE COLOR BASE
Sketch your figure with a gray 005 (0.2mm) waterproof technical pen; create flowing clothing and hair to indicate an underwater scene. Quickly blend Jade Green, Frost Blue and Pale Blue downward from the top to the bottom of the picture. Do not worry if the brushstrokes are rough and sketchy.

2 MAKE BUBBLE EFFECTS
Sprinkle Colorless Blender or rubbling alcohol all over the entire picture. Use an inexpensive or worn-out brush to dip into Colorless Blender and drop it on some specific areas of your choice.

3 PAINT THE SKIN
After the entire background dries completely, paint the shadowy areas under his neck, lower lip, necklace and armpits with Baby Skin Pink. Then apply Bisque as the middle tone to indicate muscles. Coat the entire skin with Egg Shell.

4 APPLY BLUE SHADES TO SHADOWS
Adding a hint of blue in the skin helps the character stand out. With Frost Blue and Moon White, paint on the shadowy areas. Be careful not to overpaint since we still want the actual skin color to show through.

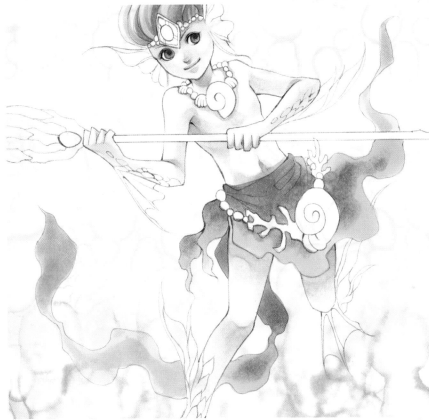

5 PAINT THE HAIR AND EYES

Use Yellowish Beige for shadowy streaks on the hair then coat with Barium Yellow. Once the colors are dry, apply Moon White and Ice Ocean on top of the shadowy streaks. Keep Ice Ocean, a darker shade, at the bottom, and the lighter shade, Moon White, at the tips of the hair.

For the eyes, paint Mint Green on the irises, and then follow with Duck Blue for the pupils.

6 APPLY COLOR BASE TO THE CLOTHES

Use Grayish Yellow on the areas close to his hip. Blend with Pale Cobalt Green, Frost Blue, and Light Crockery Blue at the edges until they run together smoothly.

7 DARKEN THE FOLDS

Pick darker shades of blue or green for the folds. Paint with Ice Ocean, and deepen some of the shadows with a darker shade such as Phthalo Blue.

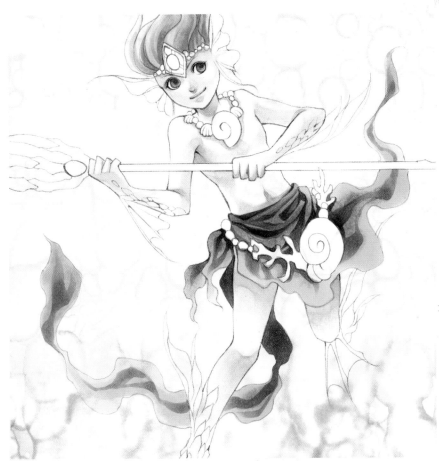

8 PAINT THE FINS AND SCALES

From the edges of the fins, gradate Soft Greenish Blue and Moon White until the colors reach the skin parts. After the colors dry, intensify shadows and details by using Light Grayish Cobalt. Use the color to create the depth in between each scale and fin line.

9 ACCESSORIZE

To add some contrast, apply Deep Orange for shadows on the corals. Afterwards, coat the corals with Cream. For the spiral seashells, first apply Chamois at the sides of the seashells. Leave plenty of spaces at the center for another layer you'll fill in later. Paint Honey on top and smooth with Chamois. Be careful to leave some tiny highlights at the center.

Once the colors are dry, use Lilac to create a pattern on the seashells. For the small seashells, blend Dull Lavender and Frost Blue together. To color the pearls, use the same colors that you paint on the small seashells, except leave some small dots on top of the pearls for shining highlights.

Use Lionet Gold to paint shadows on the golden plate, then coat those areas with Yellowish Beige. Darken the shadows again with Mint Green. For the gem at the center, dot the shadow with Duck Blue. Paint the whole gem with Mint Green and leave a highlight at the top.

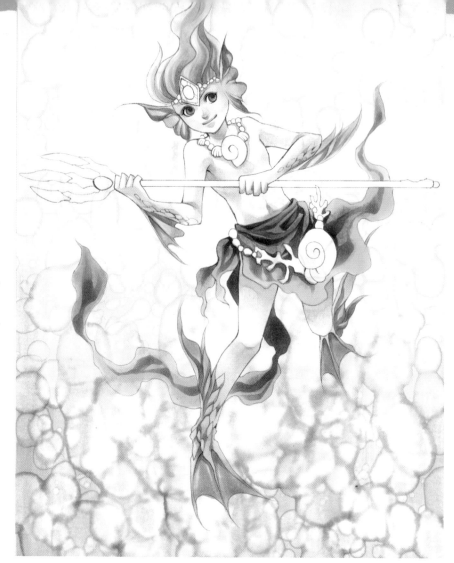

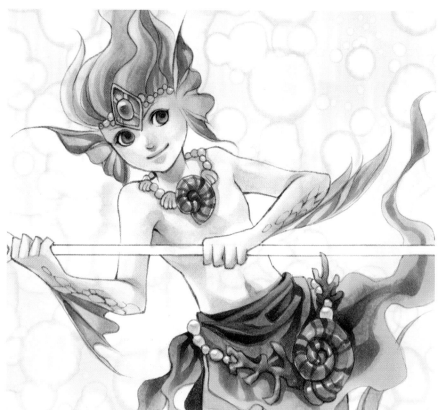

Visit impact-books.com/wonder-manga for a **free** bonus demonstration

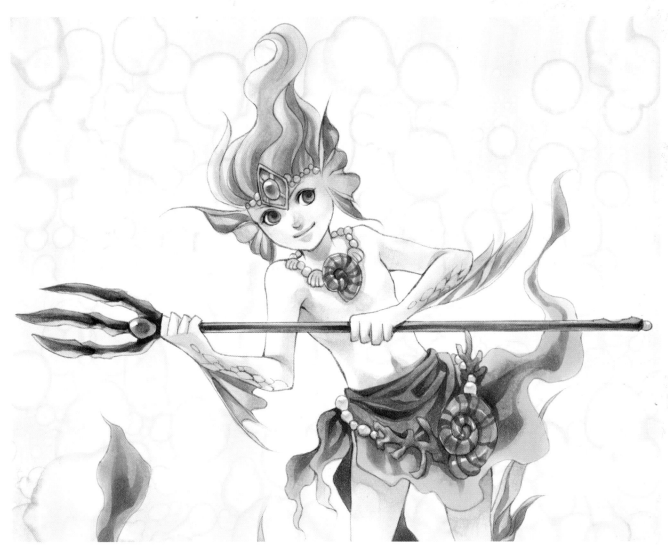

10 COLOR THE TRIDENT

With Clay, apply shadows on the trident. Leave some unpainted spaces at the sides for highlights and reflecting light. Use Mustard on the top side and Moon White at the bottom. To match the gem's color, use Duck Blue for the shadow and paint Mint Green on top. Leave some highlight as well.

11 APPLY MASKING FLUID

Use masking fluid and any inexpensive or worn no. 2 round to paint coral shapes at the bottom of the picture. Masking fluid tends to stick to bristles once it dries, so rinse your brush as soon as you finish using it.

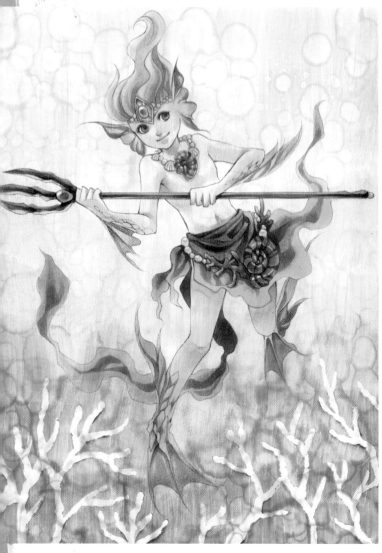

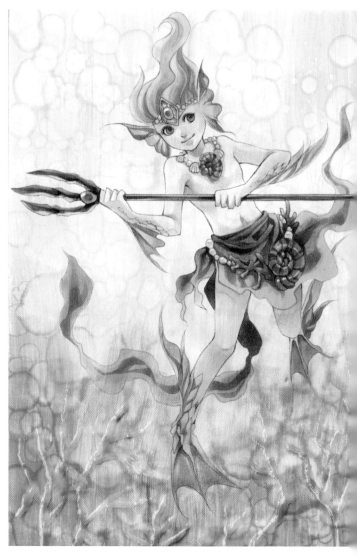

12 PAINT GLAZING MEDIUM
The glazing medium helps create texture and make colors become more intense. After the masking fluid dries (it will not stick to your fingers when you touch it), mix a very small amount of Turquoise fluid acrylic paint with glazing medium until it turns transparent light bluish-green. With a 1-inch (25mm) flat, paint this mixture on top of the picture. To darken at the bottom, continue adding multiple layers.

13 REMOVE THE MASKING FLUID
Remove the masking fluid with a rubber cement eraser. The rubber cement eraser will pick up the masking fluid and reveal the paint underneath.

14 FINALIZE DETAILS
With a no. 2 round and white acrylic paint or a white gel pen, paint the final touch-ups. Give extra highlights on his eyes, the tip of his nose, and his lips. Finally, sprinkle multiple dots as bubbles over the picture.

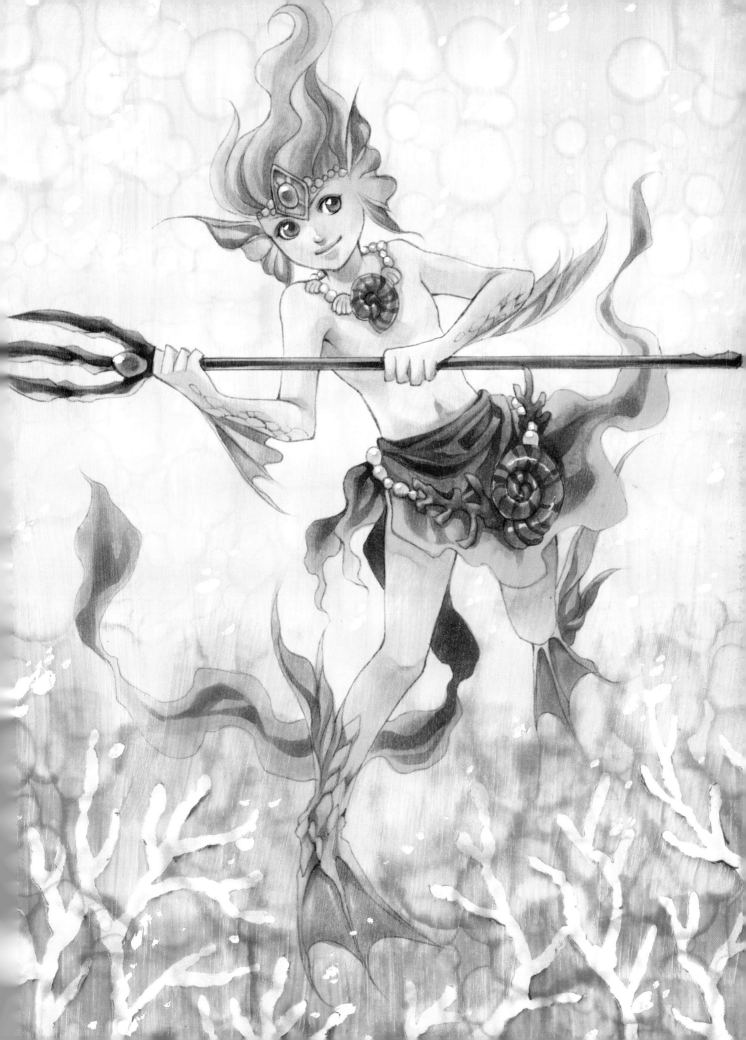

Demonstration
COMBINING MARKERS AND PAINT

While markers deliver the vivid, translucent quality of watercolor, acrylic mediums offer unique effects to your illustrations. The delicate mixture of markers and paint will make your characters and background really come alive.

MATERIALS

COPIC MARKERS
0-Colorless Blender, B21-Baby Blue, B23-Phthalo Blue, B24-Sky, B28-Royal Blue, B39-Prussian Blue, B60-Pale Blue Gray, B93-Light Crockery Blue, BG000-Pale Aqua, BG02-New Blue, BV000-Iridescent Mauve, BV20-Dull Lavender, BV23-Grayish Lavender, BV29-Slate, C4-Cool Gray No. 4, E000-Pale Fruit Pink, E11-Bareley Beige, E15-Dark Suntan, E18-Copper, E30-Bisque, E31-Brick Beige, E33-Sand, E35-Chamois, E42-Sand White, E59-Walnut, R11-Pale Cherry Pink, RV00-Water Lily, RV09-Fuchsia, RV21-Light Pink, RV32-Shadow Pink, V93-Early Grape, Y23-Yellowish Beige, YR14-Caramel

ACRYLICS
Naphthol Red Light, Titanium White, Ultramarine Violet, Yellow Ochre

FLUID ACRYLICS
Alizarin Crimson Hue, Transparent Yellow Iron Oxide

DRAWING TOOLS
cardstock paper

pencil

eraser

brown and gray 005 (0.2mm) water-proof, fine-point technical pens (Pigma Micron or Copic Multiliner)

gold marker pen (Sakura Pen-touch Gold 0.7mm)

PAINTING TOOLS
nos. 2 and 4 rounds

1-inch (25mm) flat

crackle paste and Kroma Crackle Medium

glazing medium

1 SKETCH AND INK
Sketch the overall composition and ink with a gray 005 (0.2mm) waterproof technical pen on the main character's hair, wings and dress. The rest of the illustration (except the flowers in the background, which we'll leave in pencil) will be inked by a brown 005 (0.2mm) waterproof technical pen.

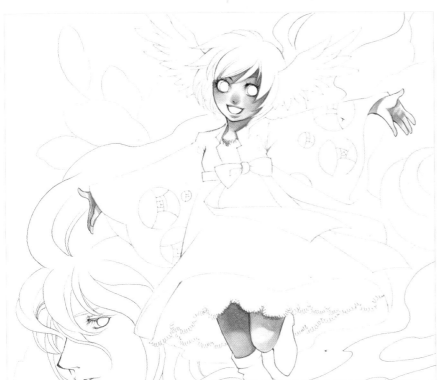

2 COLOR THE PRIMARY CHARACTER'S SKIN

For healthy blushing cheeks, paint the areas with Pale Cherry Pink and soften with Colorless Blender. Apply the same color to her fingers. Use Bareley Beige for shadows under her bangs, neck, lower lip, and hands and thighs. Apply Bisque as the middle tone and coat with Pale Fruit Pink.

Add depth to the skin with purple. With Iridescent Mauve, coat the entire area of her right thigh. Intensify the shadowy areas with Early Grape.

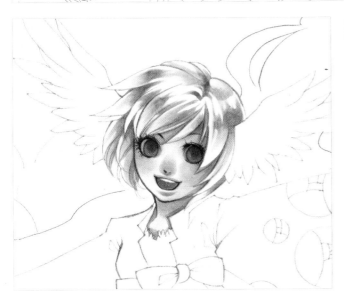

3 PAINT THE HAIR AND EYES

Create shadowy streaks at the center of the hair with Cool Gray No. 4. Make sure to leave plenty of white spaces. Smooth the edges of lower streaks with Dull Lavender and blend it with Water Lily, a really light pink shade, to the edges. Let some white spaces show through for shining highlights.

For the eyes, paint Fuchsia on the irises and Light Pink for the pupils.

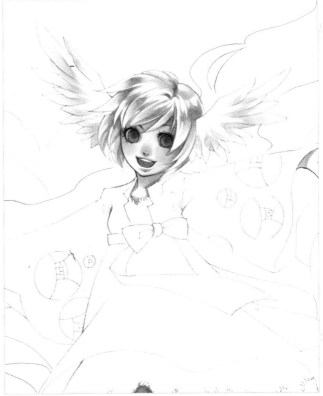

4 PAINT THE WINGS

Suggest individual feathers and apply shadows on the wings with Dull Lavender. After that, smooth the streaky edges of Dull Lavender with Pale Blue Gray and give a hint of blue with Pale Aqua.

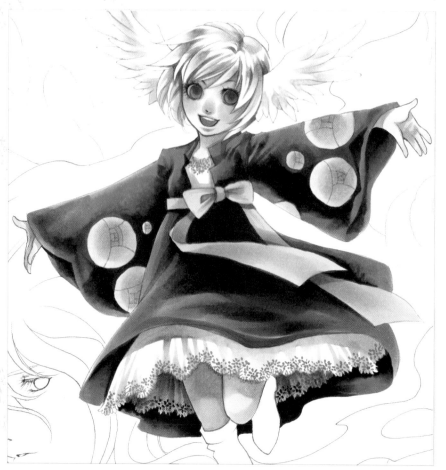

5 ADD COLOR TO HER CLOTHES

Start with the dress. Use Prussian Blue for shadowy wrinkles on the sleeves and skirt. Soften some of the wrinkle edges with Colorless Blender. Paint Royal Blue on top as the second layer and coat the entire dress with Sky. To add a hint of pink in the circular rose patterns, use Shadow Pink to at the center and soften with Colorless Blender. Paint Baby Blue on top of the pattern. The ribbon should be in the same color family but more bright than the dress. Use New Blue for the ribbon. Refine its shadows and wrinkles with Phthalo Blue and Light Crockery Blue.

Use Pale Blue Gray to paint the folds of the petticoat. Apply a darker shade for the folds with Dull Lavender. For the inner areas, gradate Grayish Lavender and Dull Lavender downward to the edges of the petticoat. To indicate delicate details on the lace, create a set pattern of dots with Grayish Lavender and Slate.

6 COMPLETE THE BOOTS

Her boots do not need to be super fancy. Apply Copper for the shadows of the boots. Soften the color with Colorless Blender on the areas you desire, then coat the entire boot with Dark Suntan.

7 ESTABLISH THE SECOND CHARACTER

Choose a warm, monotone palette for the character at the back. Apply shadows on her hair with Brick Beige and Sand White on her face. Soften some of the edges with Colorless Blender. For the clothes, paint Walnut for the deepest shade first and follow with Chamois for the second layer.

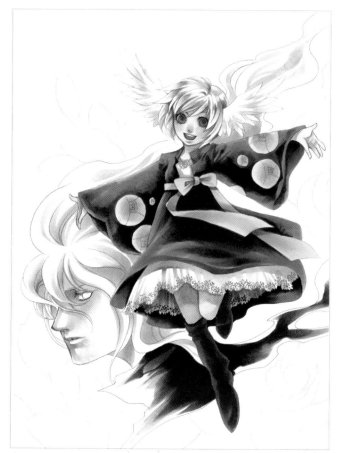

Visit impact-books.com/wonder-manga for a **free** bonus demonstration

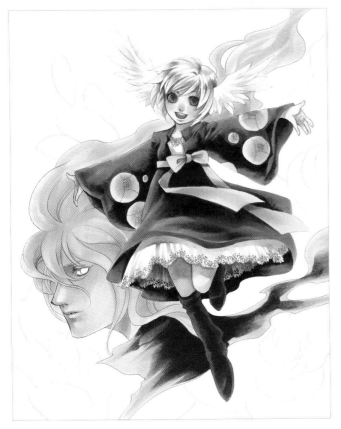

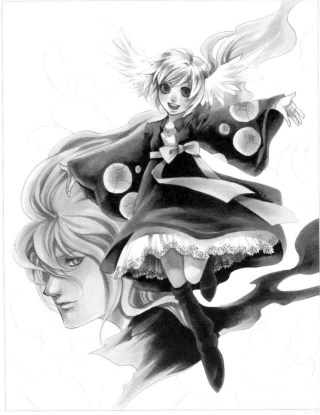

8 APPLY THE BASECOAT
Pick a relative color such as Yellowish Beige and paint the entire character except for the eyes.

9 REFINE THE COLORS
Darken the swirl at the bottom with Caramel. Blend the color outward. Refine more with Brick Beige and Sand. To match the eye with the colors of the main character's dress, delicately paint New Blue on the irises and Sky for the pupils.

10 APPLY ACRYLIC PAINTS
We'll begin working with acrylic paints first. Apply Naphthol Red Light (or any red shade) with a no. 4 round on some petals. Use different lighter and darker colors for more variety. Mix Naphthol Red Light with Titanium White for a lighter color, and Naphthol Red Light and Ultramarine Violet for a darker color. The colors should remain separate—do not blend.

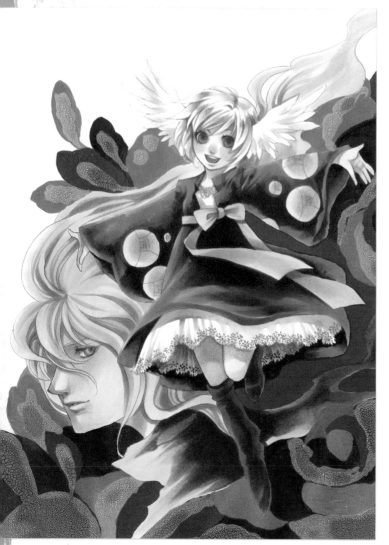

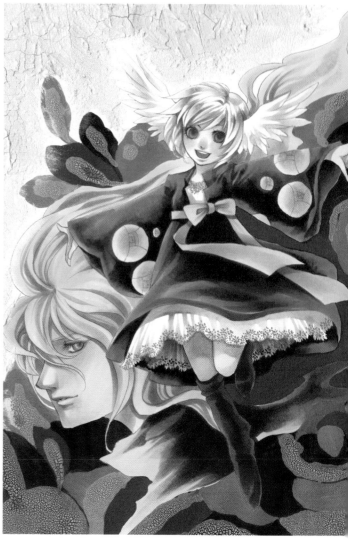

11 CREATE CRACKLE TEXTURES
Mix Kroma Crackle Medium with Yellow Ochre. Pick some selective areas such as the swirls of the background and apply the mixed crackle paint with a no. 4 round. Let the medium dry completely until you see the cracks appear. This might take several hours (or up to two days) depending on the thickness of your medium.

12 APPLY CRACKLE PASTE TO THE BACKGROUND
Crackle paste is different from Kroma Crackle Medium. The paste itself is more opaque, creamy and thick, and it creates a different crackling texture. Mix crackle paste with Yellow Ochre. Use a 1-inch (25mm) flat brush to apply the paste on the blank background. Leave the paste to completely dry until the cracks appear (this might take up to several hours).

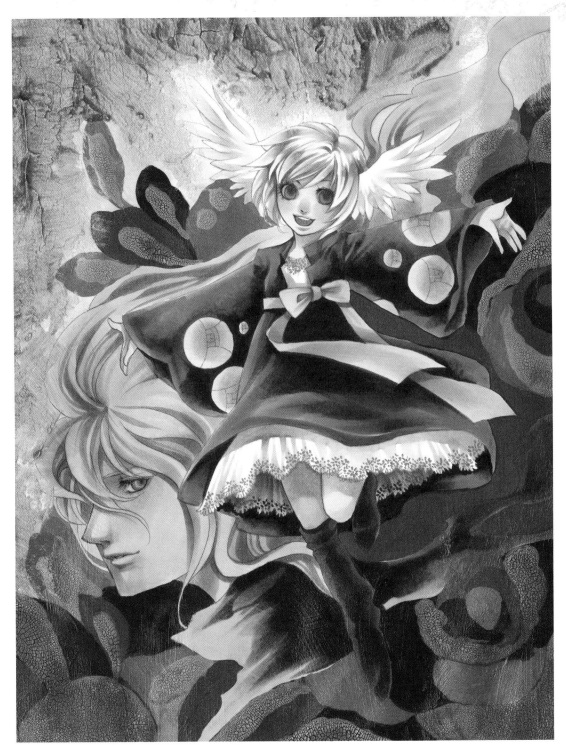

13 INTENSIFY THE BACKGROUND

Mix fluid acrylic Transparent Yellow Iron Oxide with glazing medium. Apply with a 1-inch (25mm) flat on top of the background, including the background figure. Darken the edges of the picture with a mixture of Alizarin Crimson Hue and glazing medium. This will not only intensify the colors of the background but seal the cracking flakes.

14 FINALIZE DETAILS

With an opaque gold marker pen, create golden swirl patterns on her sleeves and skirt. Refine the lines of the roses. Finish the picture by marking the highlight on the eyes, circle patterns on the sleeves and edges of the petticoat with white acrylic paint and a no. 2 round or a white gel pen.

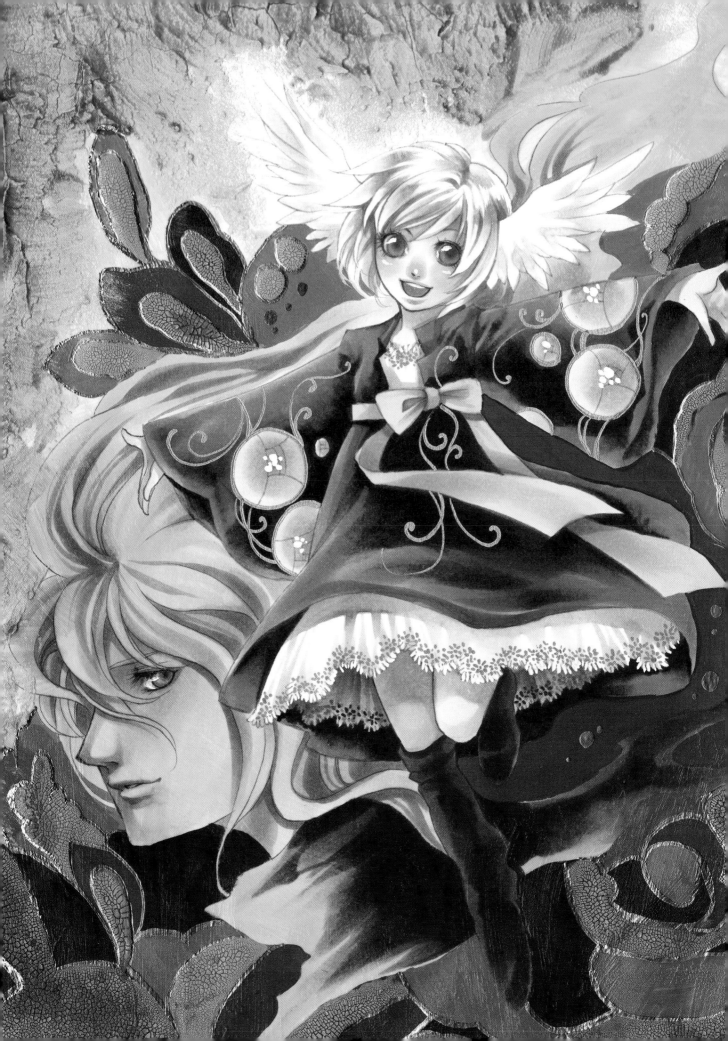

Demonstration
THE TRAVELER

Now that you're familiar rendering distance in scenery, let's build a more detailed setting. Here we'll develop the three distinct areas of foreground, middle ground and background to help tell a story.

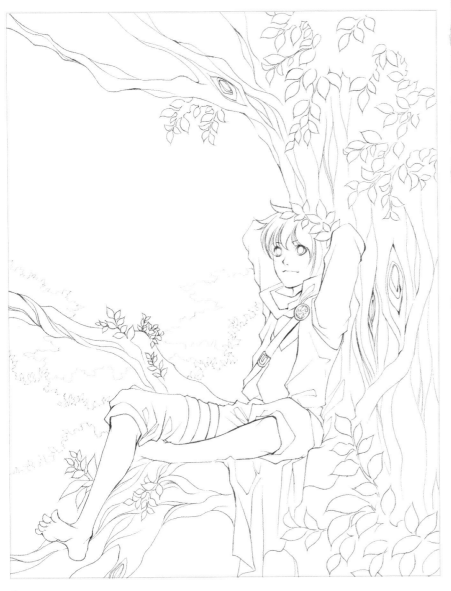

MATERIALS

COPIC MARKERS
0-Colorless Blender, B00-Frost Blue, B02-Robin's Egg Blue, B23-Phthalo Blue, B24-Sky, B32-Pale Blue, BG09-Blue Green, BG11-Moon White, BG13-Mint Green, BG49-Duck Blue, BG72-Ice Ocean, BG99-Flagstone Blue, E11-Bareley Beige, E15-Dark Suntan, E17-Reddish Brass, E30-Bisque, E33-Sand, E35-Chamois, E44-Clay, E49-Dark Bark, E50-Egg Shell, E55-Light Camel, E57-Light Walnut, E59-Walnut, E99-Baked Clay, G000-Pale Green, G05-Emerald Green, G29-Pine Tree Green, R08-Vermilion, R14-Light Rouge, R37-Carmine, R89-Dark Red, Y26-Mustard, YG23-New Leaf, YG25-Celadon Green, YG17-Grass Green, YG41-Pale Green, YG95-Pale Olive, YG97-Spanish Olive, YR14-Caramel, YR21-Cream

ACRYLICS
Brilliant Yellow Green, Hansa Yellow

OTHER TOOLS
cardstock paper

pencil

eraser

Col-Erase blue pencil

brown and gray 005 (0.2mm) waterproof, fine-point technical pens (Pigma Micron or Copic Multiliner)

white acrylic paint and a no. 2 round brush (or white gel pen)

1 CREATE THE DRAWING
Start off with the sketch first. We will divide the entire piece into three sections: foreground, middle ground and background. Pay most attention to the foreground's details such as the individual leaves, small branches, and bark pattern. Ink with a brown 005 (0.2mm) waterproof technical pen on the main character and the tree. For the foliage in the middle ground, ink with a gray 005 (0.2mm) waterproof technical pen. Sketch the furthest foliage in the background with a blue pencil.

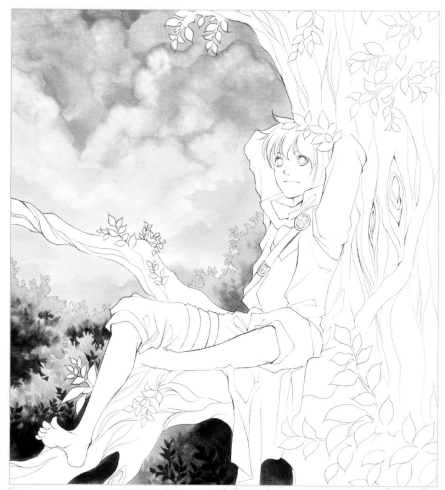

2 COLOR THE SKY

For the sky, blend Sky, Pale Blue and Frost Blue from the top down to the bottom on the background's areas. Let the paint overlap the foliage in the background. After the colors dry, use plenty of Colorless Blender to create cumulus clouds. Colorless Blender will push the colors away and make the clouds look fluffy.

3 PAINT THE BACKGROUND FOLIAGE

Apply Moon White on the foliage in the back. Leave the foliage plain in color and barely detailed.

4 PAINT THE MIDDLE GROUND FOLIAGE

At the bottom of the foliage, use Pine Tree Green to paint shadows. Apply Grass Green as the middle tone and coat it all with Pale Green. At this point, the details in the middle ground can be more refined than the background, but they don't need to be overly detailed. With Pine Tree Green and Grass Green, simply create leaves and small branches on the foliage.

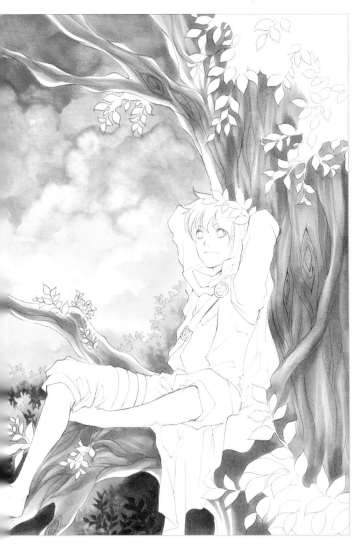

5 **ESTABLISH THE COLOR BASE OF THE BARK**
Apply shadows and bark patterns with Chamois. The shadows should follow the twisted shape of the bark. To soften the shadows, paint Light Camel on top. Make sure to leave some room for reflected light on the sides of the branches.

6 **SHOW THE REFLECTED LIGHT ON THE BARK**
On the top branches, use Frost Blue to depict reflected light from the sky. Apply the same color on the middle branch. For the lower branches, since they are close to the foliage, paint Moon White on the reflected light area and lightly on top of the major bark.

7 DETAIL THE BARK

Emphasize the details of the bark with darker shades of brown. Use Light Walnut to make texture details. If you want to soften the darkest shade, pick some lighter browns such as Dark Suntan and Reddish Brass and blend these colors with the darker shade. At the top right of the picture, paint shadows cast from the leaves with Clay. Apply the same color on the areas where the character is sitting.

8 PAINT THE FOREGROUND LEAVES

Establish the color base for the foreground leaves first. Paint Spanish Olive as shadows in leafy shapes, and then soften them with Colorless Blender. After the color dries, paint Celadon Green on top of the leaves, including the small ones on the branches.

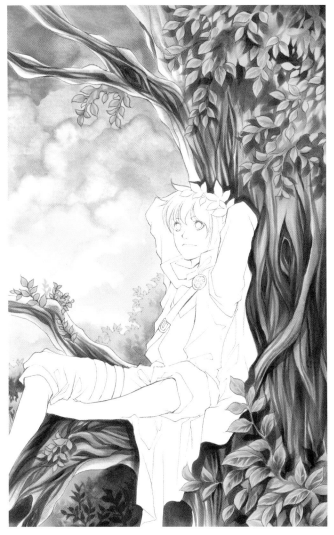

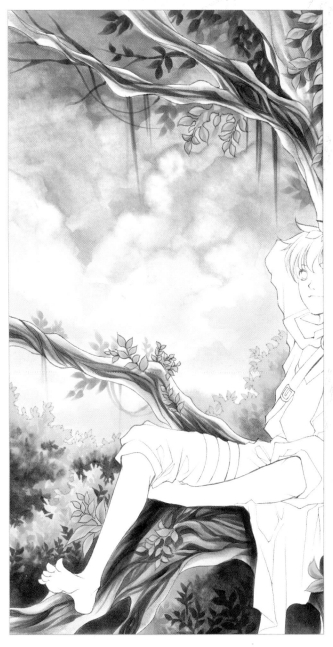

9 FINISH THE FOREGROUND LEAVES

For leaves close to the viewer at the bottom right, carefully paint the small veins with Duck Blue and Emerald Green. Use the same colors to paint on the top leaves, but these don't need to be as refined as the bottom ones. To make the leaves pop, paint Blue Green for the darkest shadows and Mint Green as lighter shadows between leaves.

10 ADD DISTANT BRANCHES, LEAVES AND VINES

Adding distant foliage helps the balance of the tree and the entire background. Use Duck Blue to paint distant foliage and branches behind the top branches. For the middle branch, create small leaves and vines with Mint Green and Ice Ocean.

11 PAINT THE SKIN

Use Bareley Beige for shadows on the figure's skin. Apply the middle tone with Bisque and make sure to leave some unpainted space for reflected light. Coat the entire skin with Egg Shell. To apply greenish shadows and reflected light, use Ice Ocean on the deepest shadows of his skin. Color the reflected light areas with Pale Green.

12 COLOR THE HAIR AND EYES

Paint the dark streaks and shadowy areas where the leaves cover the head with Phthalo Blue. Apply Robin's Egg Blue as the second layer and leave shiny highlights at the center of the strands. For the eyes, apply Cream for his irises and Caramel for the pupils.

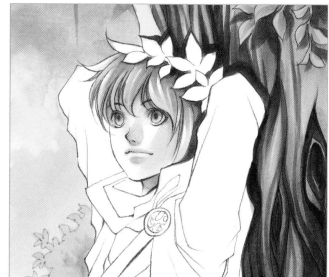

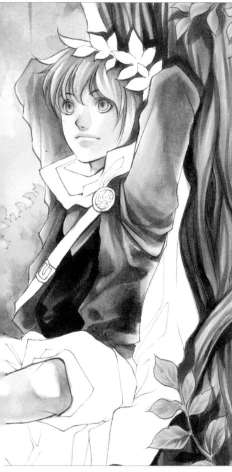

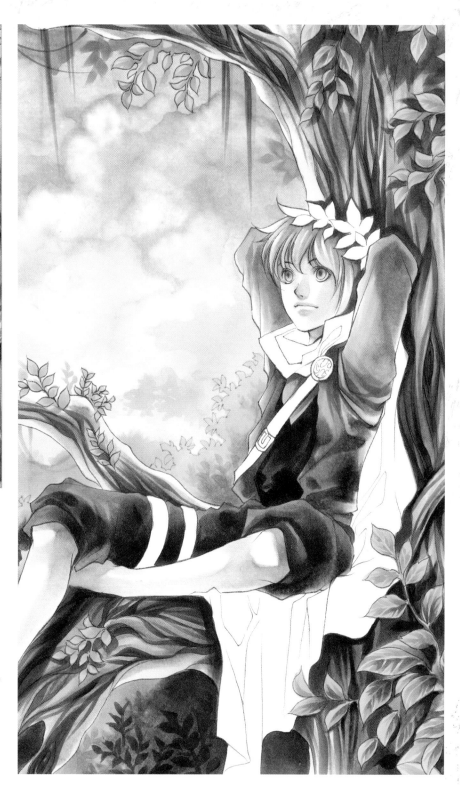

13 PAINT HIS CLOTHES

Start off with his tunic; paint Sand on the fabric as shadowy wrinkles and soften the color with Colorless Blender. Coat the entire garment with Mustard. Remember to leave some unpainted areas on the right for reflected light. Establish shadowy wrinkles on his jacket by painting Flagstone Blue. Paint another layer on top with Pale Olive. For his vest, paint Dark Bark as shadows and then coat on top with Walnut.

For the reflected light, use Moon White on unpainted areas on the right.

14 COLOR THE PANTS

Apply Walnut as shadowy wrinkles on his pants. Soften the color with Colorless Blender, and then color the basecoat with Caramel.

15 COLOR THE CLOAK

To make the character stand out more, use strong color for his cloak. Add Dark Red to the shadows on the cloak to create drapes and folds. Soften the color with Colorless Blender, and then blend from top to bottom with Vermilion and Light Rouge. Wait until the colors dry, then refine those shadowy folds with Carmine and Dark Red.

16 FINISH THE SMALL DETAILS

Begin to color the straps at the legs and belt with Baked Clay, and then apply Sand on top. Use Cream to color his pin and belt buckle. For the wreath, paint Grass Green on the bottom of the leaves. Smooth the color at the edges of the leaves with New Leaf.

17 FINALIZE THE DETAILS

Use acrylic paint on the parts where markers will no longer show. Mix Hansa Yellow and Brilliant Yellow Green together (or any light yellow or green acrylic paints) and paint additional leaves on the foliage and branches and random vines.

With a no. 2 round and white acrylic paint or a white gel pen, make simple shapes of a flock of birds flying in the sky. Also create the highlight on the eyes, the tip of the nose, and the left side of the figure where the light is hitting.

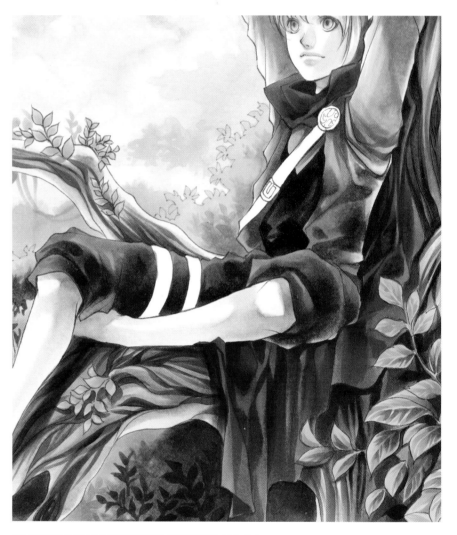

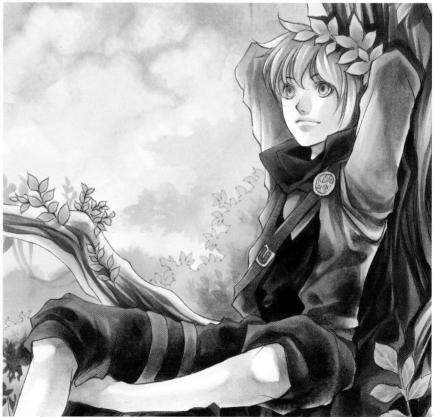

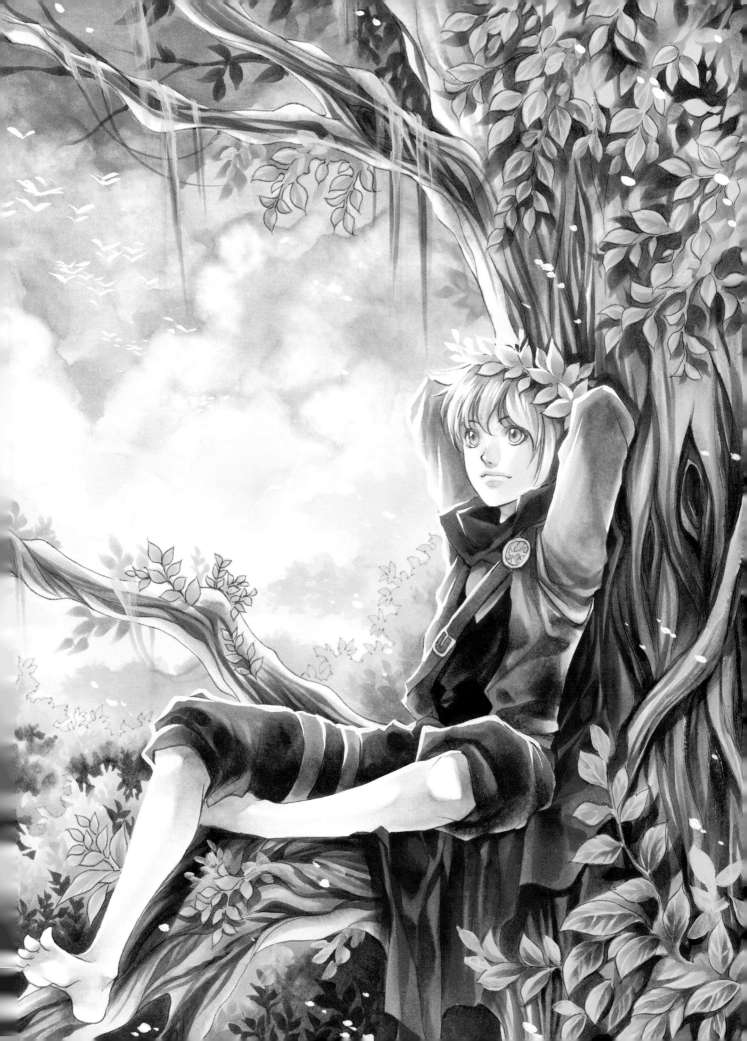

Demonstration
NAILING PERSPECTIVE IN NO NAME CAFÉ

Tucked away in the big city, if you know where to look, you can find a great little diner called the No Name Café. This café's employees, Lawrence, Edmond, Jonathan and Ethan, dish out more than good food—it's an out of this world experience. Though there's a lot happening in this perspective scene, once you decide what elements you really want to show, it's a piece of cake to organize.

## MATERIALS

COPIC MARKERS

0-Colorless Blender, B000-Porcelain Blue, B04-Tahitian Blue, B32-Pale Blue, B41-Powder Blue, B45-Smoky Blue, B63-Light Hydrangea, B93-Light Crockery Blue, BG01-Aqua Blue, BG09-Blue Green, BG13-Mint Green, BG72-Ice Ocean, BG78-Bronze, BV000-Iridescent Mauve, BV20-Dull Lavender, BV23-Grayish Lavender, C2-Cool Gray No. 2, C4-Cool Gray No. 4, C5-Cool Gray No. 5, C6-Cool Gray No. 6, C7-Cool Gray No. 7, C8-Cool Gray No. 8, C10-Cool Gray No. 10, E000-Pale Fruit Pink, E11-Bareley Beige, E17-Reddish Brass, E18-Copper, E21-Baby Skin Pink, E25-Caribe Cocoa, E30-Bisque, E31-Brick Beige, E33-Sand, E42-Sand White, E43-Dull Ivory, E50-Egg Shell, E71-Champagne, G21-Lime Green, G29-Pine Tree Green, G99-Olive, R08-Vermilion, R14-Light Rouge, R59-Cardinal, V93-Early Grape, V95-Light Grape, YB00-Barium Yellow, Y11-Pale Yellow, Y23-Yellowish Beige, Y28-Lionet Gold, YG00-Mimosa Yellow, YG03-Yellow Green, YG13-Chartreuse, YG41-Pale Green, YG45-Cobalt Green, YG67-Moss, YG91-Putty, YR02-Light Orange, YR21-Cream, YR61-Yellowish Skin Pink, YR65-Atoll, YR82-Mellow Peach

OTHER TOOLS

cardstock paper

pencil

eraser

brown 005 (0.2mm) waterproof, fine-point technical pens (Pigma Micron or Copic Multiliner)

white acrylic paint and a no. 2 round brush (or white gel pen)

1 SET THE SCENE

Let's work on one-point perspective for the interior of the café. After sketching the background and lining up the horizontal line, place characters there in different positions. Use a standing character as your guideline (Lawrence, who is standing at the back), and adjust the other characters' heights and positions accordingly. Ink the entire drawing with a brown 005 (0.2mm) waterproof technical pen.

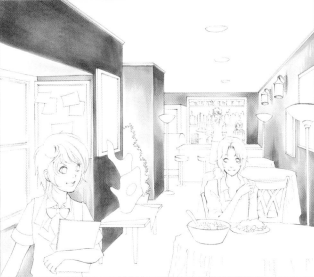

2 PAINT THE WALL

Use Yellowish Beige to paint the wall in the background.

3 DARKEN THE SHADOWS

After the basecoat dries, use Light Grape for the darkest areas, like the corners on the right wall. Paint Early Grape as the second layer for lighter shadows on the back wall and the corners, and the areas around picture frames. For the wall at the left that doesn't face the sunlight directly, blend Light Grape and Sand from top to bottom.

4 PAINT THE CEILING AND FLOOR

Since the light source is from the left, the right areas of the ceiling should be darker. Blend the colors from left to right with Bisque and Sand White, which is darker than Bisque. Blend the colors together until they are smooth.

For the floor, blend Bisque, Putty and Lime Green from top to bottom. Leave the green shades in the foreground.

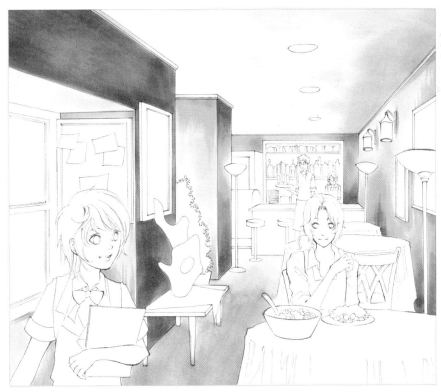

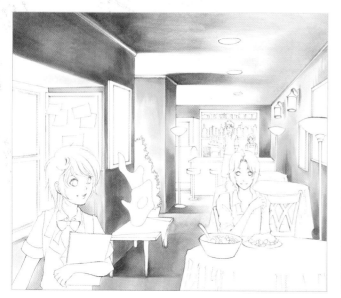

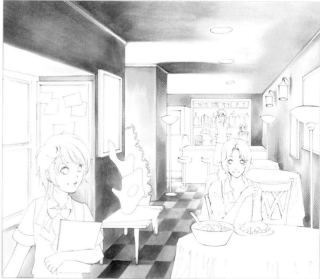

5 ADD CAST SHADOWS

On the ceiling areas where the wall blocks the sunlight, paint cast shadows by blending Grayish Lavender and Dull Ivory from left to right. Follow the same directions on the floor with Grayish Lavender and Putty.

6 PAINT THE TILES

For the floor, create tile patterns from the vanishing point and horizontal grids. Pick different shades of green with a range of light and dark. Paint Sand on the few blocks at the bottom and then add another layer on top with Ice Ocean. Color the other blocks moving toward the center with Ice Ocean until almost reaching the top areas. Use Pale Green on the blocks in the background.

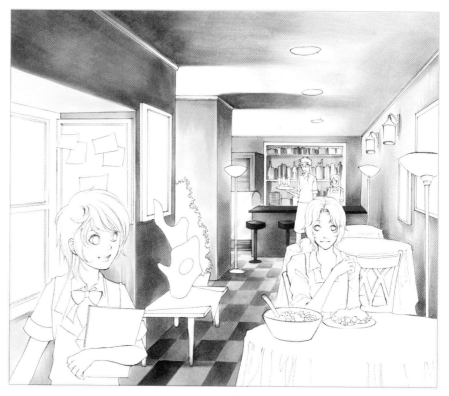

7 PAINT THE ITEMS AT THE BAR

It's better to keep the items at the back simple. Paint the cabinet at the left with Brick Beige and add shadows with Champagne. The bakery display case needs reflection on its glass; use Dull Lavender to create reflecting streaks. Paint Cool Gray No. 4 on the bottom of the case and follow with Cool Gray No. 6 for shadows. Light color is a good choice for the shelf, so apply Egg Shell on the areas and paint shadows with Brick Beige and Champagne on darker shadows. Paint the items on the shelf with Light Crockery Blue, Cool Gray No. 4 and Lime Green.

From left to right, blend Light Orange and Light Rouge on the countertop and chair seats. Apply shadows on the areas with Cardinal. Paint the counter itself with Cool Gray No. 4 and apply a hint of brown by coating Brick Beige on top as the second layer. Paint Cool Gray No. 6 on the chair legs with Light Rouge at the bottom.

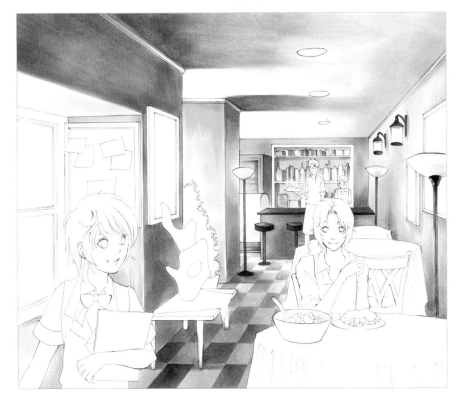

8 PAINT THE LIGHTS

Apply Cream at the bottom of the lamp shades. Use Colorless Blender to soften that before coating with Pale Yellow. Use the same steps on the wall lamps and the ceiling lights. Paint Cool Gray No. 6 on the lamp stands and lamp arms on the wall. For the lamp stand closest to the viewer, use Cool Gray No. 8 at the center of the stand as the darkest shadow, and then coat the entire area with Grayish Lavender.

9 APPLY COLORS TO DETAILS

For the painting frames, use whatever colors you have and paint them in any style. Paint Reddish Brass on the picture and bulletin frames to depict mahogany. Wait until the color dries to add Copper on top as shadows. For the bulletin board, blend Ice Ocean and Bronze from top to bottom. Leave the darker color at the bottom of the board. Use bright, vivid colors for the sticky notes—Barium Yellow, Mimosa Yellow and Mellow Peach. Create scribbles on top of those sticky notes with Sand. Apply Bronze for cast shadows behind them.

Paint the streaky shine on the window with Powder Blue and Porcelain Blue. Use Brick Beige on the picture frames and add another layer with Sand and Light Grape on top as shadows.

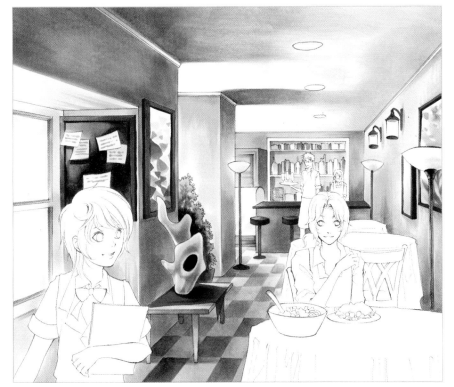

10 PAINT SHRUBBERY AND SCULPTURE

Paint the tea table with Brick Beige and apply Light Grape to shadow areas. To suggest some distance, paint Grayish Lavender on the table legs that are distant from the viewer. Create cast shadows from the sculpture on the cloth with Cardinal. Soften the edges with Colorless Blender and be careful not to make the color bleed off the area. Coat Vermilion on top of the cloth.

Following the curves and figures of the sculpture, paint a form shadow with Smoky Blue and leave some room for highlights at the left and reflected light at the right. Paint Mint Green over the top and coat the sculpture (except for the reflected light areas) with Pale Green. On the reflected light areas, paint Yellowish Skin Pink to depict the color that reflects from the red cloth.

Paint a mixture of Olive and Blue Green as shadows on the bush. Blend Yellow Green and Ice Ocean from top to bottom. Wait until the colors completely dry before you finalize the leaf details with Moss.

11 PAINT THE TABLES AND CHAIRS

Gradate Powder Blue and Iridescent Mauve from top to bottom on the tablecloths. On the tablecloth closest to the viewer, after letting the colors dry completely, use Grayish Lavender for shadows underneath the bowl and plate. Build up shadowy drapes around the edges of the table by using Pale Blue. Apply the second layer of shadows with Light Hydrangea and Light Crockery Blue.

If you want another layer of shadows, use Grayish Lavender. For the other tables behind, simply apply Pale Blue and Light Crockery Blue on their shadowy drapes. Paint Sand on the chairs and Caribe Cocoa on the shadowy areas. For the food, use Atoll on the bowl and the dish and Light Grape on top for its shadows. The food doesn't need to be in fancy colors, so use Cobalt Green and Mimosa Yellow on the salad and a variety of warm colors such as Light Rouge, Lionet Gold and Cream for the burger.

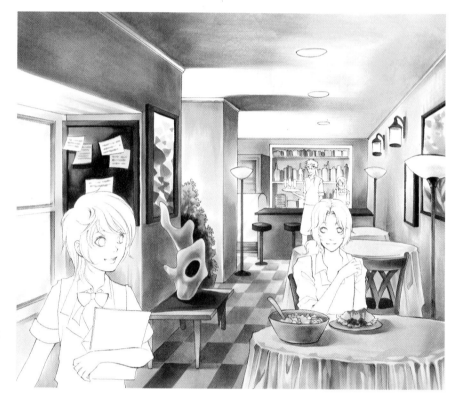

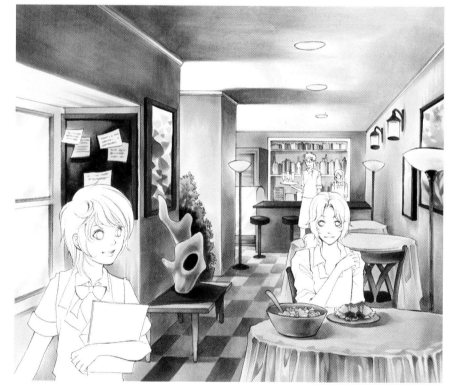

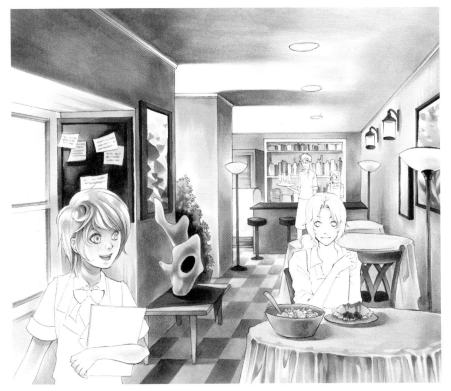

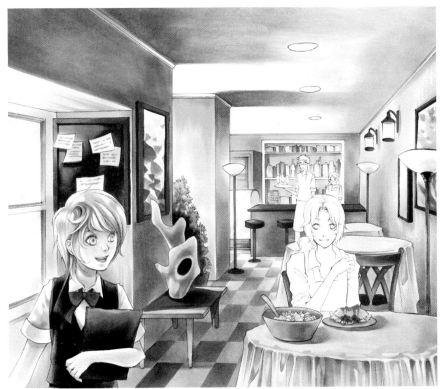

12 COLOR ETHAN'S SKIN AND HAIR

Start with the front figure, Ethan. Apply Bareley Beige for shadows under his bangs, neck, lower lip and sleeves. Paint Baby Skin Pink, then coat Pale Fruit Pink over that. Leave some small areas at the sides of his skin for highlights.

Create shadowy streaks on Ethan's hair with Lionet Gold and paint Yellowish Beige on top. On the areas that you want to become darker, deepen the streaks with Light Hydrangea. Paint the eyes with Aqua Blue on the irises and Tahitian Blue for the pupils.

13 PAINT HIS OUTFIT

Use Cool Gray No. 10 for shadowy wrinkles on Ethan's vest. Soften some of the edges with Colorless Blender. Paint Cool Gray No. 7 on top as the second layer, then coat the entire vest with Grayish Lavender. For his shirt, paint Dull Lavender and Cool Gray No. 2 on the wrinkles. Paint Light Rouge on the bowtie and apply Cardinal on top as shadows. Blend Ice Ocean and Bronze from top to bottom on the menu he's holding.

14 COLOR EDMOND

Move on to Edmond seated at the table. Apply Bareley Beige for shadows on Edmond's skin. Use Bisque as the second layer and coat his entire skin with Pale Fruit Pink. Paint shadowy streaks on his hair with Lionet Gold and color Yellowish Beige on top. Leave some highlights around the middle of his head. To depict Edmond's green eyes, use Chartreuse on the irises and make darker dots for his pupils with Pine Tree Green.

Paint Pale Green on his shirt. Color the shadowy wrinkles with Mint Green and Ice Ocean. Paint Cool Gray No. 10 on his apron to make shadows, then coat the entire area with Cool Gray No. 5.

15 COLOR THE BACKGROUND CHARACTERS

Since Lawrence and Jonathan are standing in the back farthest from the viewer, coloring them with simple colors and details is adequate to balance the picture. Paint their skin with Bisque and mark some shadows with Baby Skin Pink. Color their hair with Cool Gray No. 8 and Grayish Lavender.

For their aprons, use Cool Gray No. 7 for the shadows, then coat the entire surface with Cool Gray No. 4. Paint Sky on Lawrence's shirt and soften with Aqua Blue. Use Light Crockery Blue on his jeans, and apply Sand on the tray that Lawrence is holding. With Dull Lavender, paint shadowy wrinkles on Jonathan's shirt.

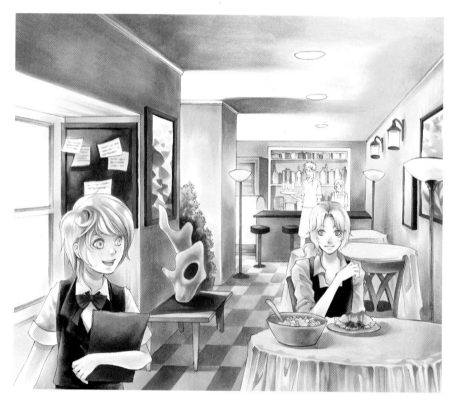

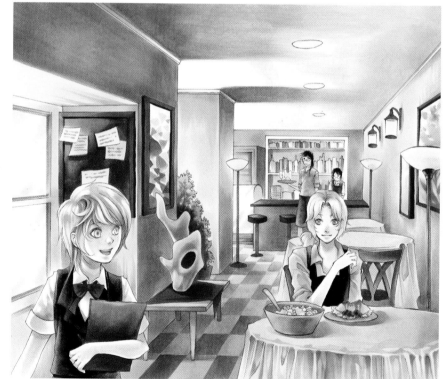

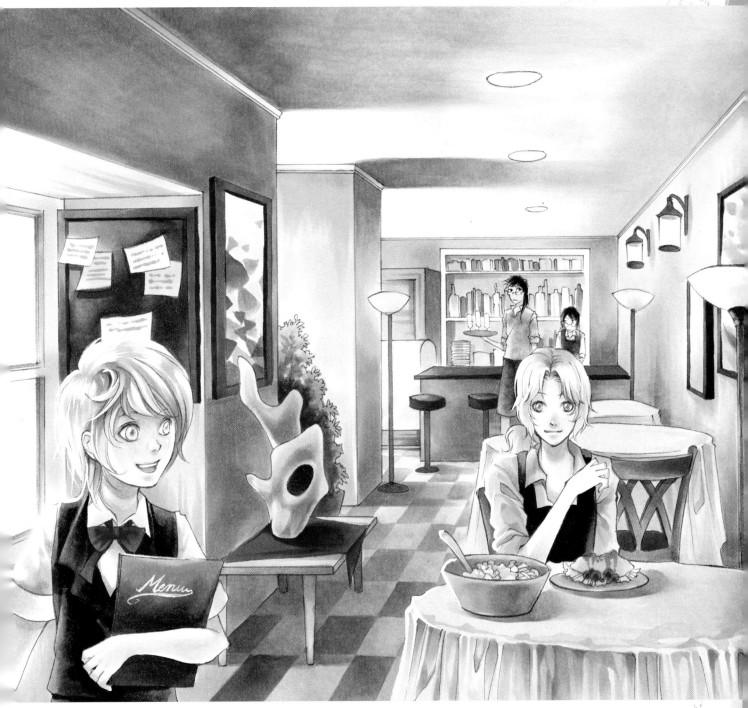

16 FINISH THE SCENE

With a no. 2 round and white acrylic paint or a white gel pen, create highlights on Ethan and Edmond's eyes, noses, hair and left sides.

Index

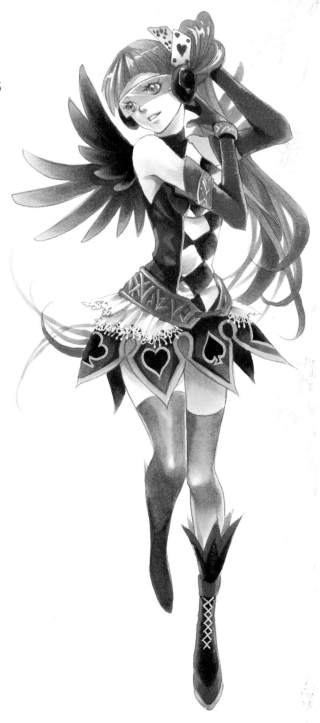

ABOUT THE AUTHOR

Known as Ecthelian on deviantART since February 2004, Supittha "Annie" Bunyapen is a prolific young manga and cover artist whose site has received more than two million pageviews. She earned her BFA in sequential art from Savannah College of Art and Design, and currently works in the game industry for Kiz Toys (kiztoys.com). Bunyapen's influences include the Japanese manga and Konami game artists Ayami Kojima and Fumi Ishikawa; Taiwanese manga, comic book and video game artist Jo Chen; yaoi manga artist Naono Bohra; writers J.R.R. Tolkien and the Brothers Grimm. When not busy working at Kiz Toys or on personal commissions, she spends her free time taking photos, listening to music and traveling. She divides her time between her home in South Carolina and Bangkok, Thailand. Visit her deviantART page at ecthelian.deviantart.com.

Other fine IMPACT Books are available from your favorite bookstore, art supply store or online supplier. Visit our website at www.fwmedia.com.

15 14 5 4

DISTRIBUTED IN CANADA BY FRASER DIRECT
100 Armstrong Avenue
Georgetown, ON, Canada L7G 5S4
Tel: (905) 877-4411

DISTRIBUTED IN THE U.K. AND EUROPE
BY F&W MEDIA INTERNATIONAL LTD
Brunel House, Forde Close, Newton Abbot, TQ12 4PU, UK
Tel: (+44) 1626 323200, Fax: (+44) 1626 323319
Email: enquiries@fwmedia.com

DISTRIBUTED IN AUSTRALIA BY CAPRICORN LINK
P.O. Box 704, S. Windsor NSW, 2756 Australia
Tel: (02) 4577-3555

Edited by Vanessa Wieland and Sarah Laichas
Designed by Wendy Dunning
Production coordinated by Mark Griffin

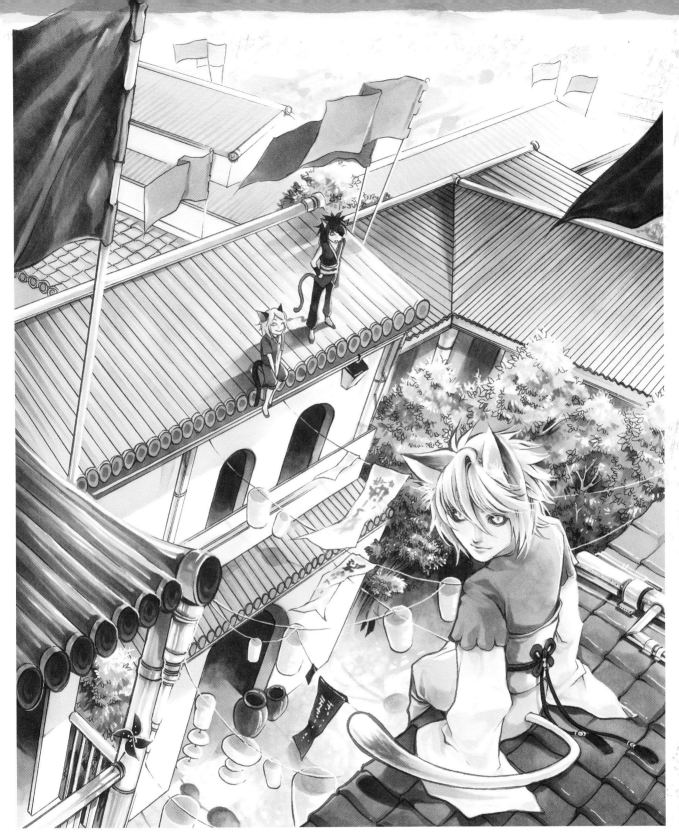

ACKNOWLEDGMENTS

This book couldn't have existed without my two fantastic editors, Pam Wissman and Sarah Laichas. Thanks also to my great friend Kay for the names of the No Name Café's characters, to P'Ann for Rudy's family, to my MO friends, and last but not least, to Ming Zhang—my best roommate, friend and coworker—for always feeding and helping out a lazy bum like me.

DEDICATION

I would like to dedicate this book to my family for supporting me through everything and never complaining about the paths I choose. Also to my two great art professors, Mr. Pittaya and Bob Pendarvis.

Ideas. Instruction. Inspiration.

These and other fine IMPACT products are available at your local art & craft retailer, bookstore or online supplier. Visit our website at impact-books.com.

IMPACT-Books.com

- Get the latest in comic, fantasy and sci-fi art
- Great deals, demos and videos by your favorite artists
- Fun and newsy blog updated daily by the IMPACT editorial staff